david
casavant
archive

david
casavant
archive

DAMIANI

xavier cha

matao chamorro

raúl de nieves

thomas eggerer

dese escobar

maggie lee

eric n. mack

ryan mcnamara

joyce ng

hanne gaby odiele

jacolby satterwhite

heji shin

ryan trecartin

wu tsang and boychild

stewart uoo

kanye west

foreword
by andrew
durbin

L told me about the time she met an artist who would later become extremely famous, at least famous in the peculiar way artists become famous. Their meeting took place when she was still an MFA candidate at 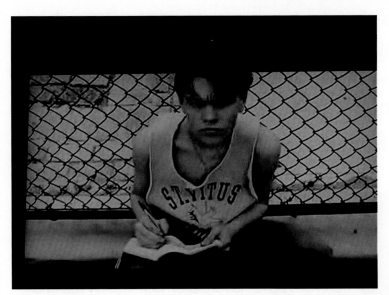 a prominent school in Los Angeles that L was visiting as a guest lecturer, but even then, the artist had *something*, she said. Now that she is famous, I imagine that *something* was a protean form of her implacable side-winding intelligence, with its love of slippery, uneasy ideas, mostly about language, mostly about humor, mostly about the flimsy distinctions we make between what's on the wall and what's off it. (That is, the world). When they met, it was "one of those brief moments that last forever," L said, full of the restless energy that marks a first encounter with someone who will, for you or for others, someday matter. The terms of that mattering are then unknown; that there will be terms is obvious. It's in the eyes. A spark of knowing. Knowing what?

The year is 1995. L is in California, I'm elsewhere. Or, rather, let's say I'm in a moving-picture theater, the long arm of light crossing the darkness and spinning, my eyes fixed on the screen. (That's a quote from Delmore Schwartz's "In Dreams

Begin Responsibilities," by the way, but for our purposes, I want you to think it's by me.) The audience is having one of those brief moments that last forever, with a movie about a young man in Manhattan who is hoping to become a poet, given his natural talent for describing the world. The problem—or plot—is that he's failing terribly at it, so much so that he loses everyone and everything he loved because of an addiction to heroin. He has *something*, everyone knows it, but he doesn't know

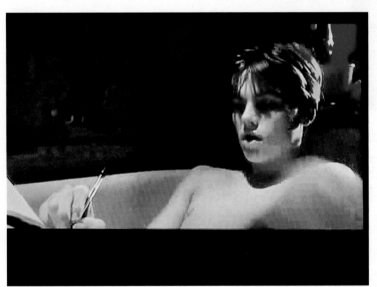

what to do with it yet. The poet is named Jim Carroll, and he's played by Leonardo DiCaprio, who balances on that long arm of light crossing the darkness and spinning throughout the movie version of Carroll's memoir, *The Basketball Diaries*.

In the Schwartz story, the narrator sits for a film version of his parents' first date. He watches them meet with a melancholy resignation, as the past becomes this great wandering beast, a monster that begat the monster of himself. It's like that in the *Basketball Diaries*, too, history rampaging into the present, only this time it has the baby face of Leonardo DiCaprio. Remember the scene where the real Jim sits with Leo in a smack den, discussing downtown days of old? Jim looks like a stick of ivory

smoothed by the many hands who held it. He smiles sadly at this avatar of his younger years, which, for theatergoers, is a kind of present, an eternal present of needles strewn about the floor, of mendicant pity.

Typically, in high school, literature teachers assign "In Dreams Begin Responsibilities." Perhaps you've read it? I'm bringing it up hoping that you have, because it is a text that both argues for a familiar idea (that we are shaped by what and who came before us) and is itself a familiar vessel of the idea—or at least familiar if you went to a school that cared about writers like Schwartz. Perhaps Leo, or Jim, or Leo-Jim read it, too. As its narrator spies upon his younger parents, Schwartz's story bears some resemblance to the movie version of The Basketball Diaries, though

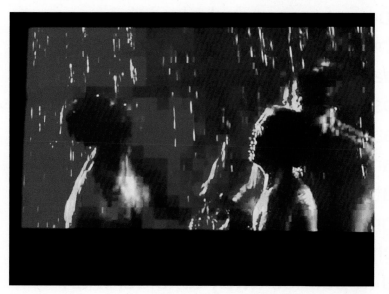

instead of mom and dad, the real Jim sees himself as a kid, laboring through the pain that will produce the author of the novel the film is based on. He sees the face of Leonardo DiCaprio, the child actor whose changes we have all come to know, whose progression from boyhood to adulthood has always seemed incredible, as if it were itself an effect of movie magic. In every film, Leo always recalls another face which we have seen before—or will see again, depending

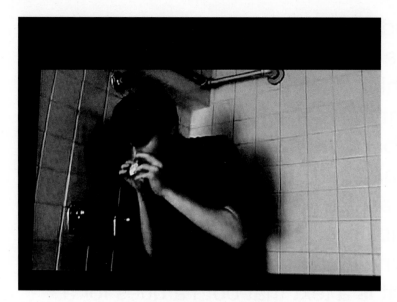

on where we find ourselves in the actor's catalog. Leo is always a collage of characters he has played.

Leo-Jim holds within himself both the unnerving promise of a rebellious boy of remarkable intelligence and the certainty of its taming, of the cage that he and the world will fashion for that intelligence, to control it, to keep it still. He grins. Did Jim Carroll grin like that? Jim Carroll, whom I never knew but saw a few times around town before he died in 2009, was a slim, ethereal figure, as if his body had been cut down to its barest possibility before it slipped past perception. Later, Leo weeps and tumbles down into the world, the world of Jim but also of 1995. It's the apex of queer-and-almost-queer cinema: between Gus van Sant's *My Own Private Idaho* and Gregg Araki's *Teenage Apocalypse* trilogy, a feisty, horny, uncertain world. Youth, the film suggests, is this flagrant and terrible thing fleered by violence and beauty, with bruised lips, blemishes, and hungry eyes already too-mindful of what adults want from children. In several scenes, Jim pushes away an older man whom he assumes wants a blowjob, even if he has not made any lusty moves toward the ruined poet. It's just known.

Brief, and yet forever: the idea might

be found on a greeting card, or destroyed in the face of Leonardo DiCaprio: in the face of the wolf of Wall Street, or in the face of the nineteenth century frontiersman Hugh Glass, to use two recent examples from DiCaprio's filmography, both of whom channel—and are very nearly destroyed by—a masculinity that Jim, who might have been an NBA star (he played ball as a kid and was *good*), ultimately sloughs off through his own self-destructive journey into the dark heart of downtown. They are each a revenant, annihilated and then reborn in a death of the self, undergoing an act of reckoning in drugs and poetry, girls and cash, wilderness and dominion that shreds that self in order to see its reinvention, as a downtown poet, a motivational speaker, the living among the dead. A long arm of light crossing the darkness. A projection, or a dream, like the one Schwartz's unnamed narrator had, who wakes up and leaves the theater when the

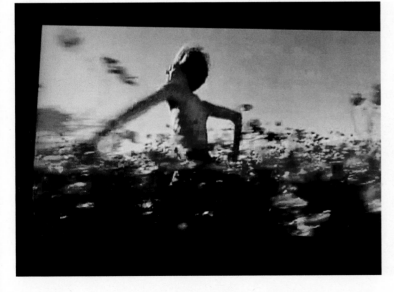

film becomes too much for him. A *something*.

With Leo, we often find ourselves in the position of the narrator in the dream-theater, watching someone we have known for much of our lives, and for nearly all of his, as he enacts and reenacts failures, successes, losses, deaths,

desires, returns, and departures. It is always too brief, yet everlasting in that strange space of an implacable forever, which might be film or memory or some Schwartzian parenthesis of the two. We never quite know who we are seeing and why we are seeing him, these men's faces that are one man's face, Leo's face, catching up in Jim Carroll, winding down in Howard Hughes, breaking in Frank Wheeler, each animated by DiCaprio's rage, a rage containing small but manifold sadness. And spinning. Spinning forward.

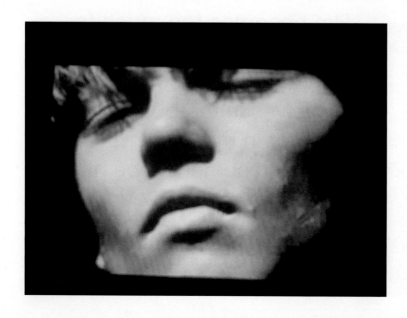

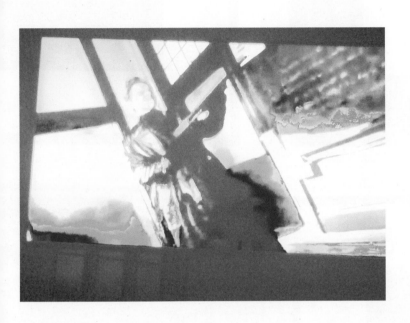

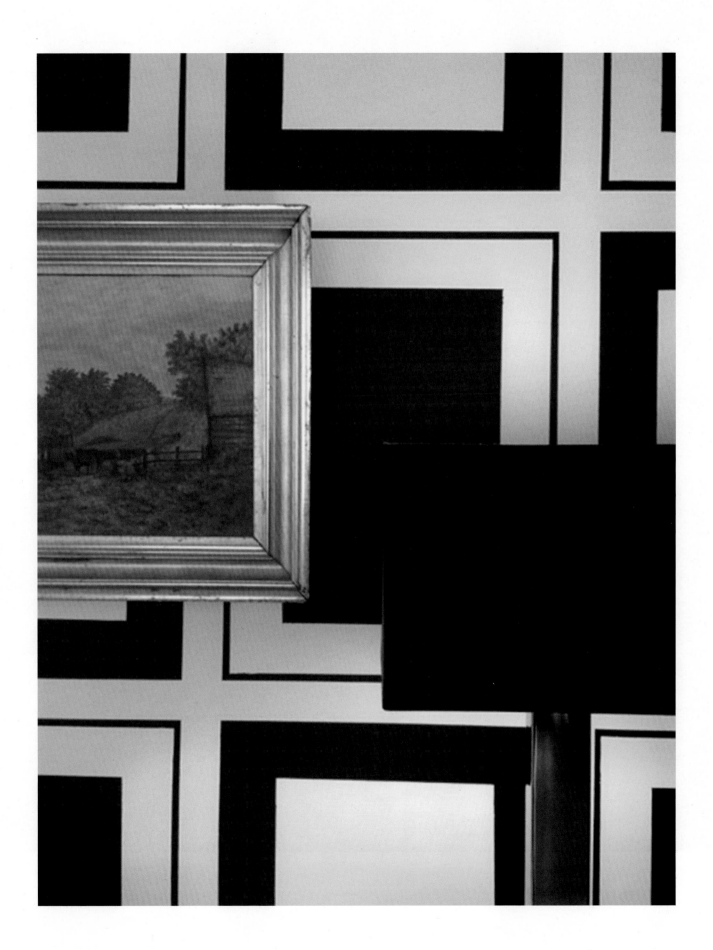

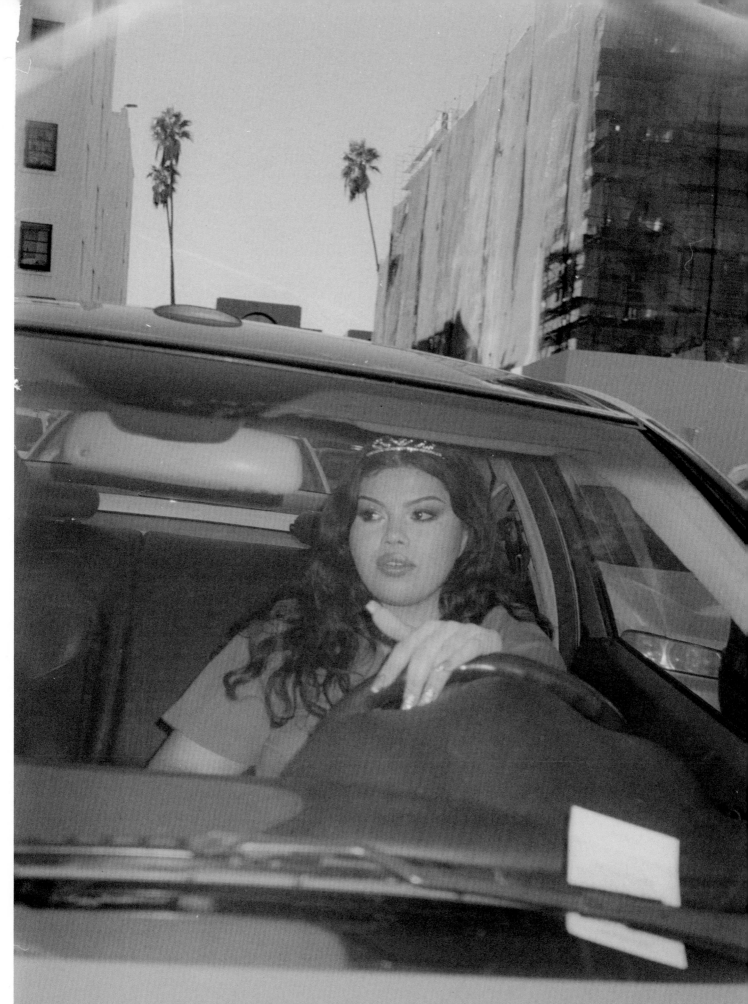

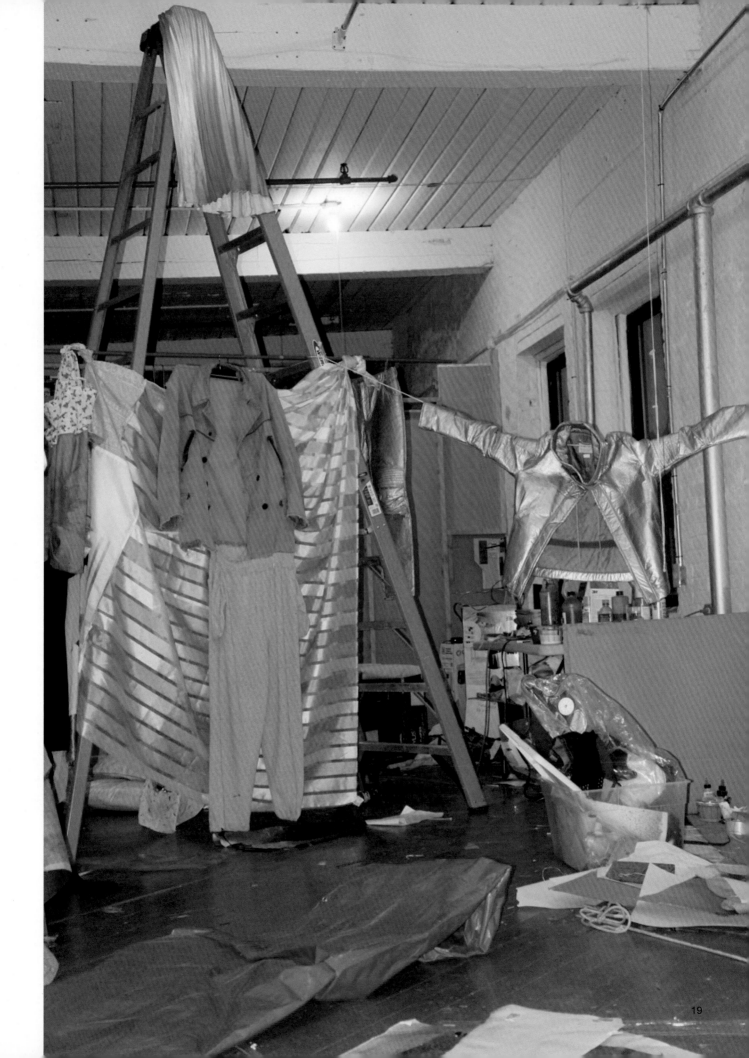

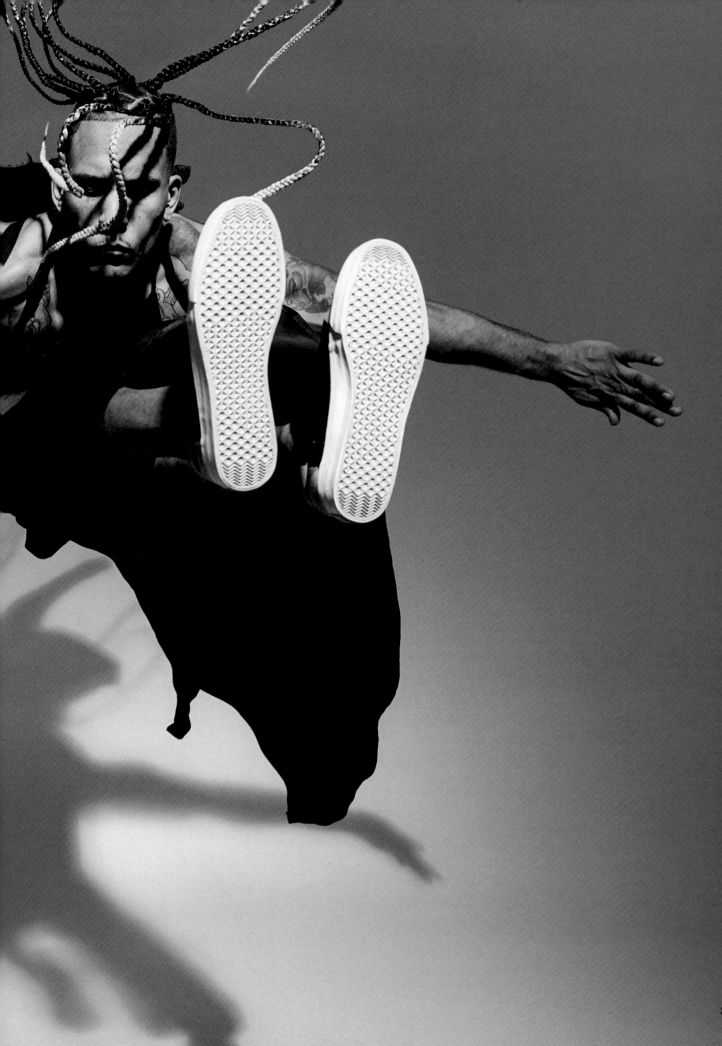

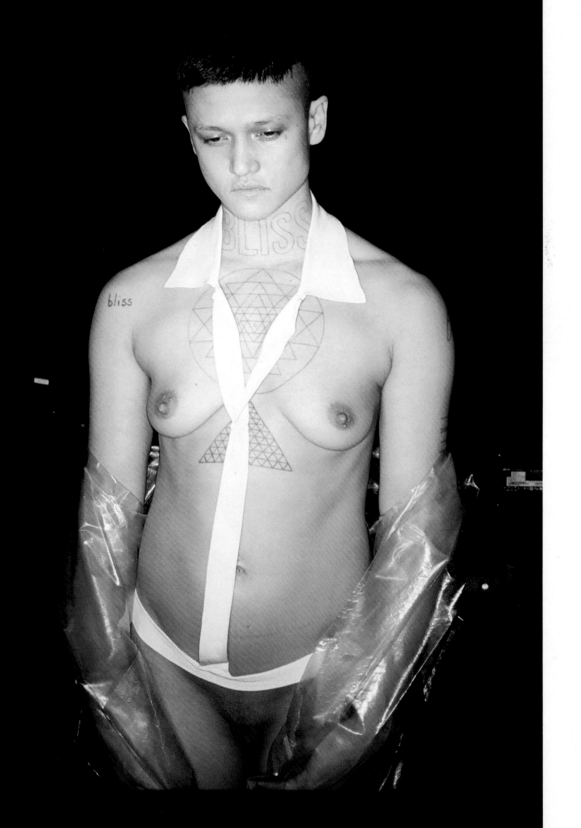

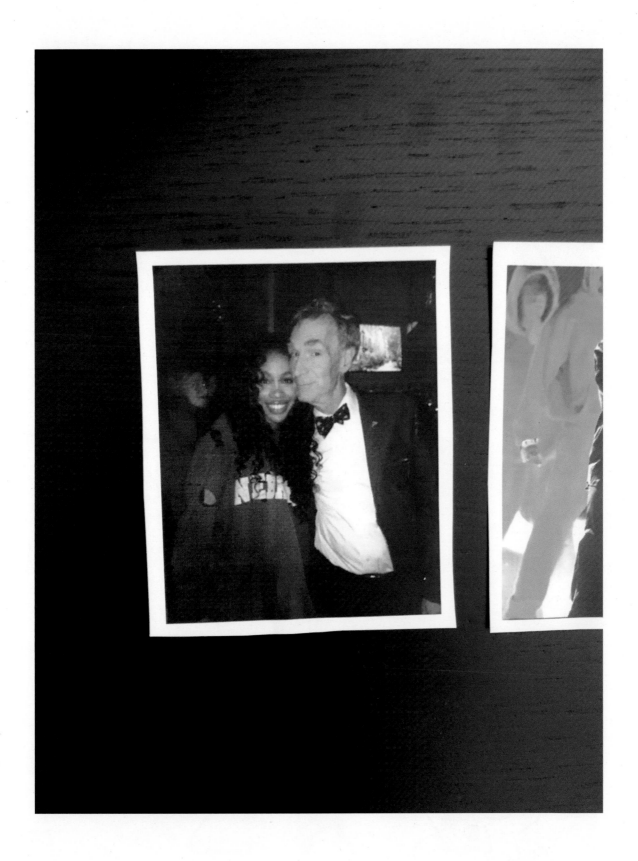

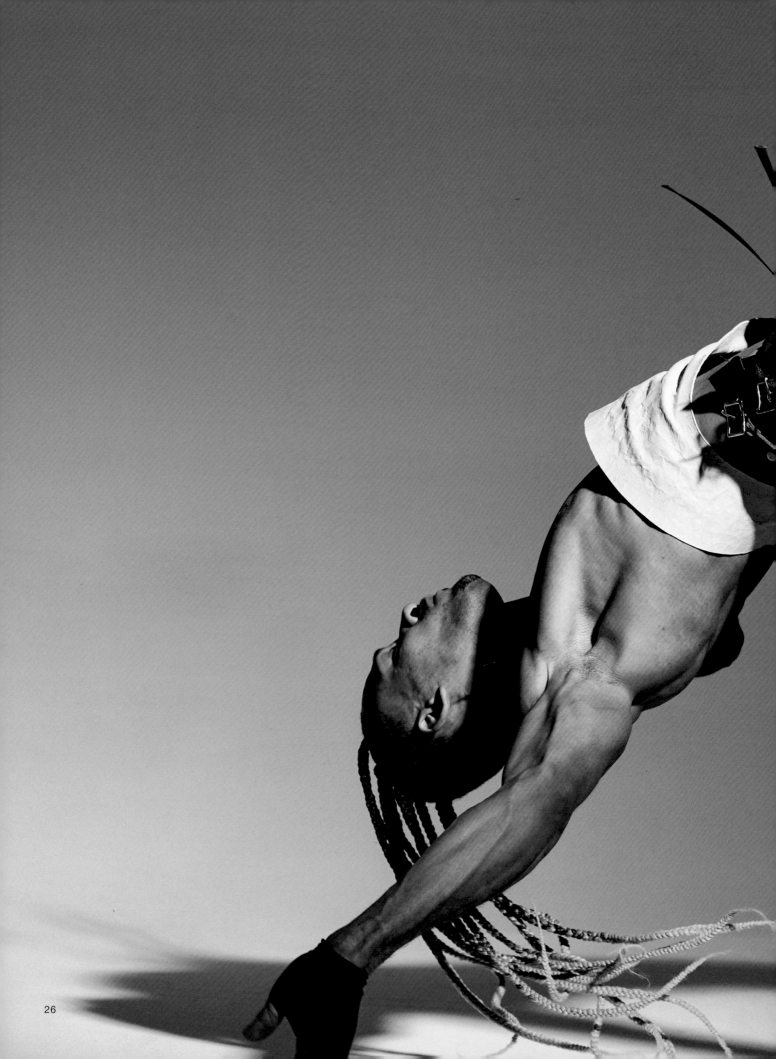

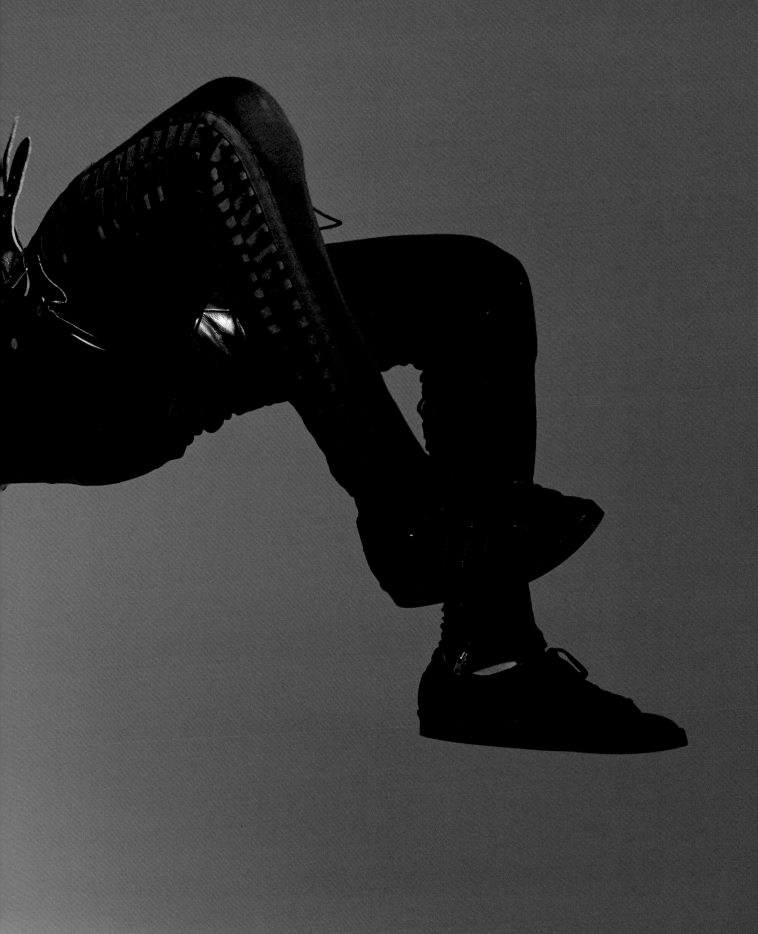

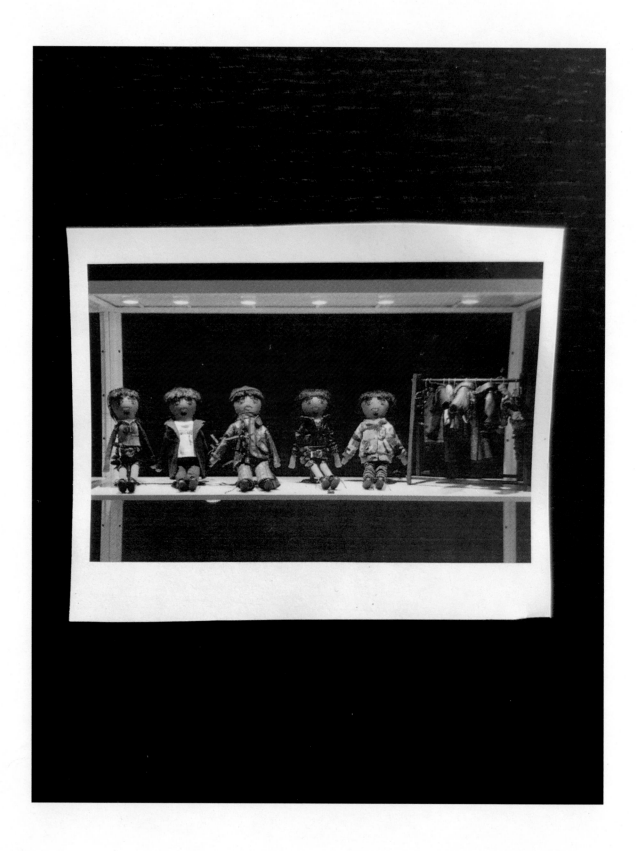

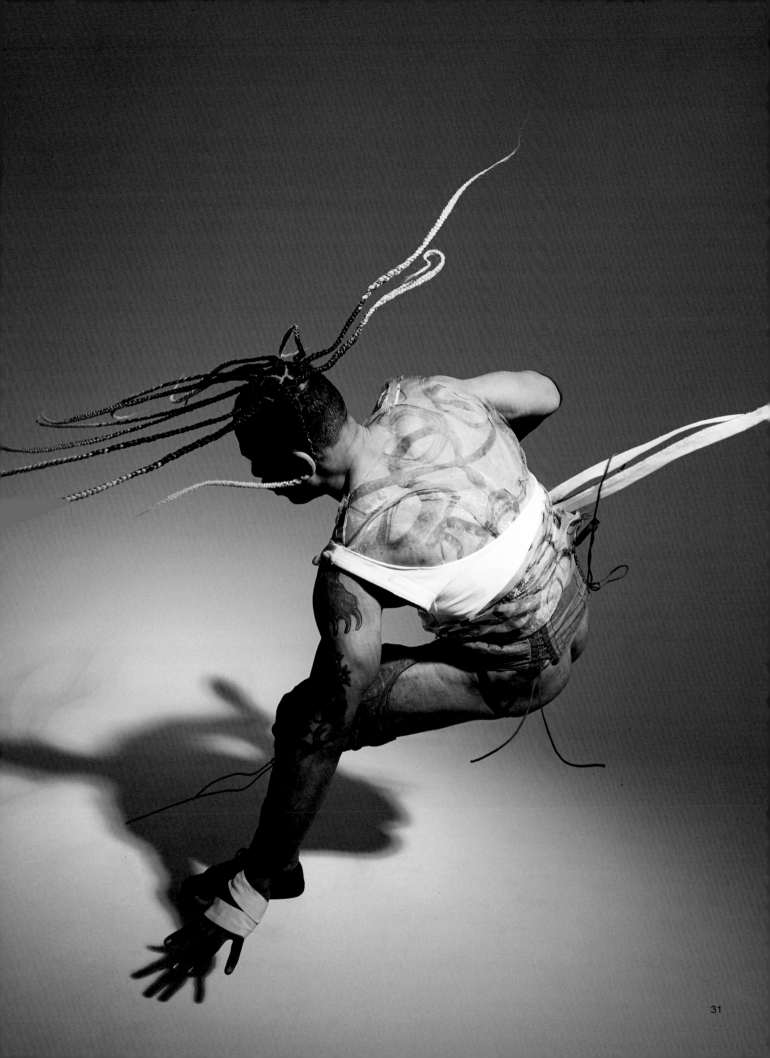

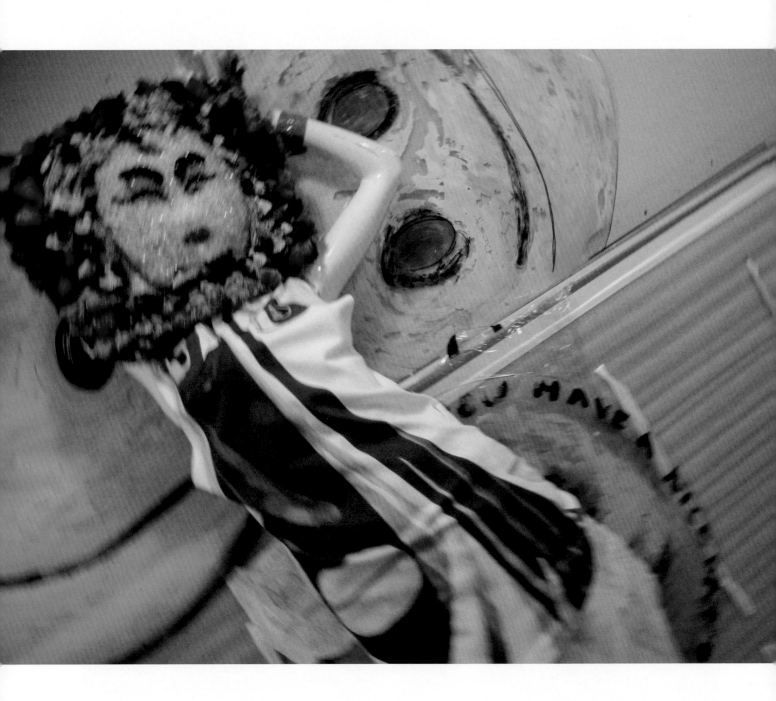

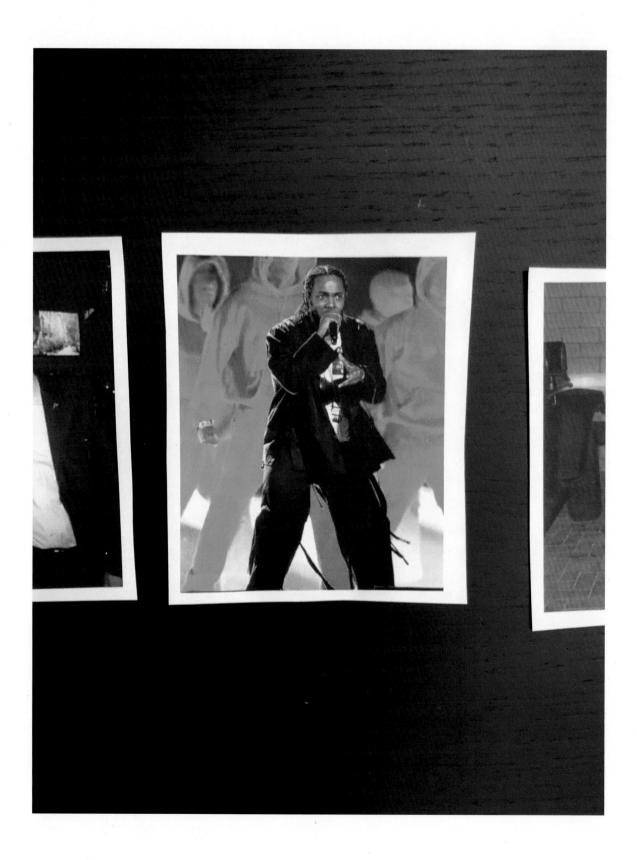

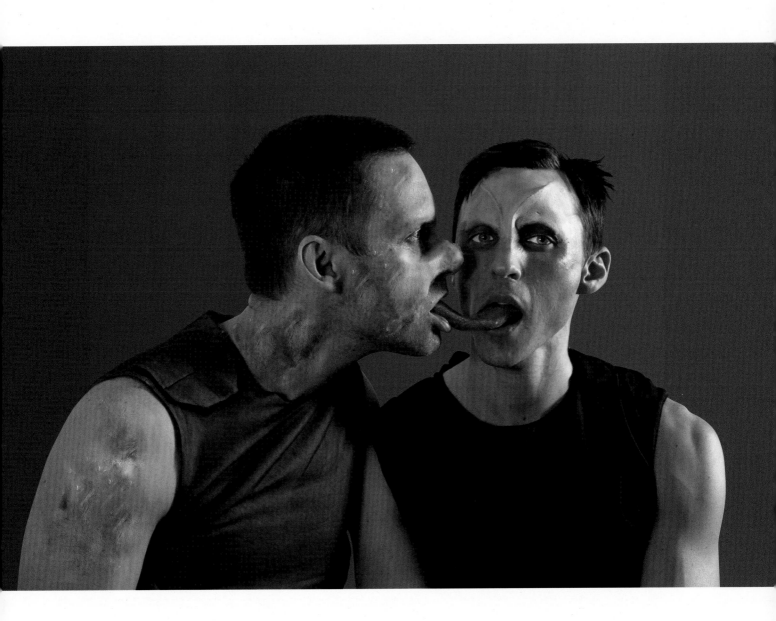

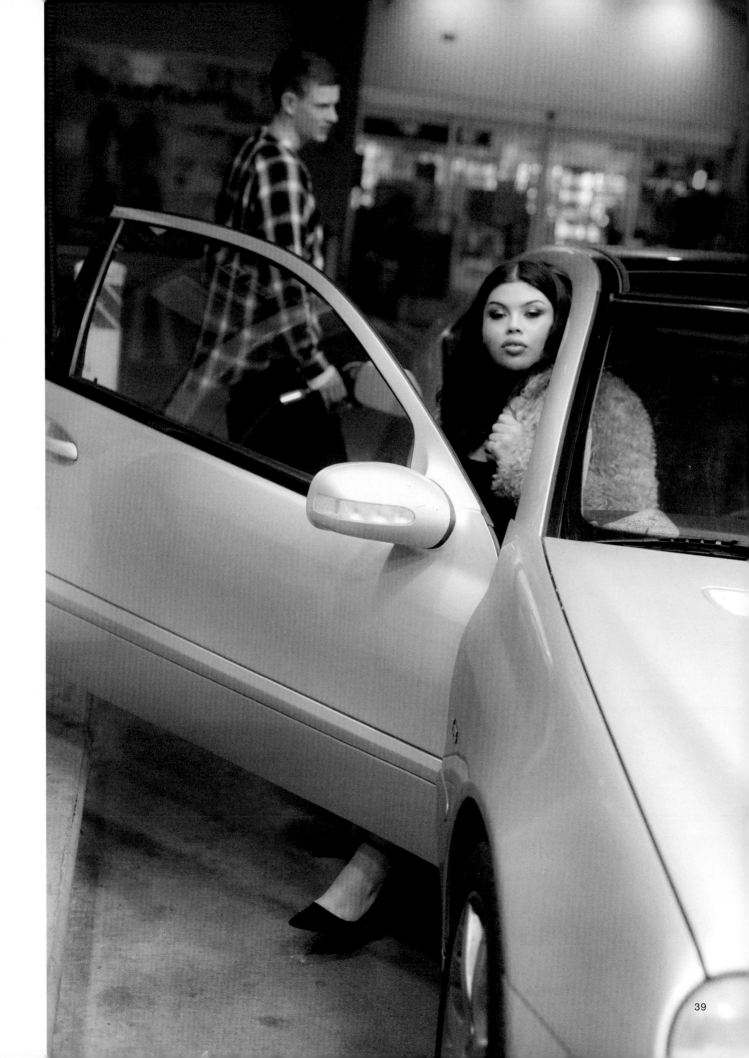

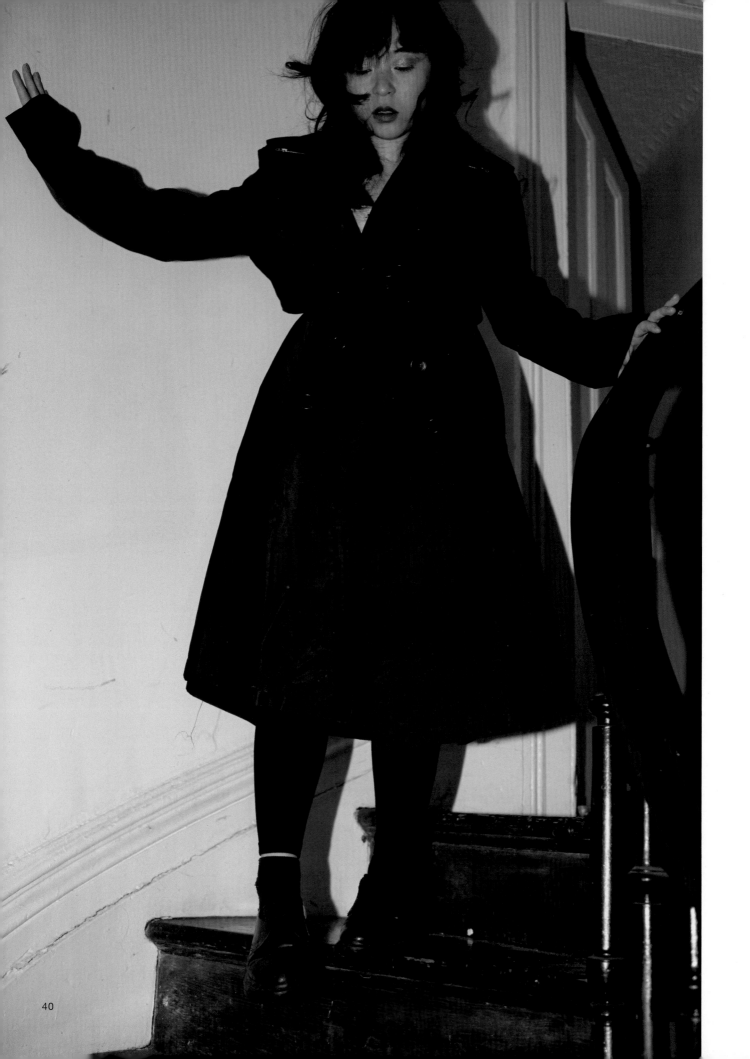

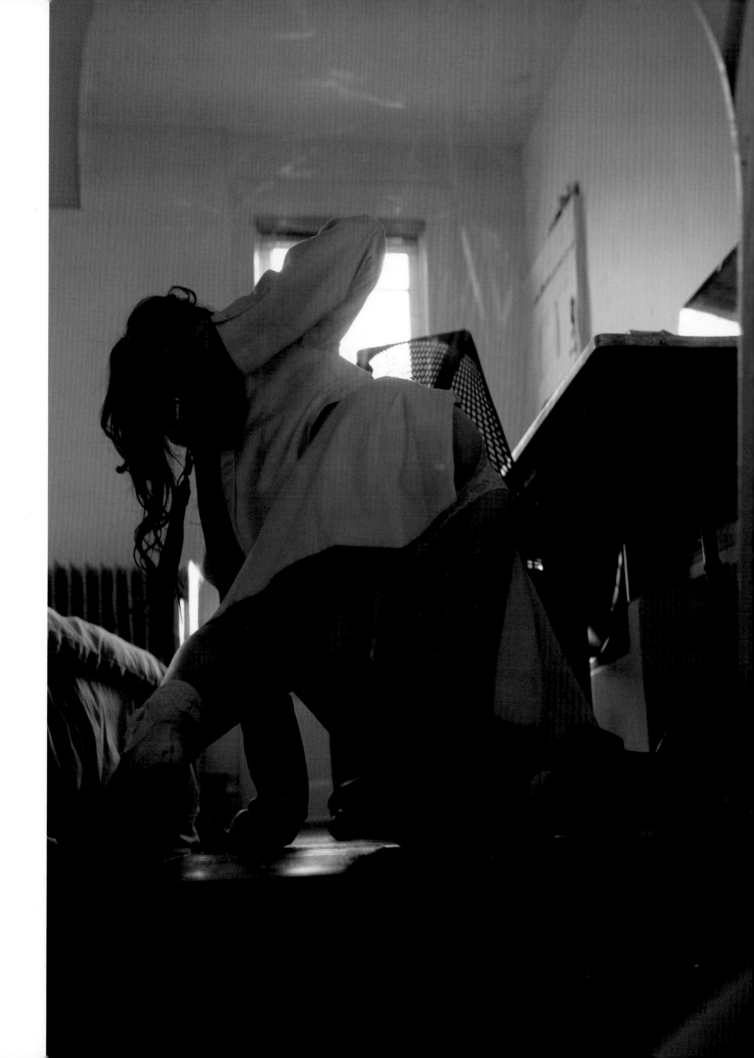

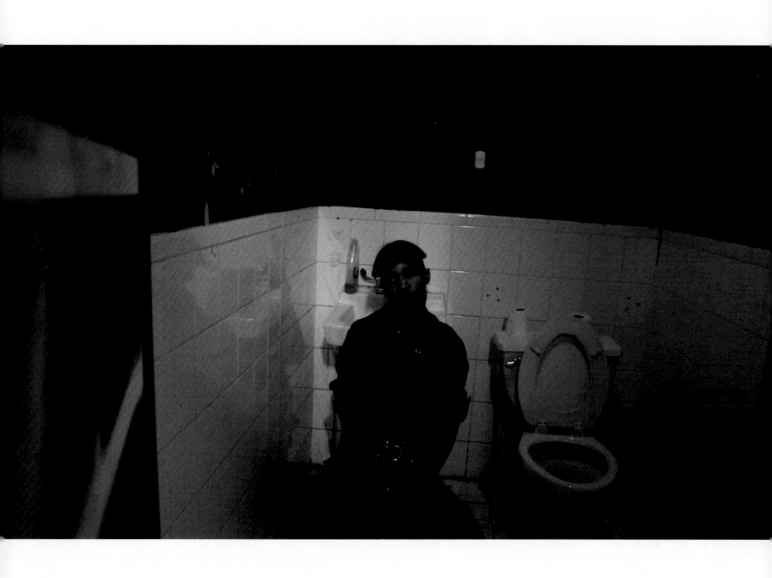

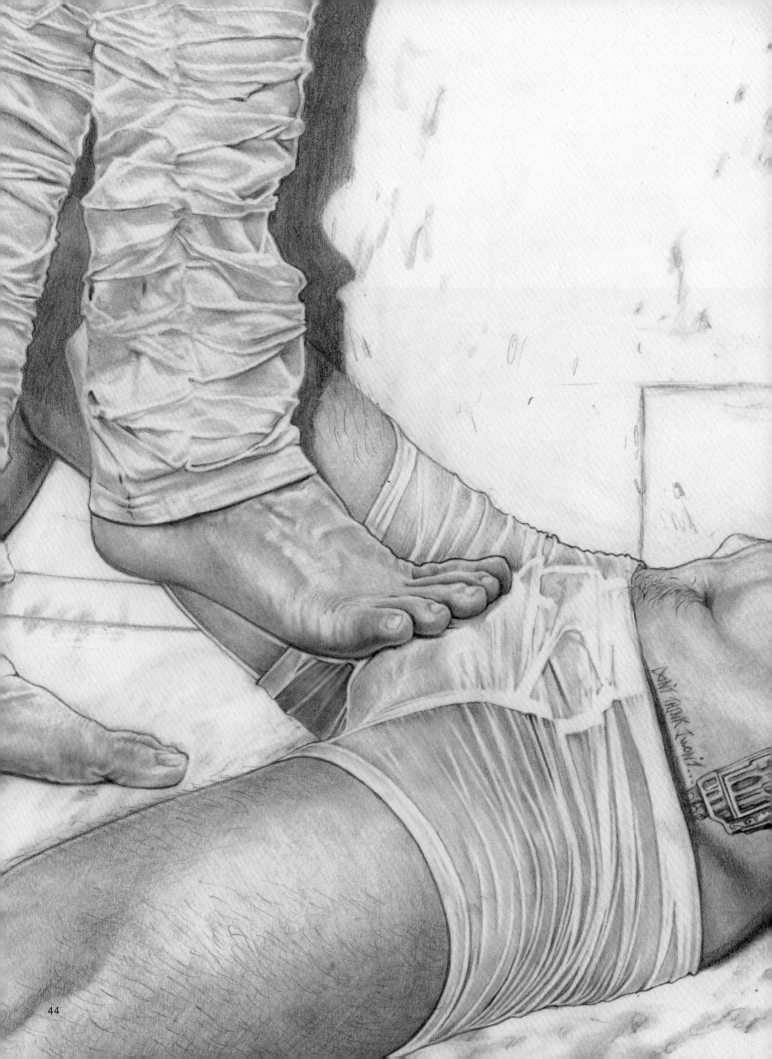

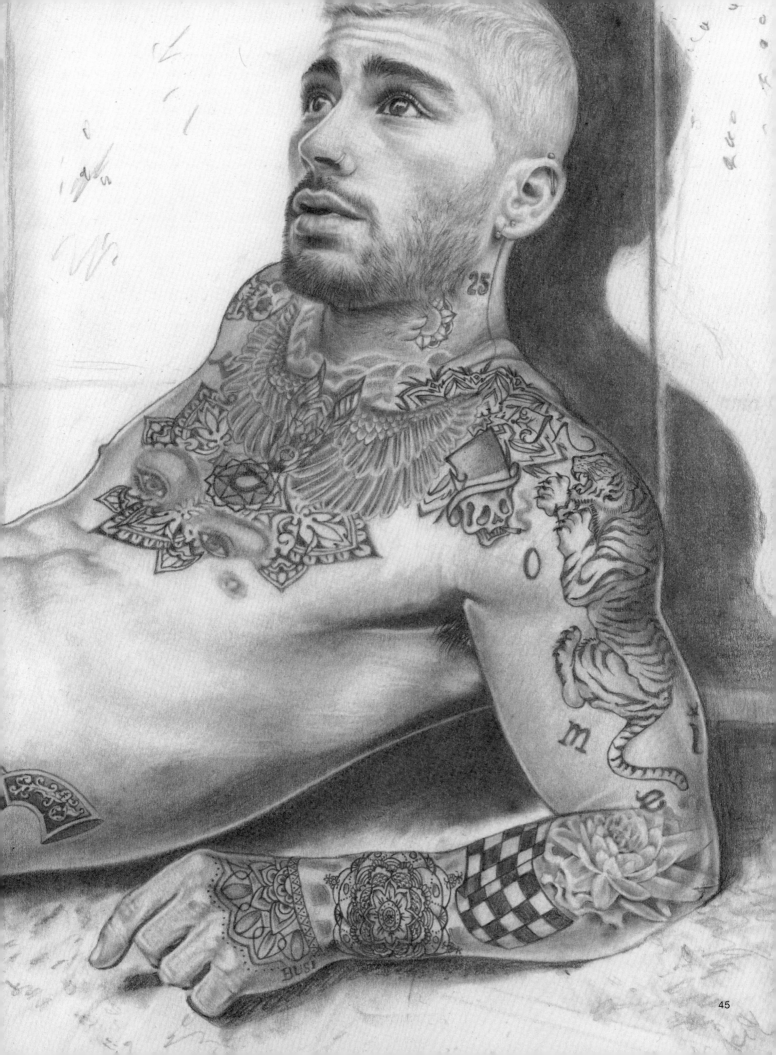

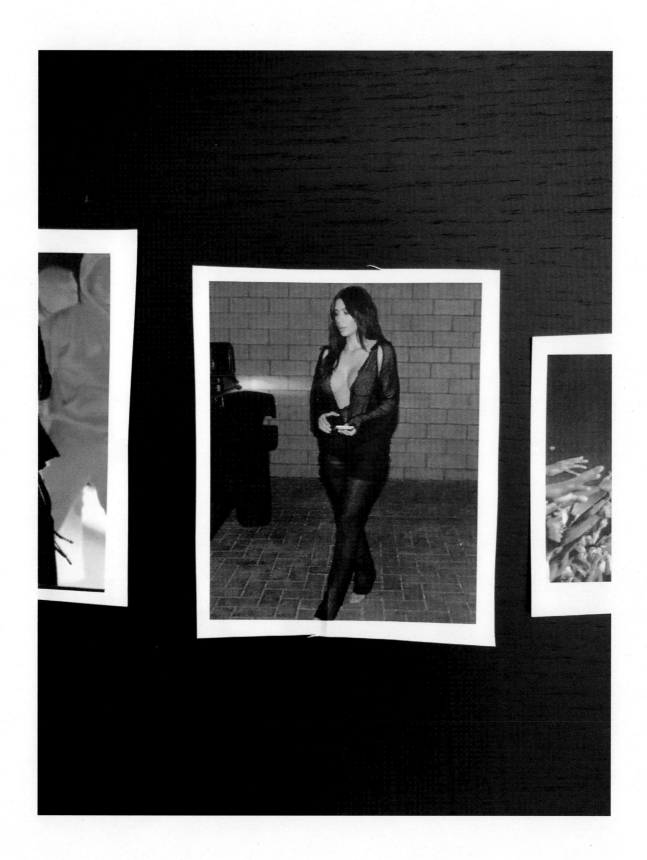

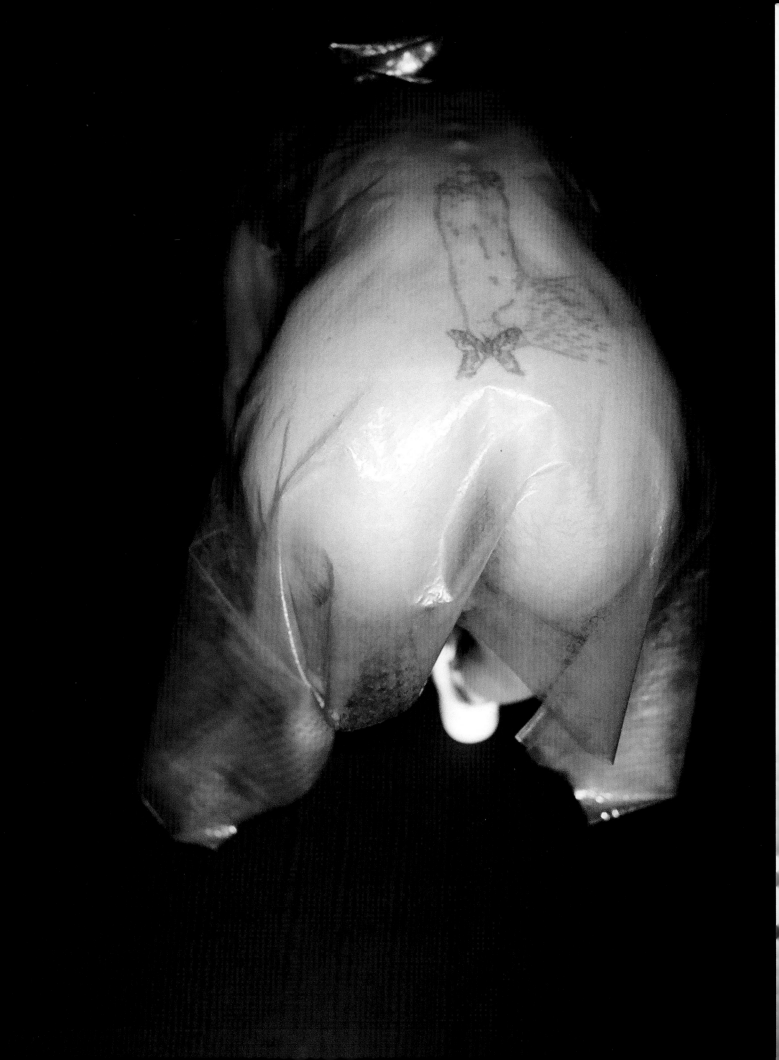

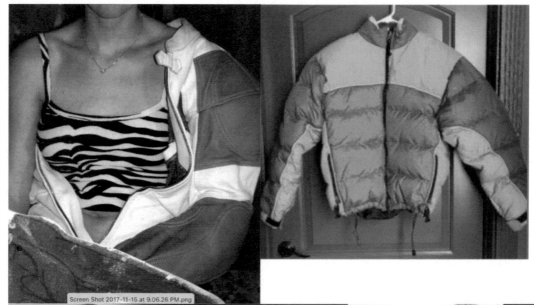

Screen Shot 2017-11-15 at 9.06.26 PM.png

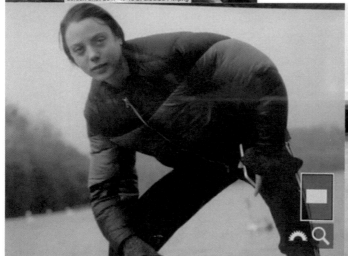

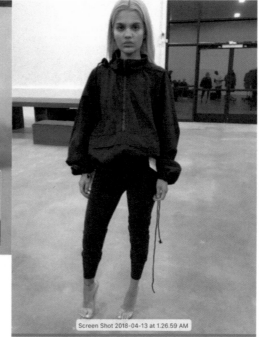

Screen Shot 2018-04-13 at 1.26.59 AM

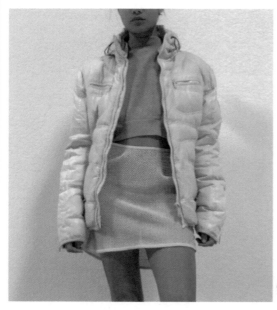

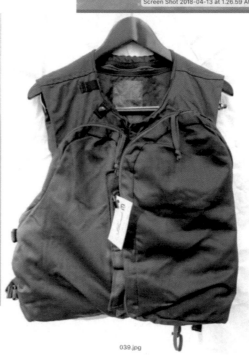

039.jpg

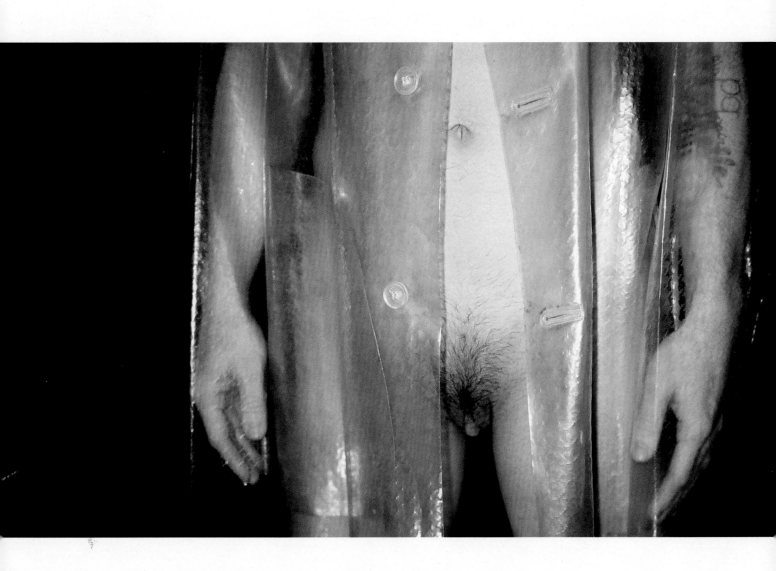

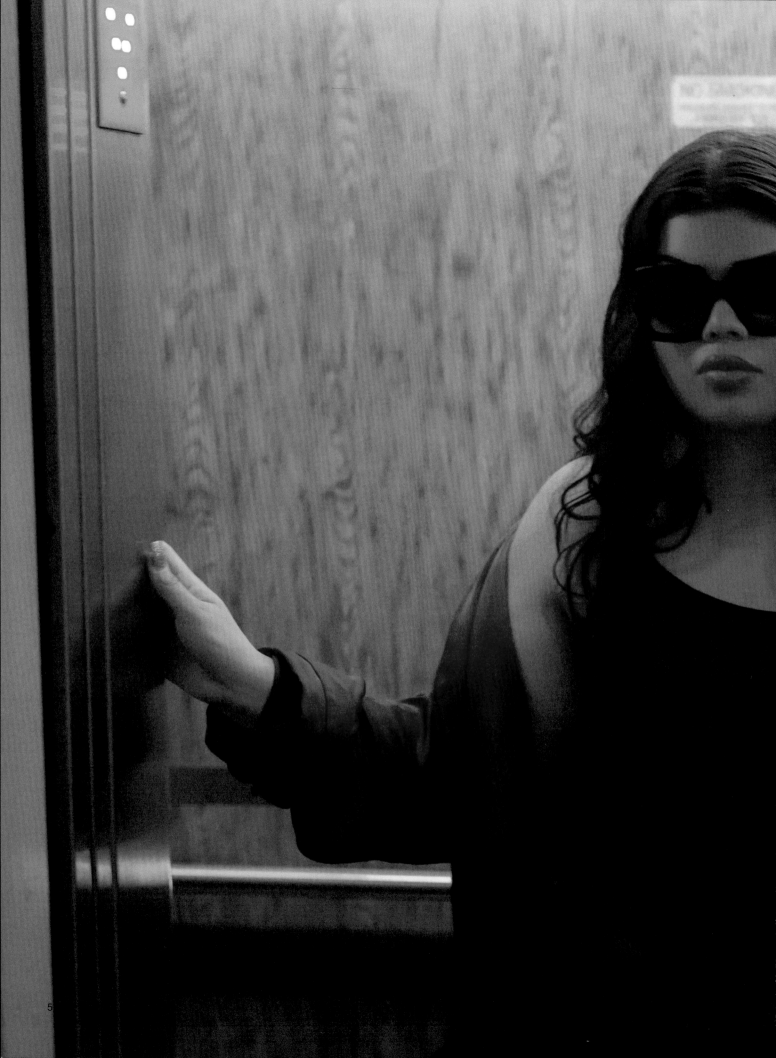

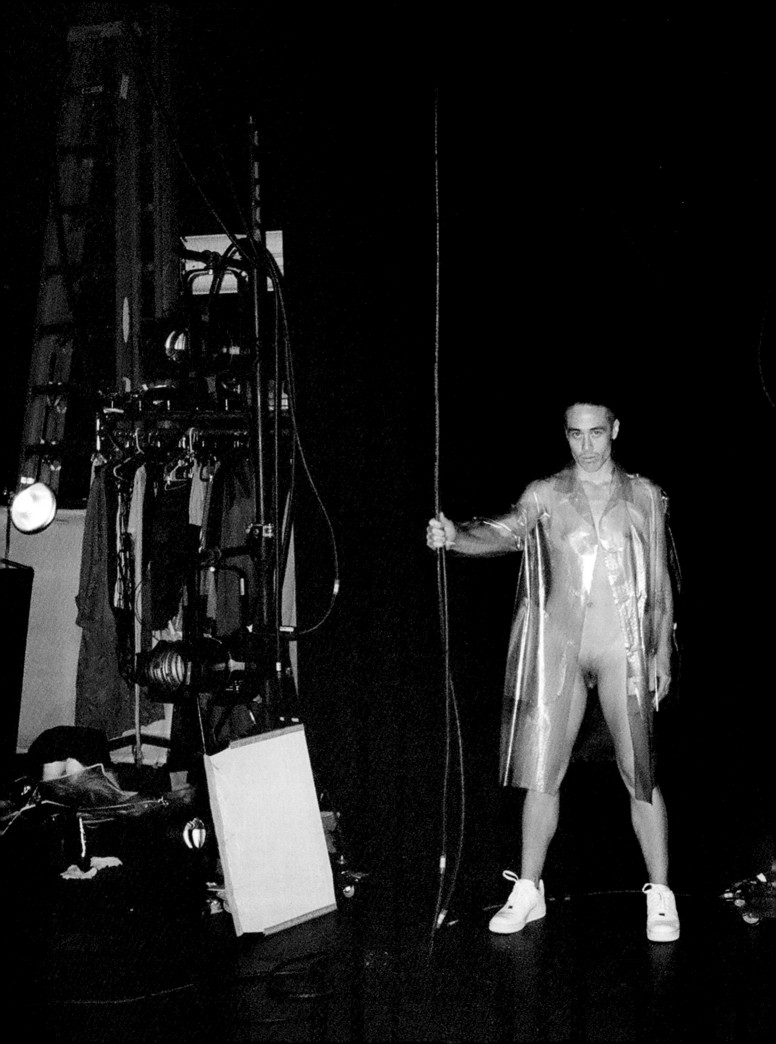

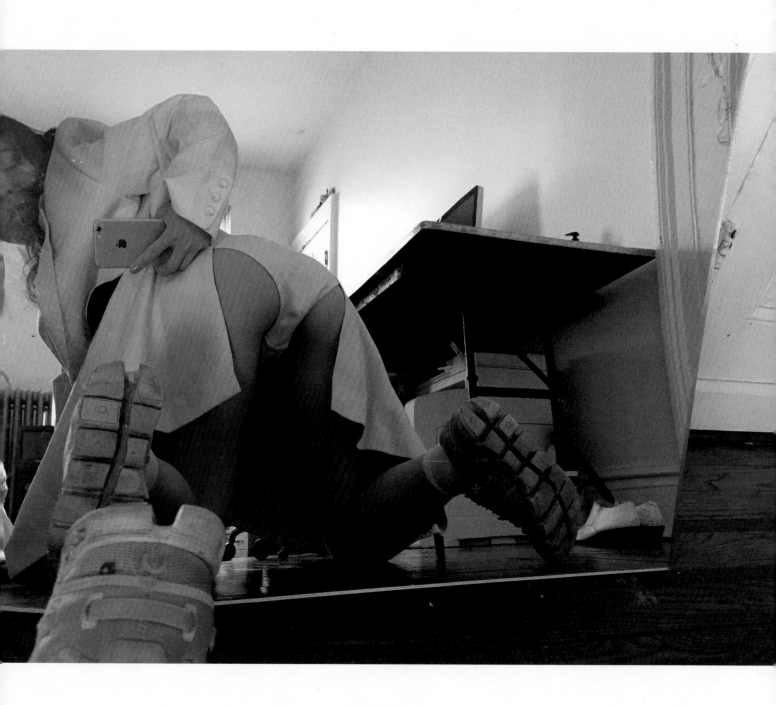

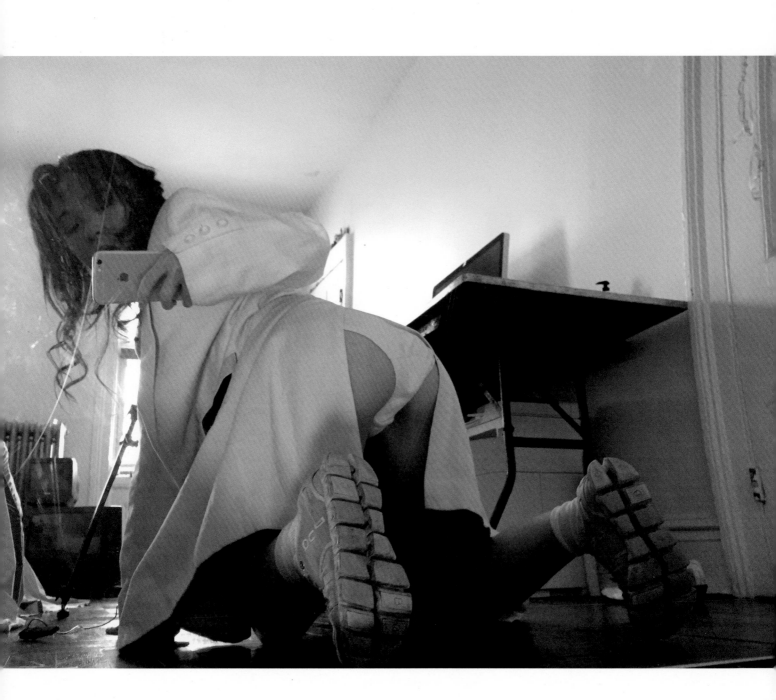

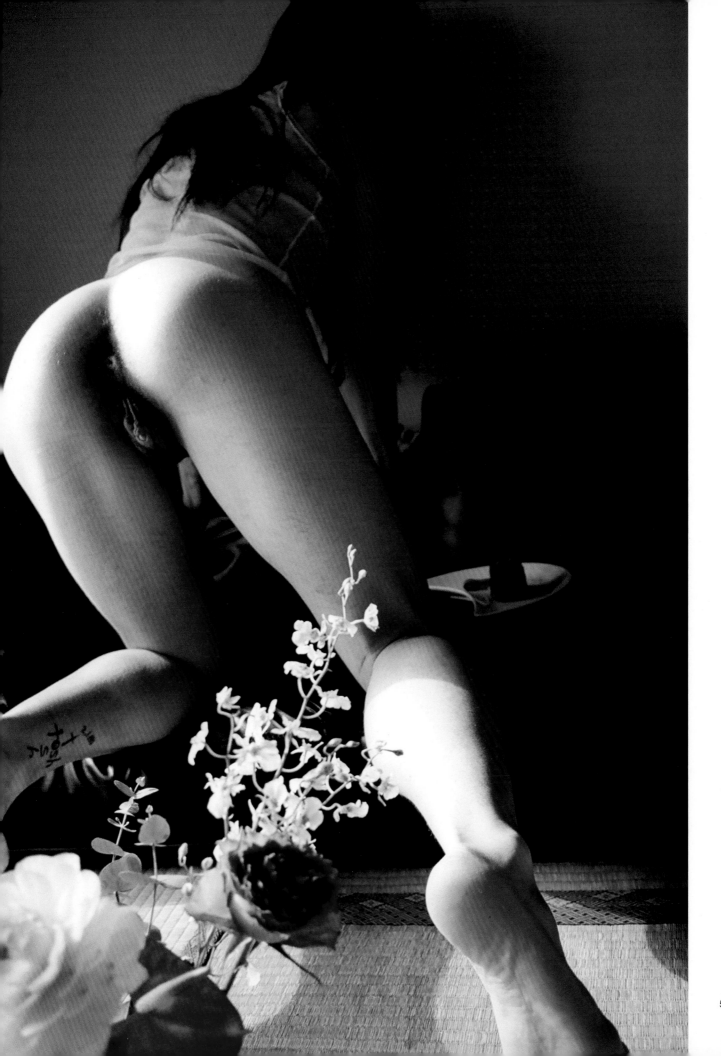

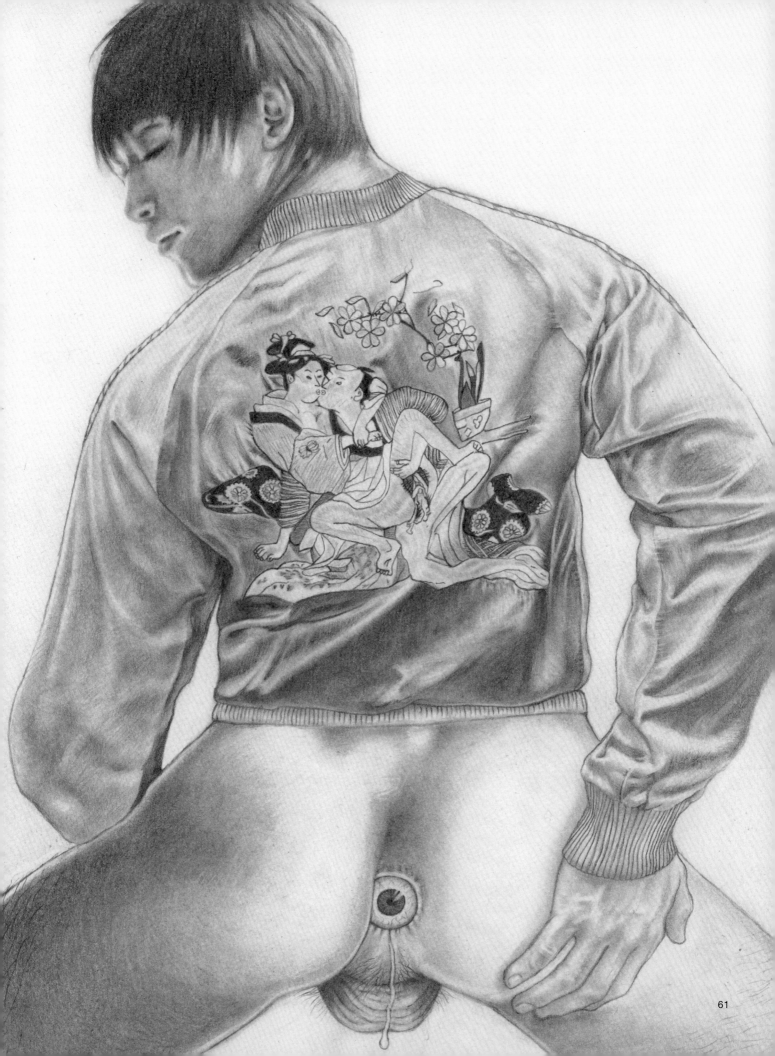

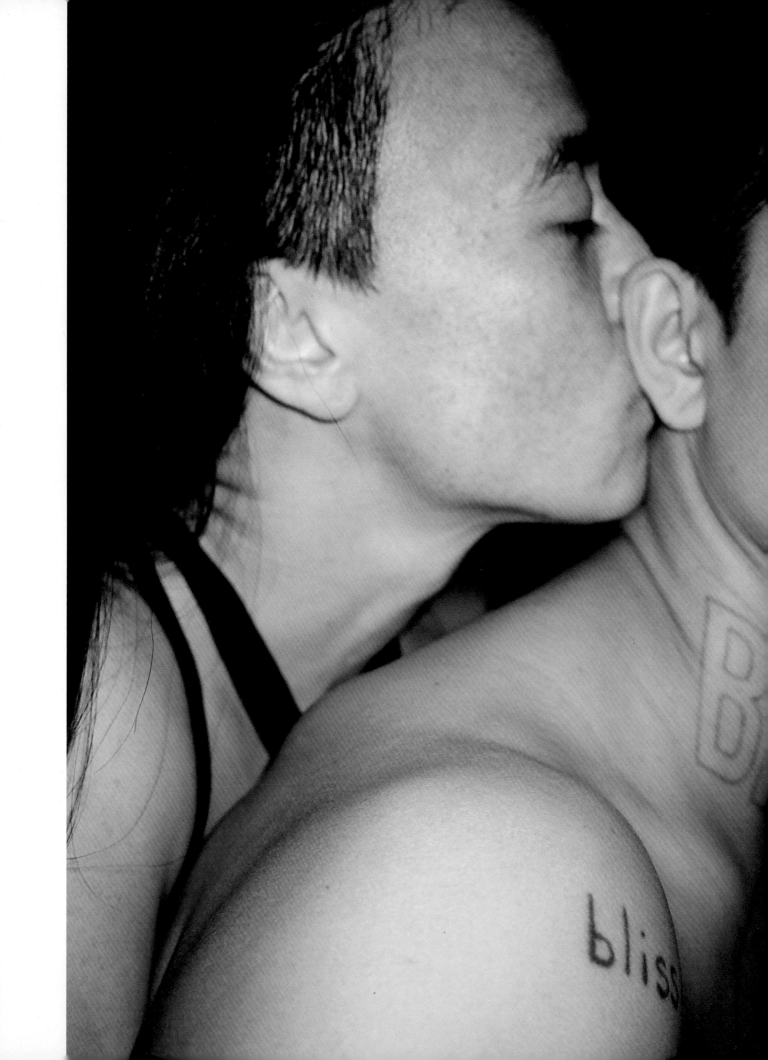

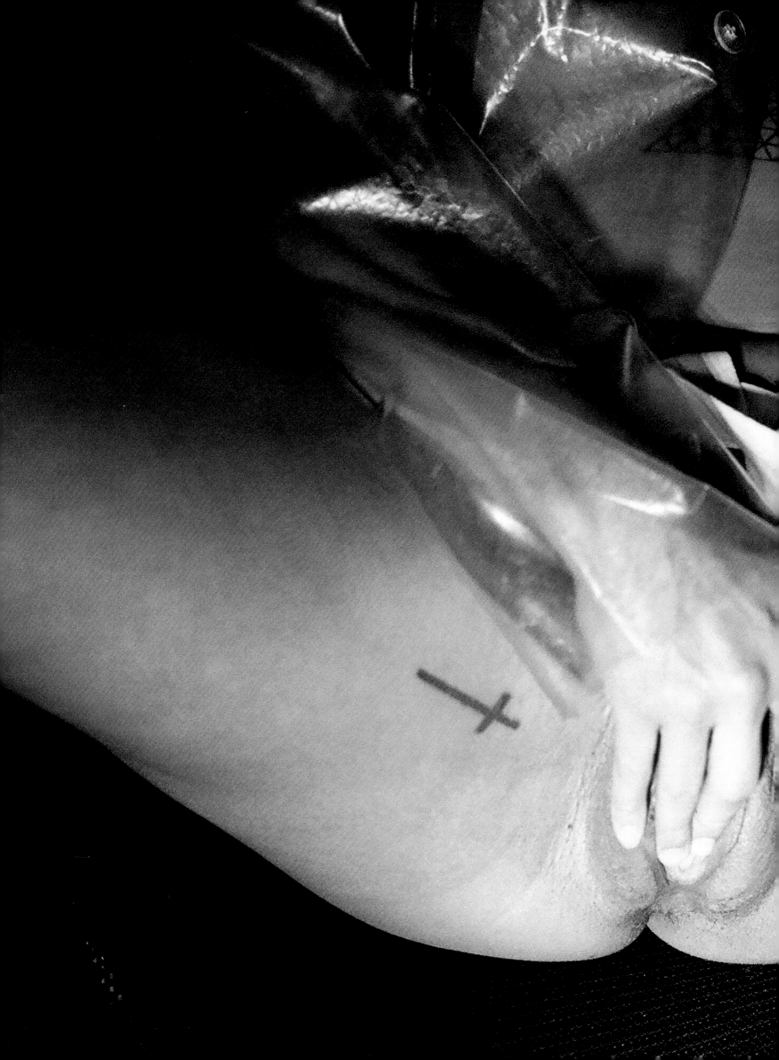

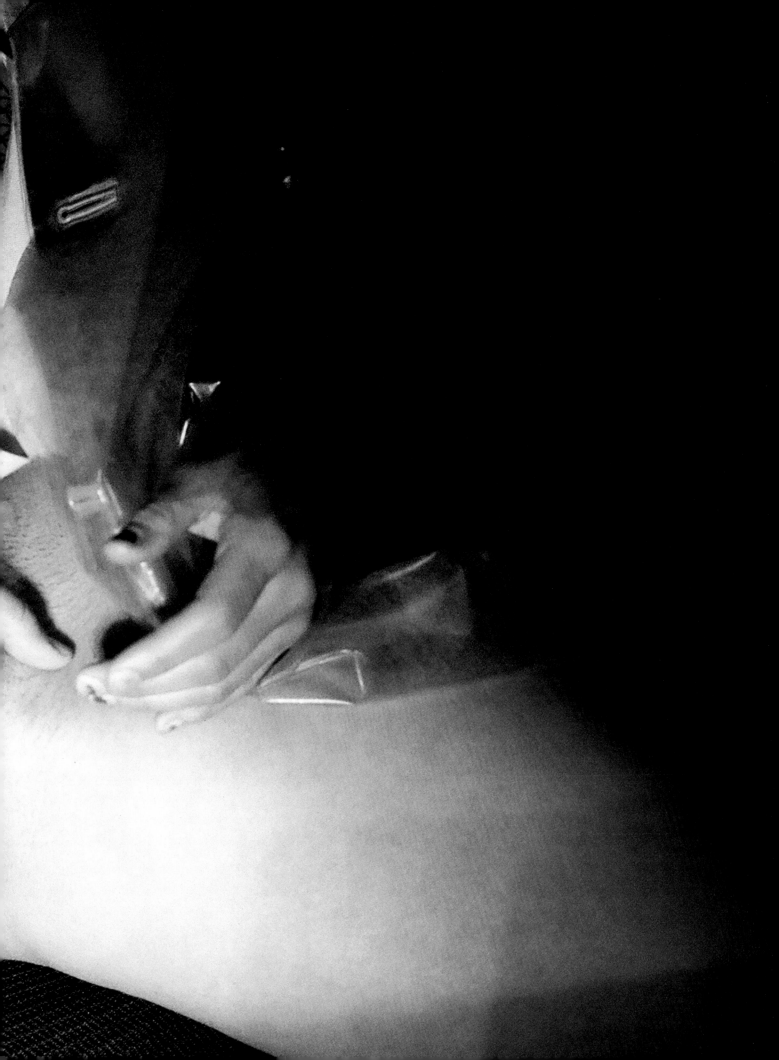

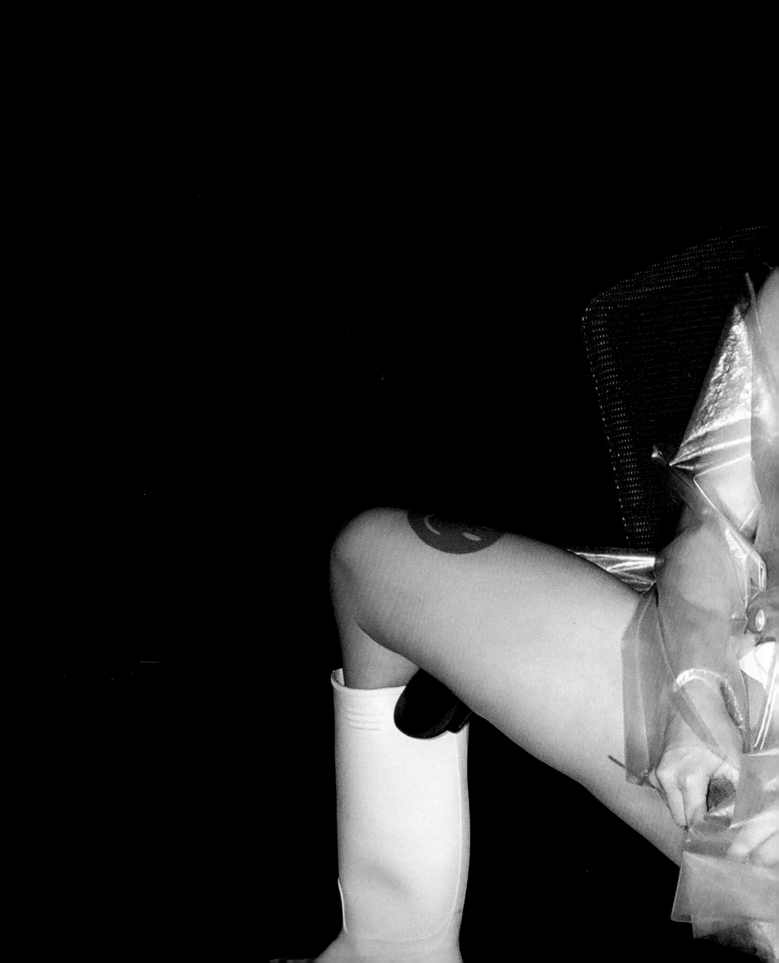

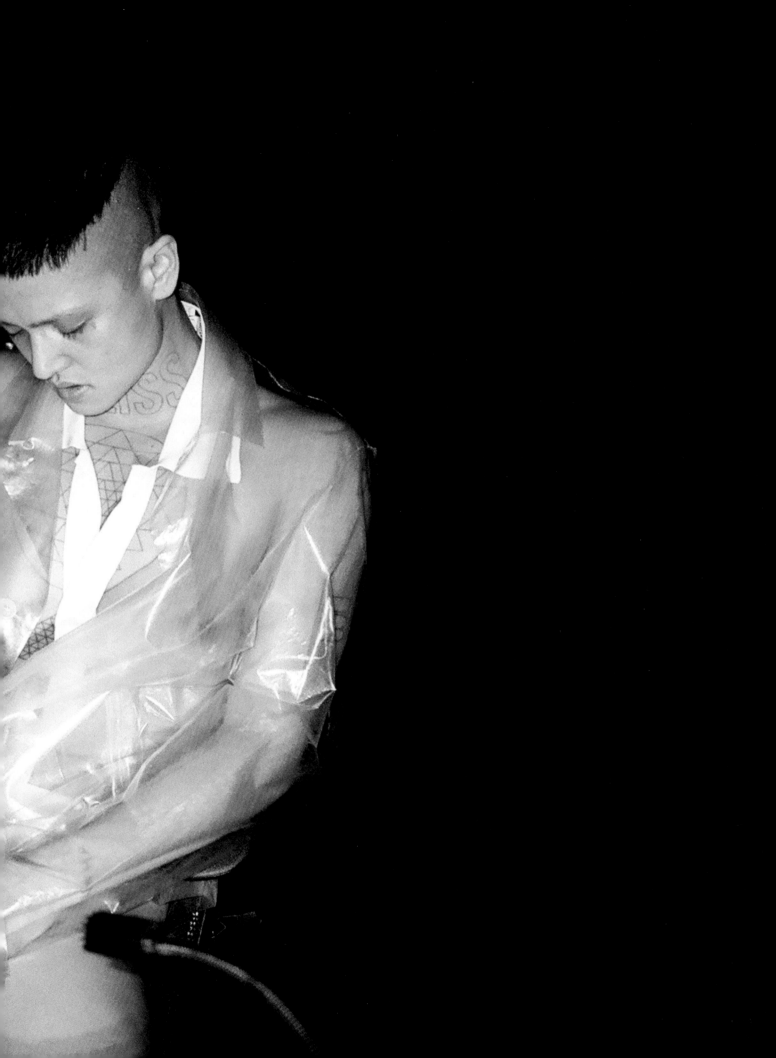

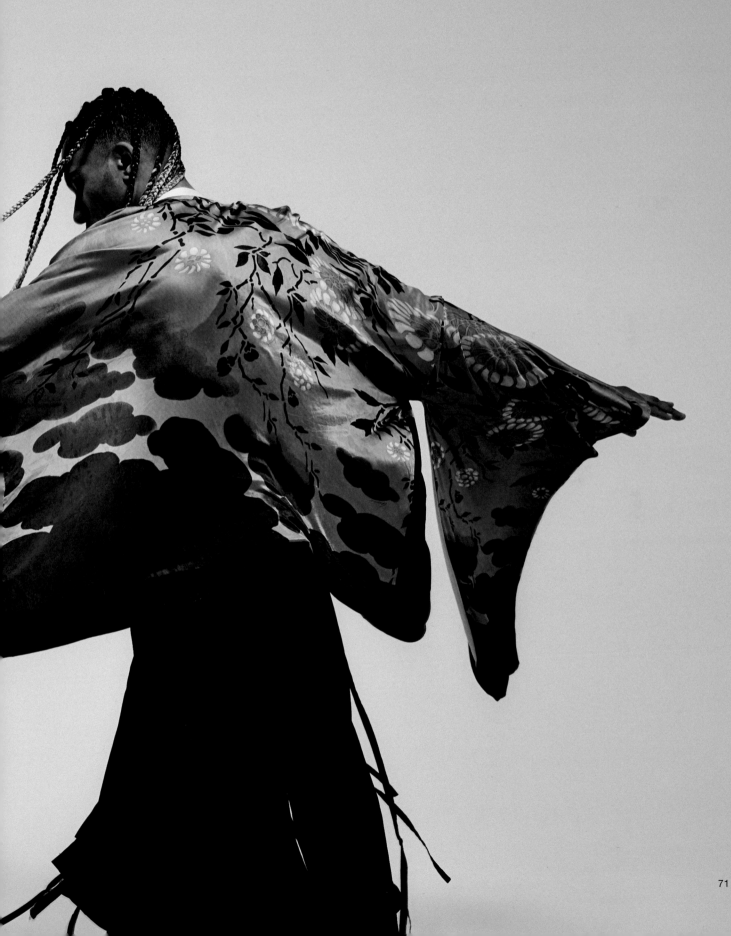

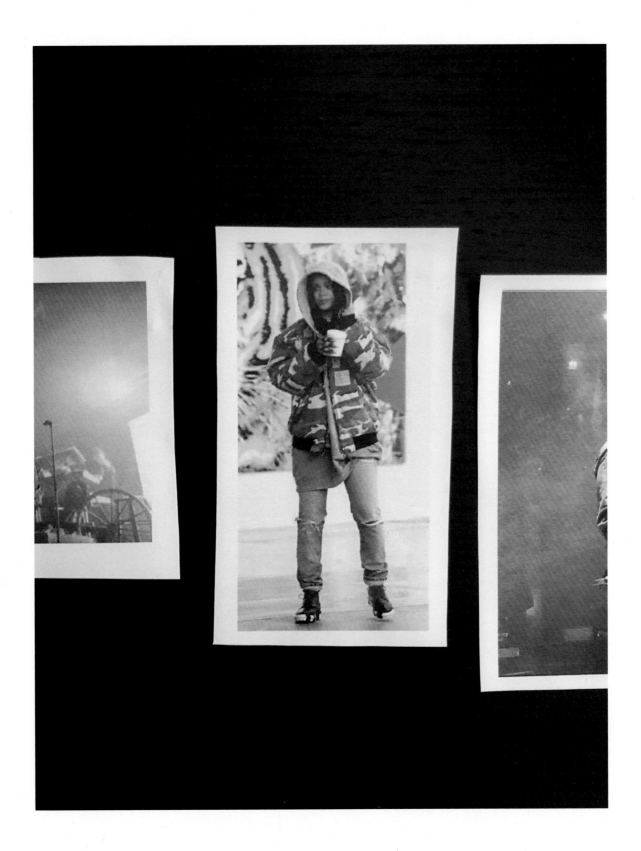

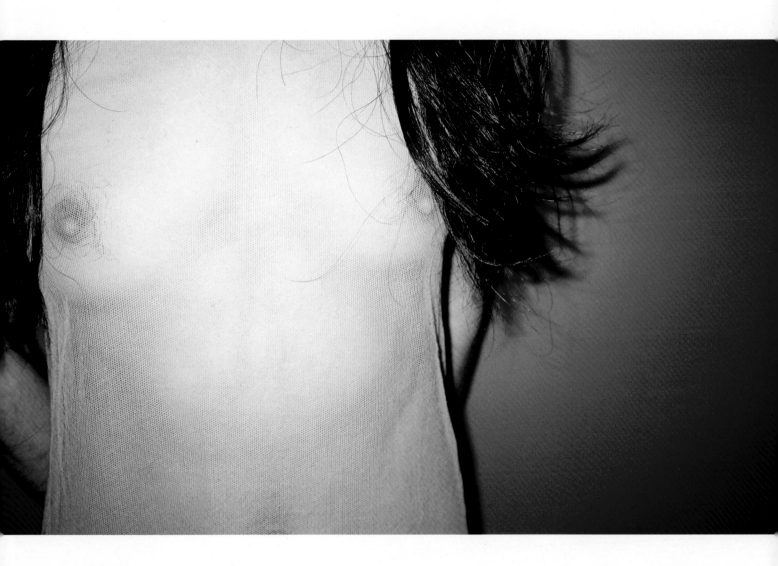

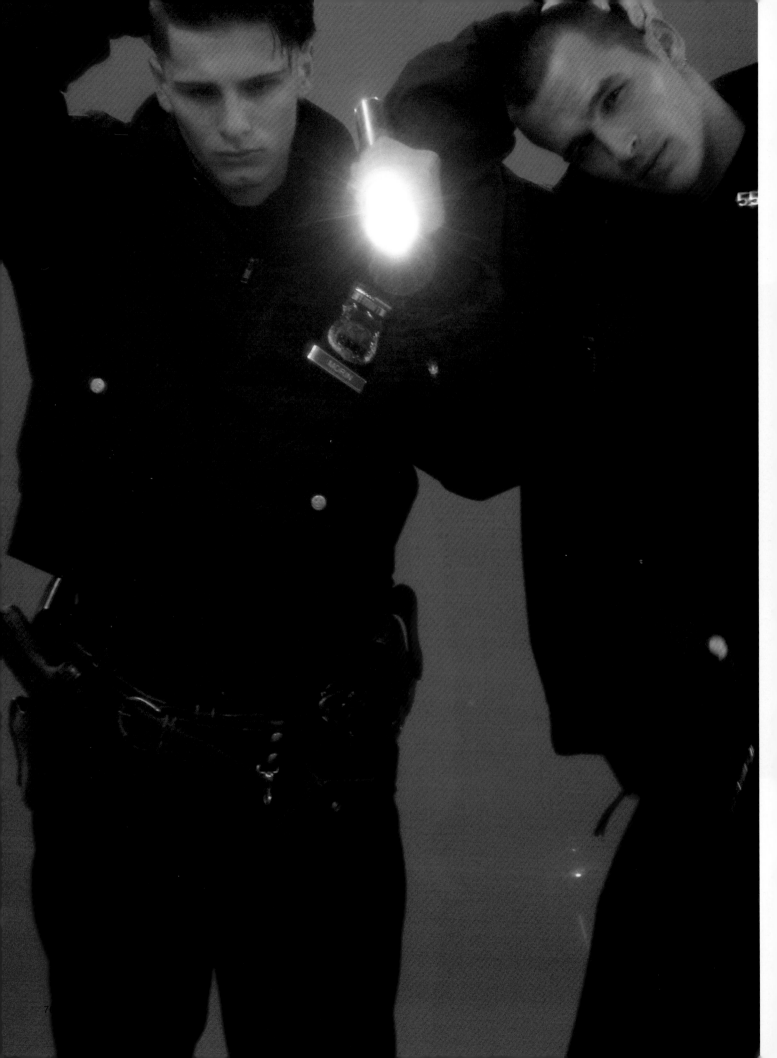

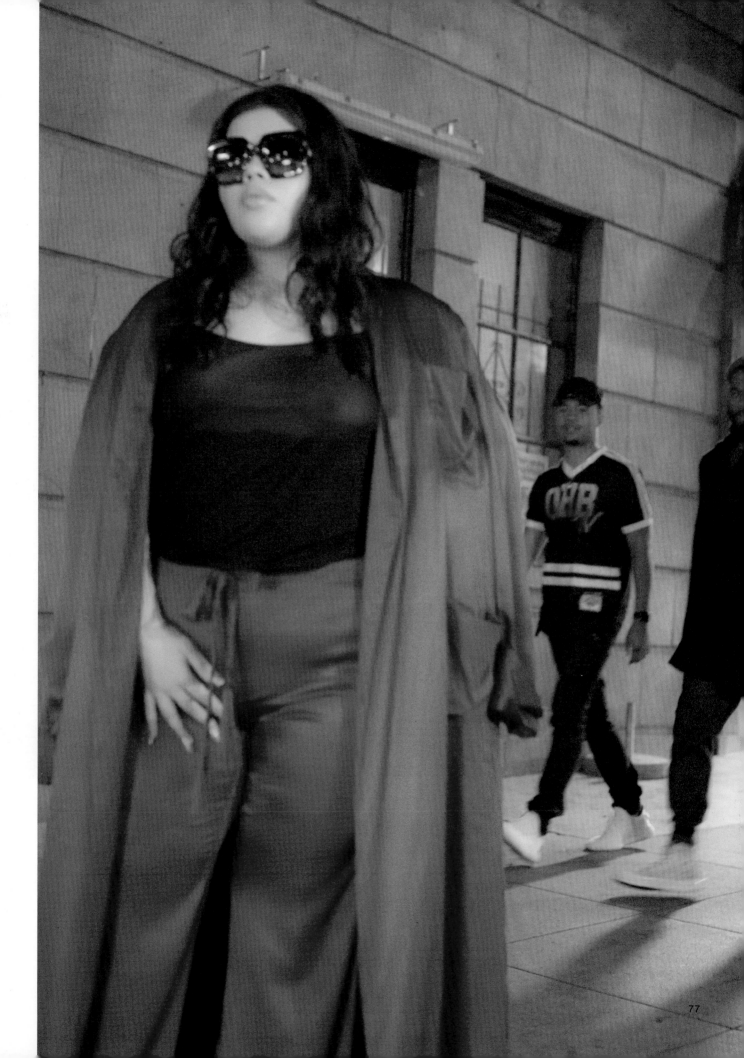

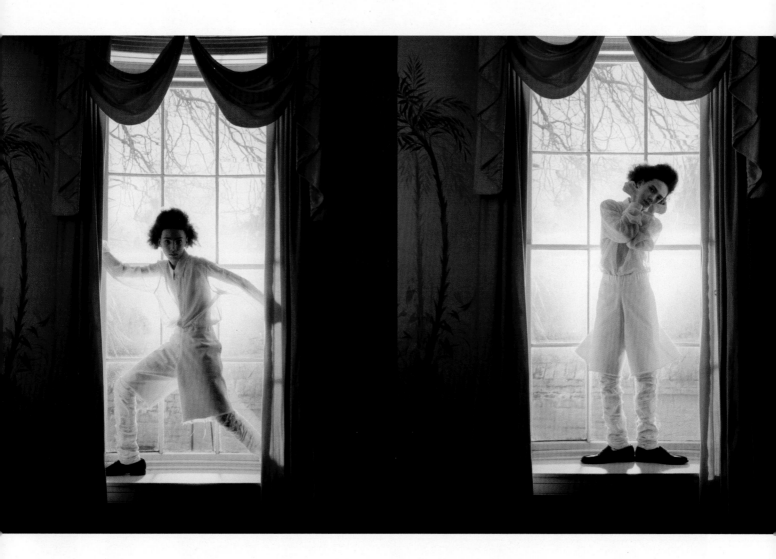

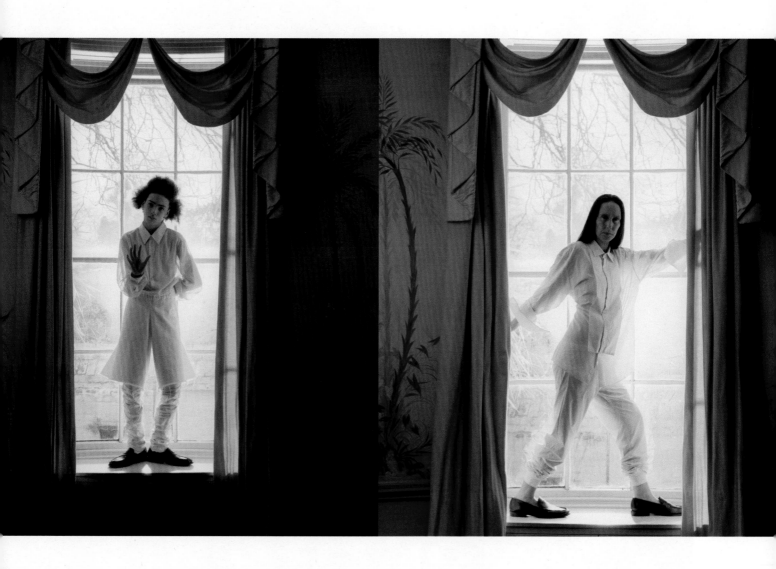

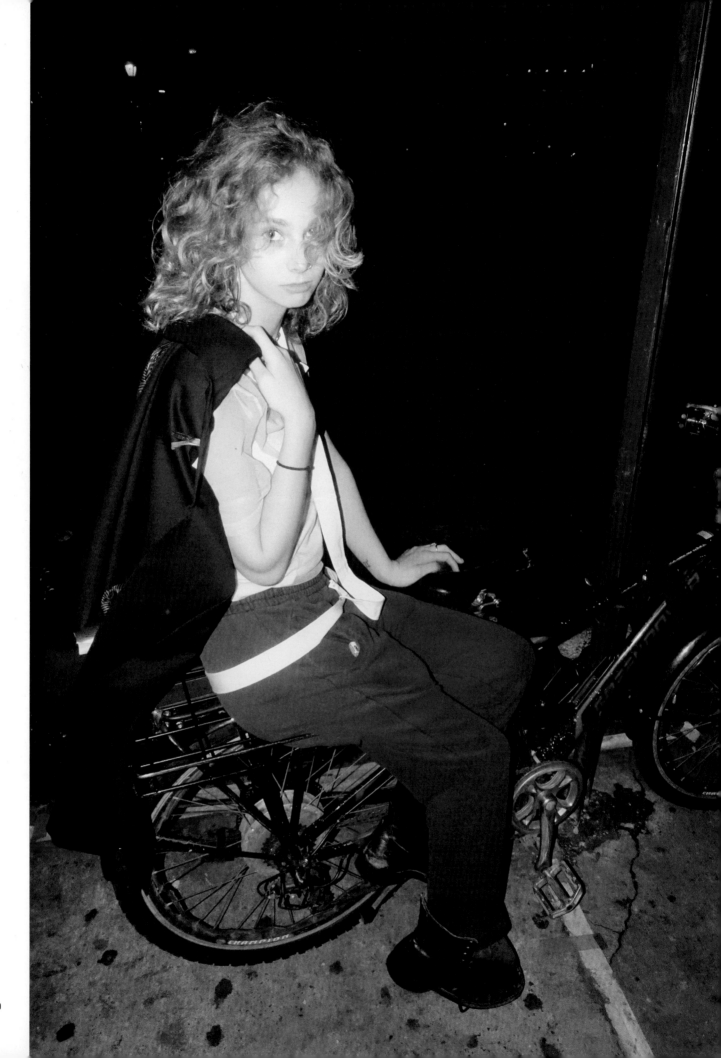

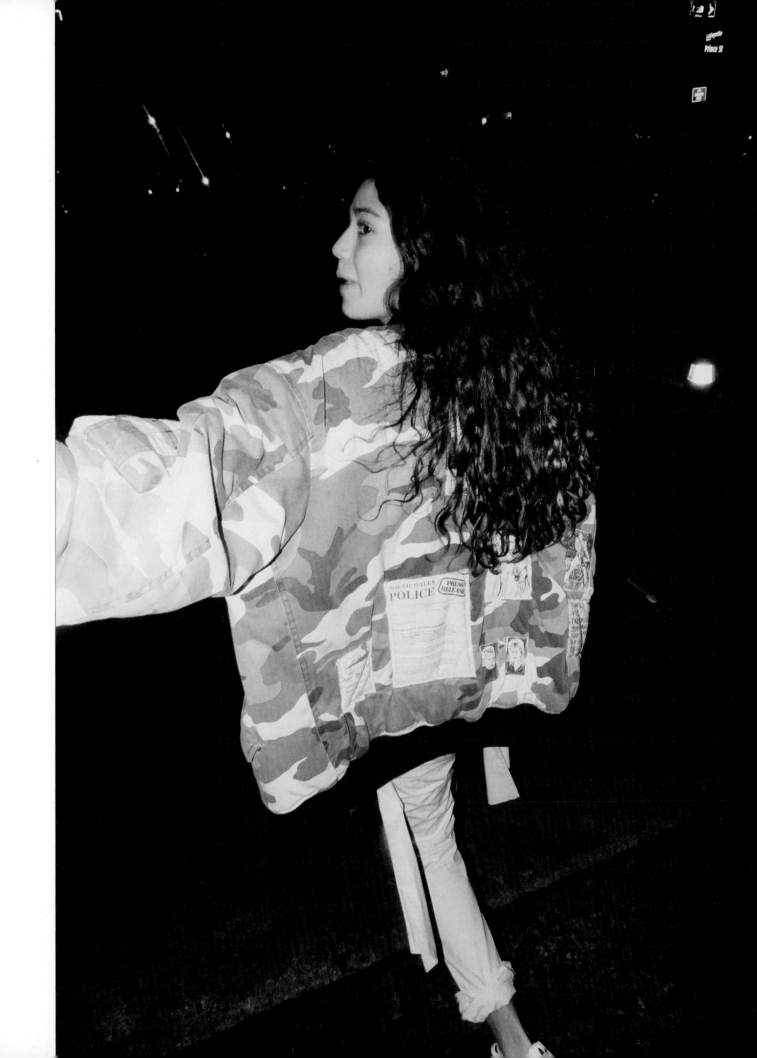

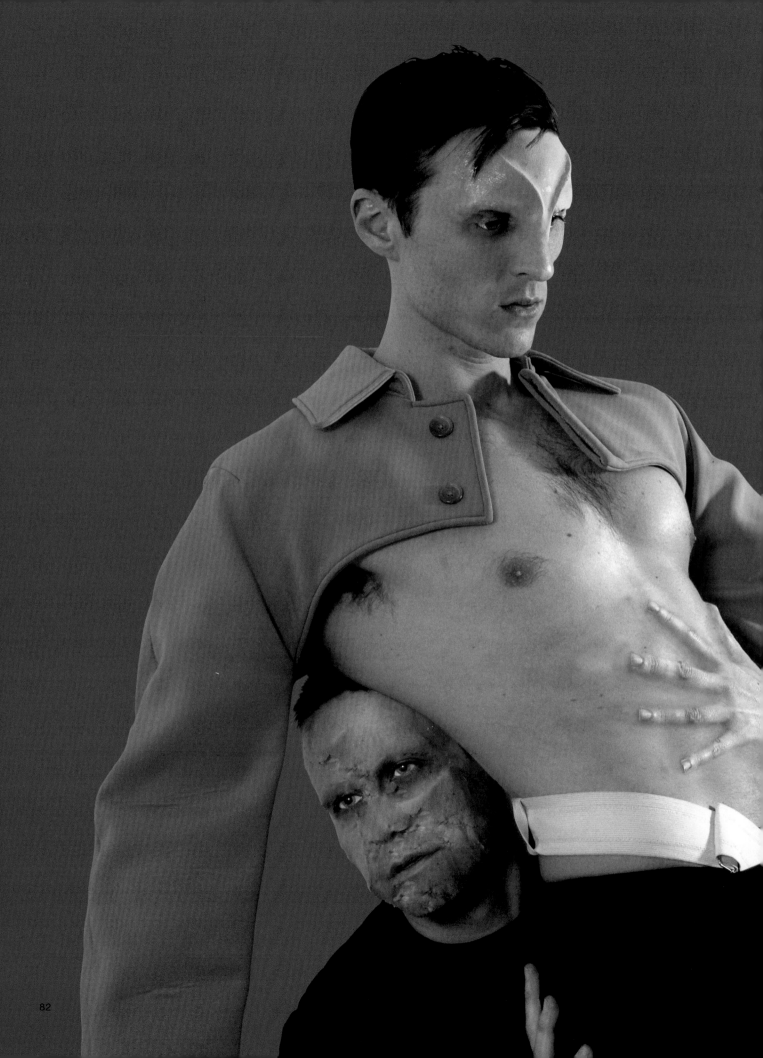

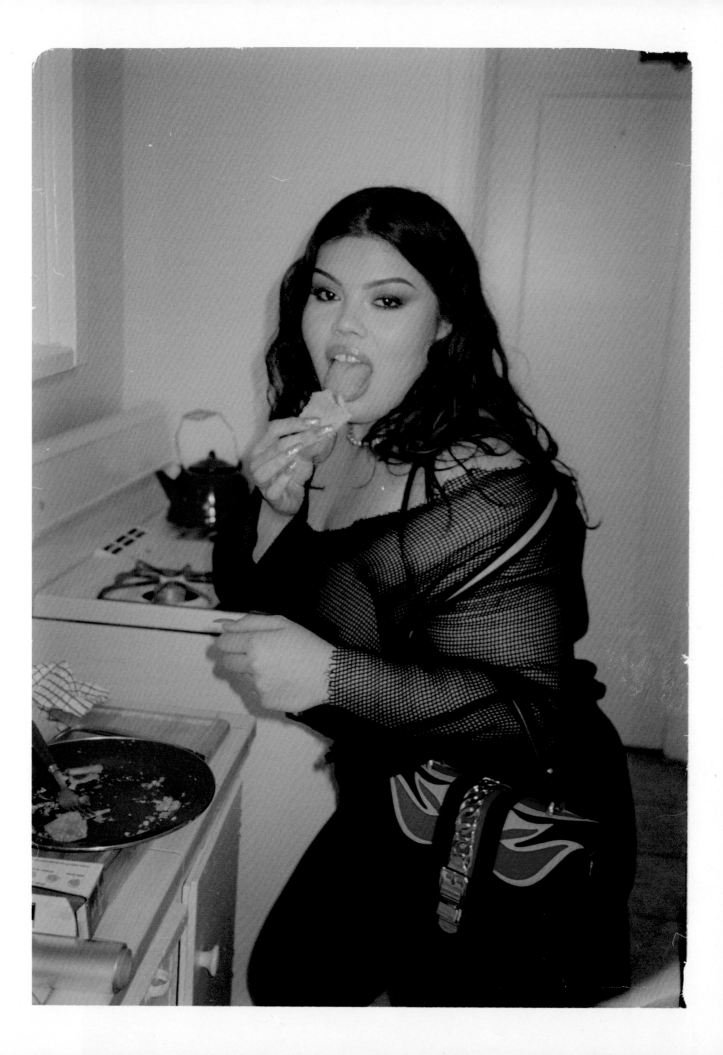

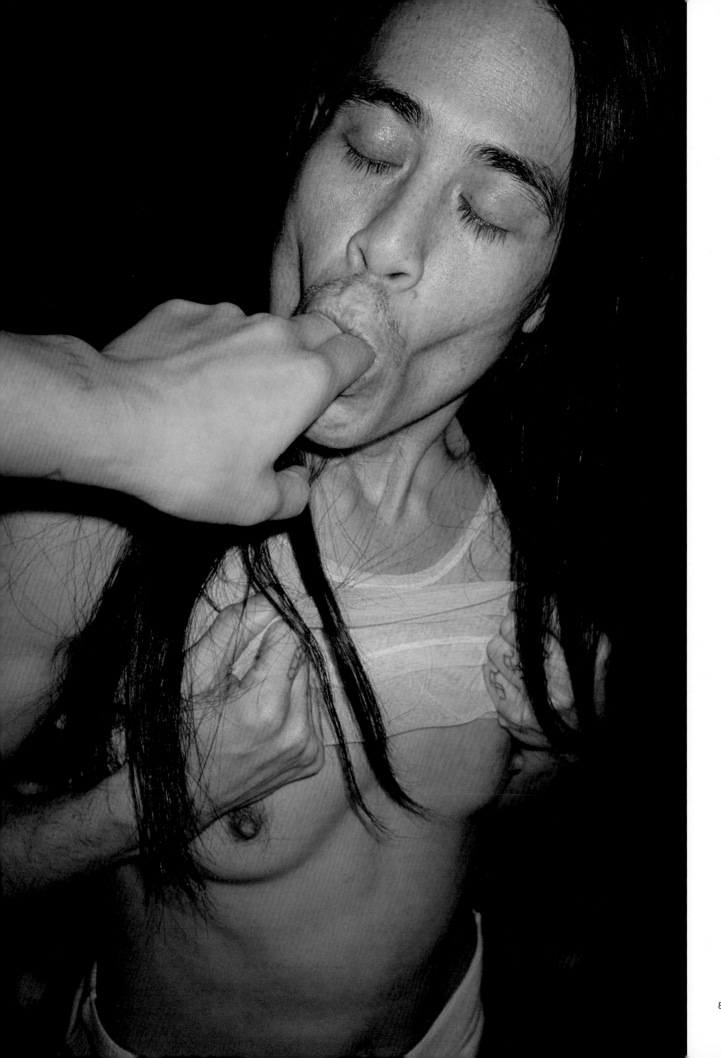

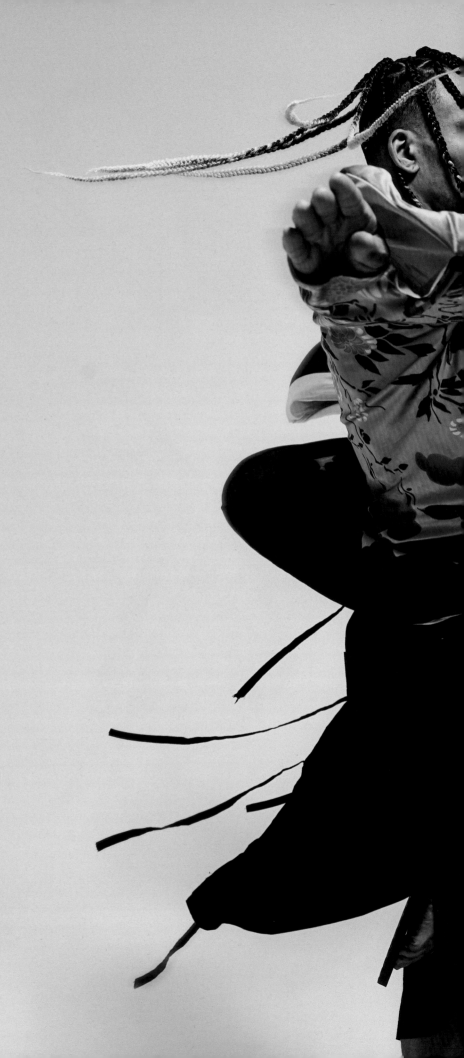

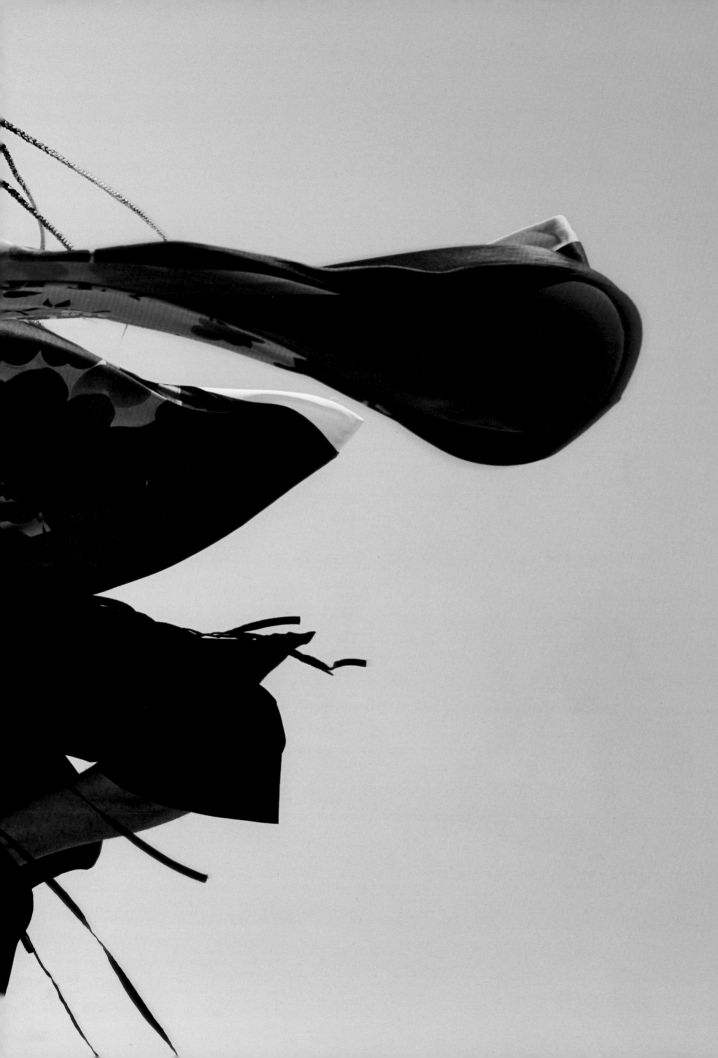

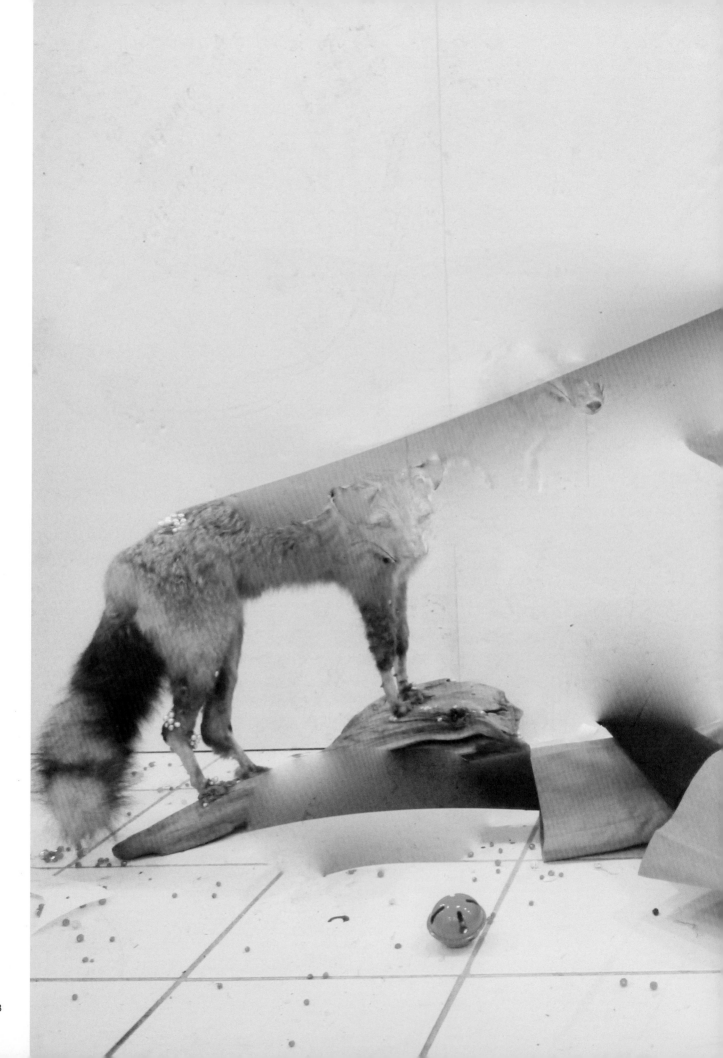

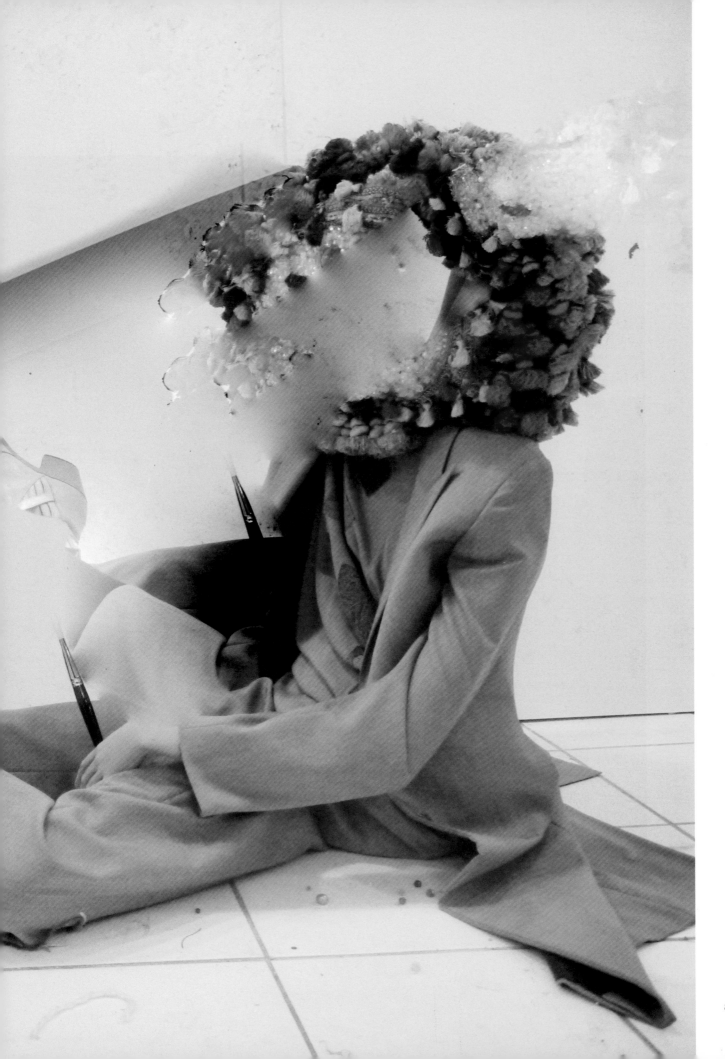

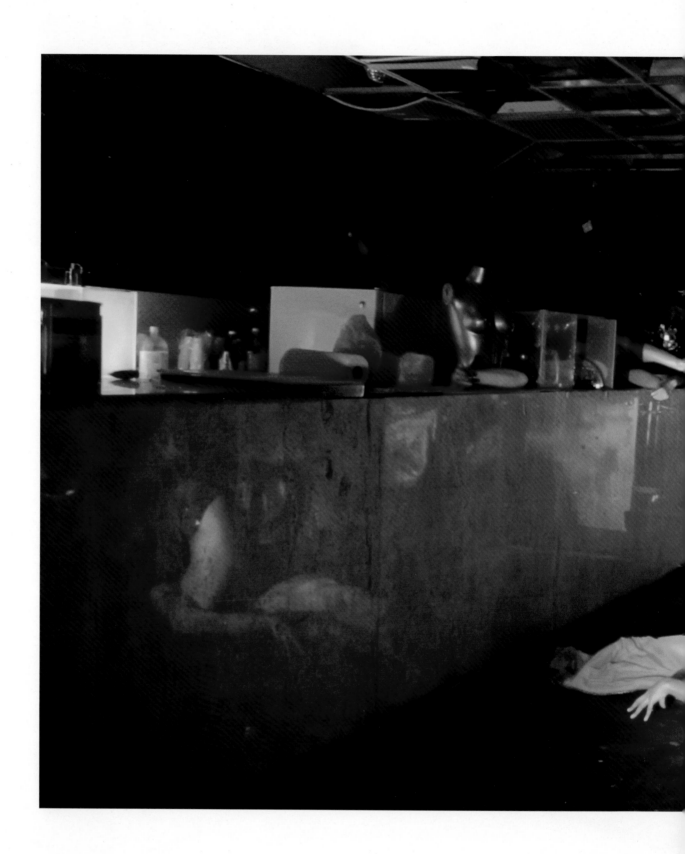

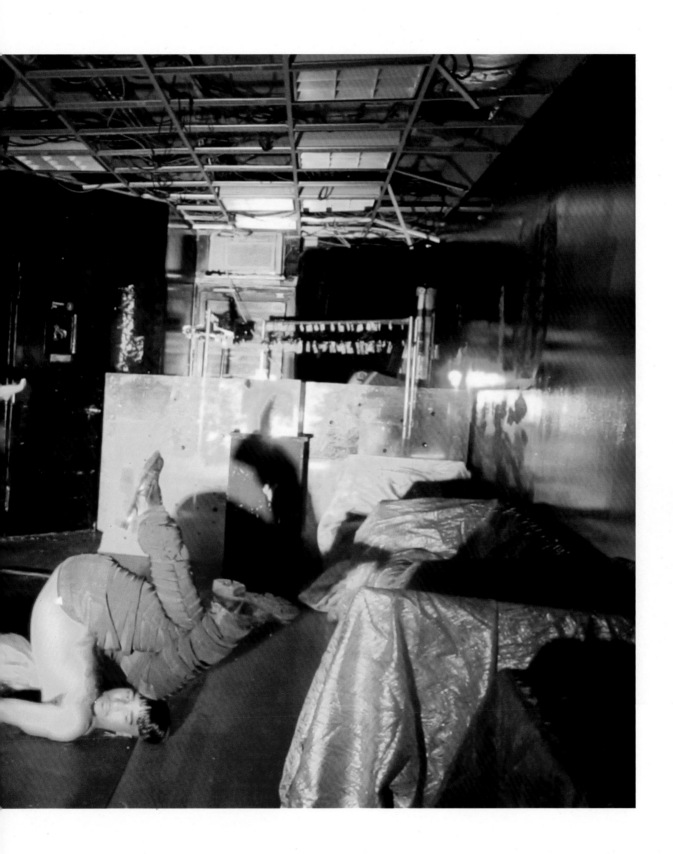

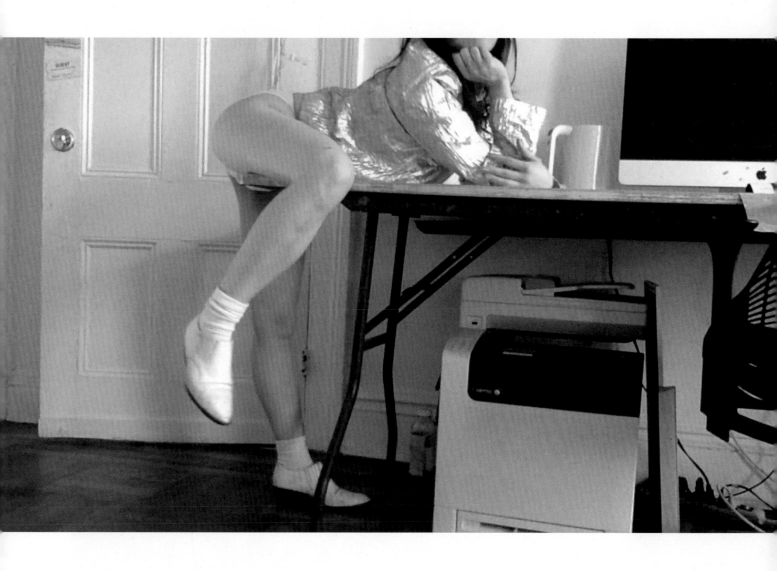

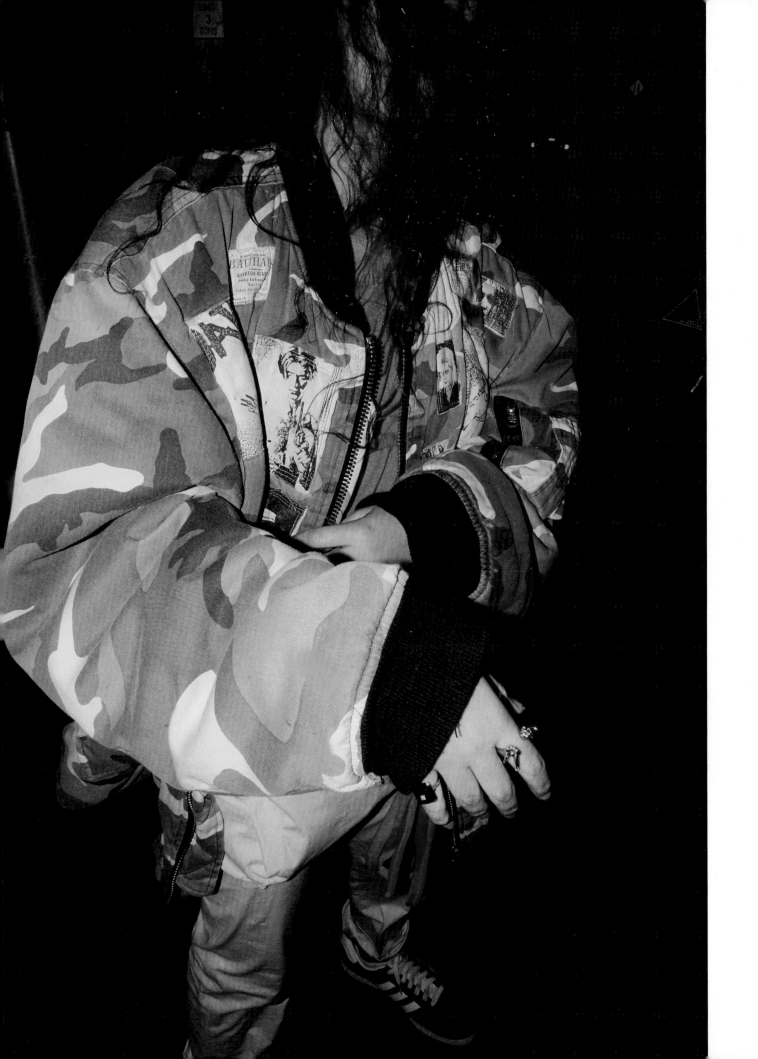

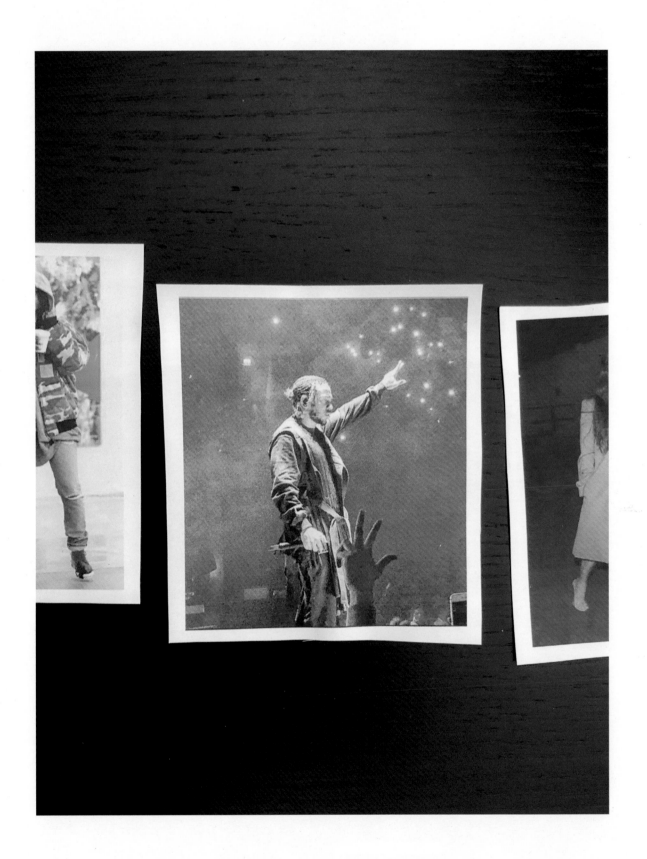

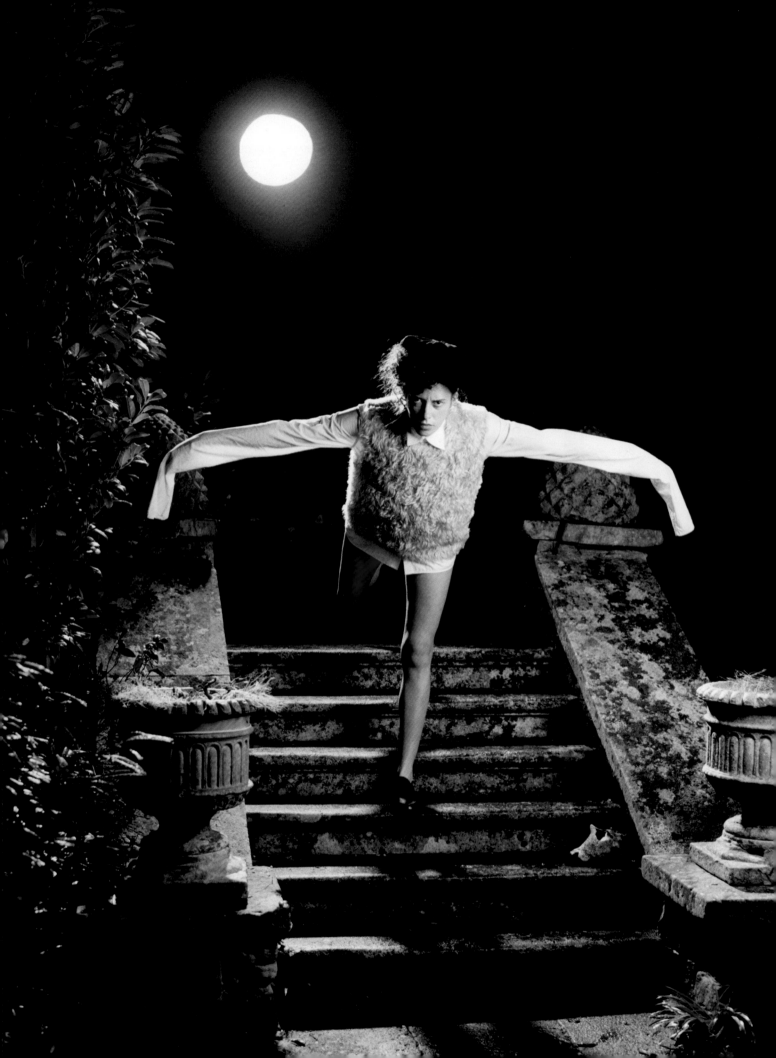

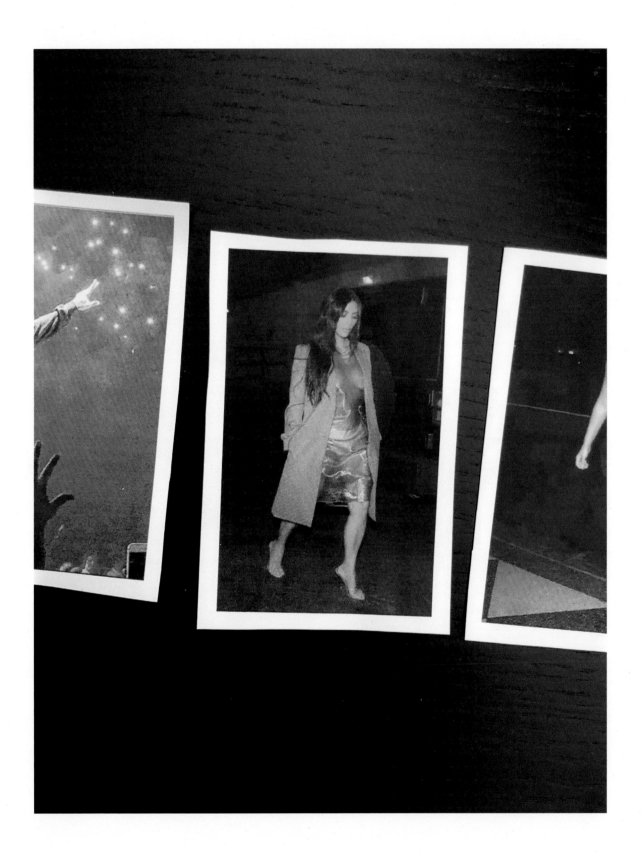

Screen Shot 2018-03-28 at 7.29.04 AM

Screen Shot 2017-04-18 at 4.46.11 PM.png

Screen Shot 2018-04-04 at 11.32.27 AM

Screen Shot 2016-04-22 at 1.19.19 PM.png

Screen Shot 2018-04-04 at 6.31.20 PM

tu Screen Shot 2018-04-15 at 8.34.37 AM).jpg

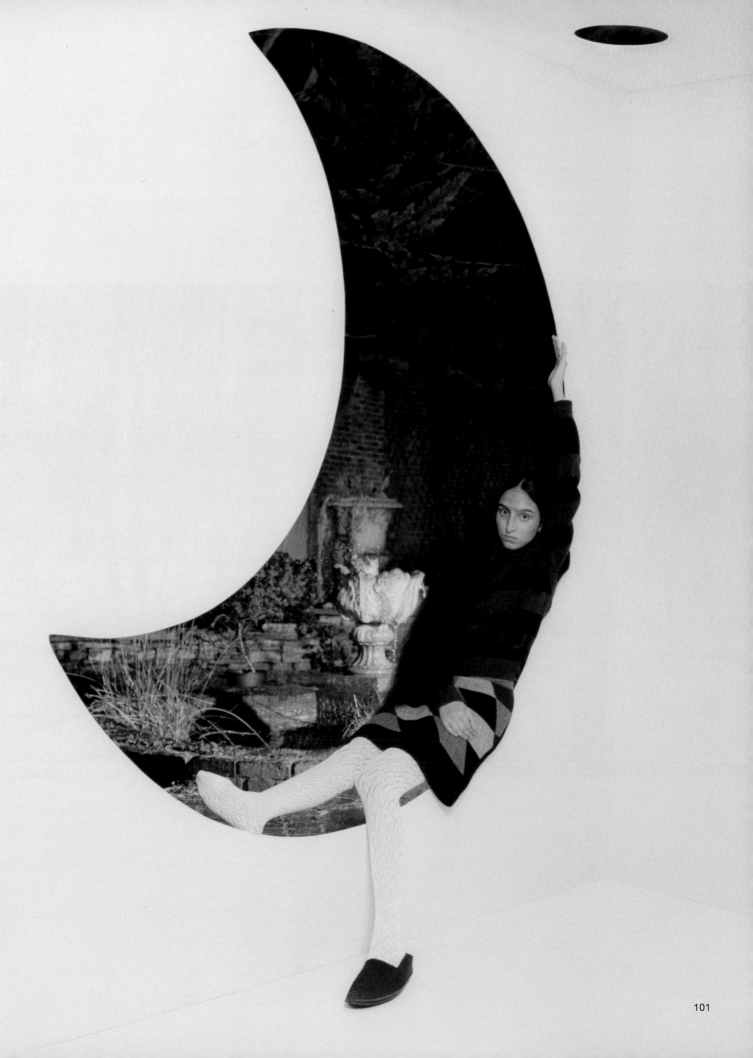

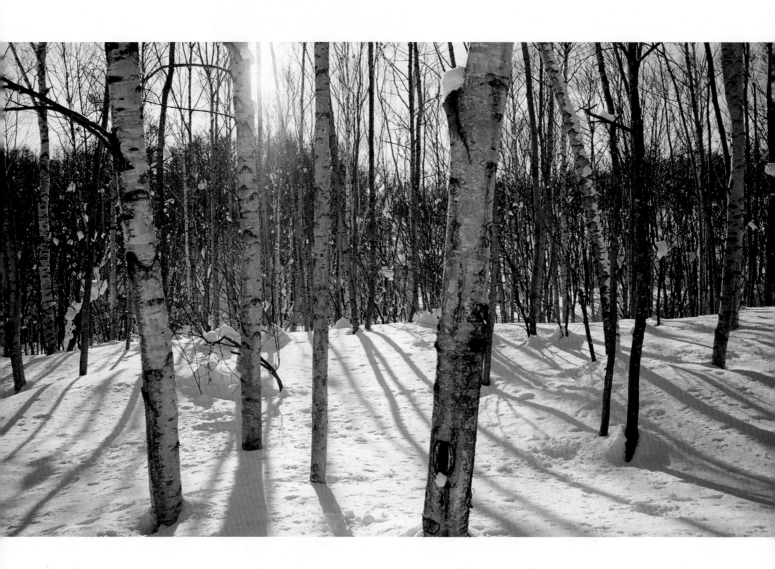

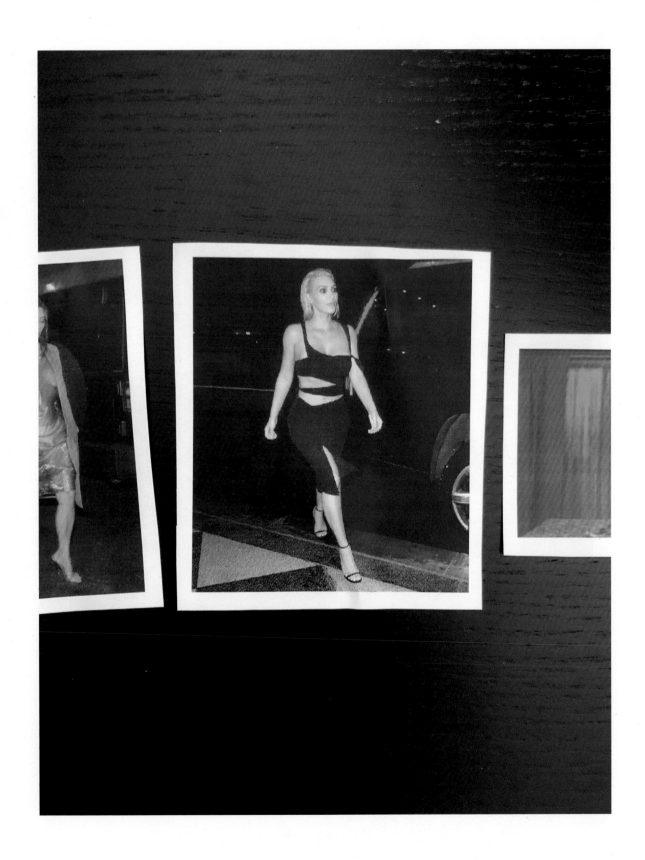

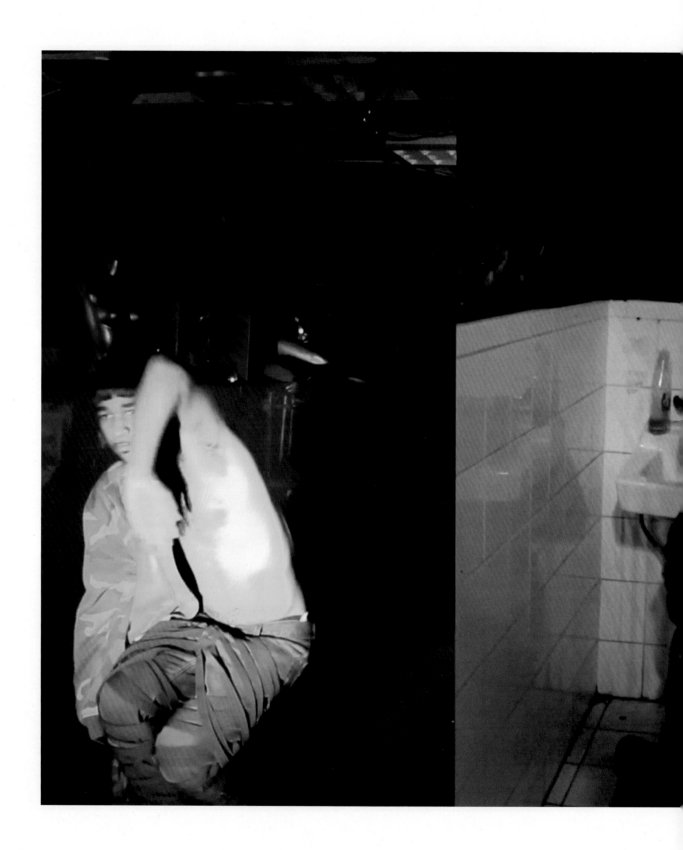

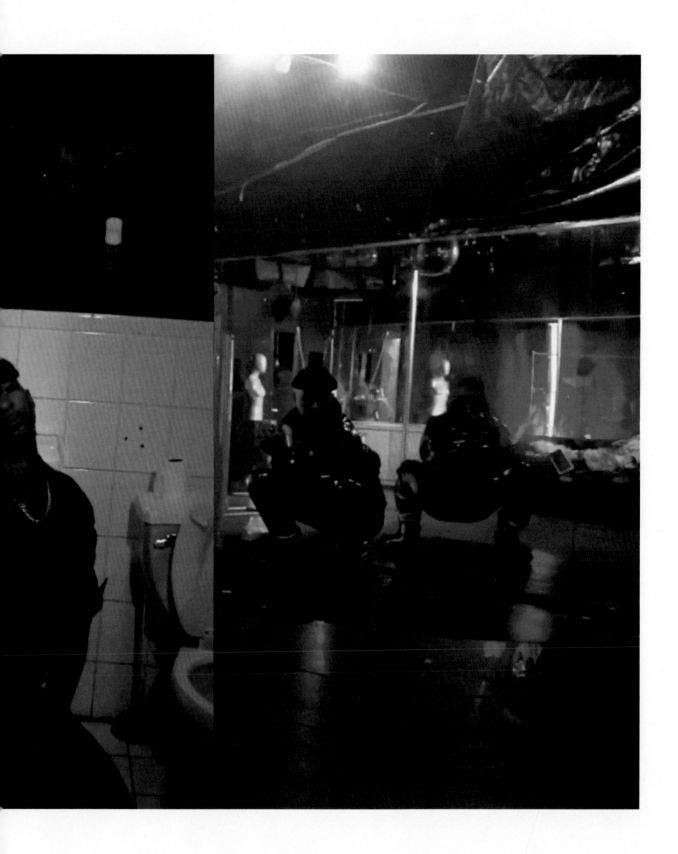

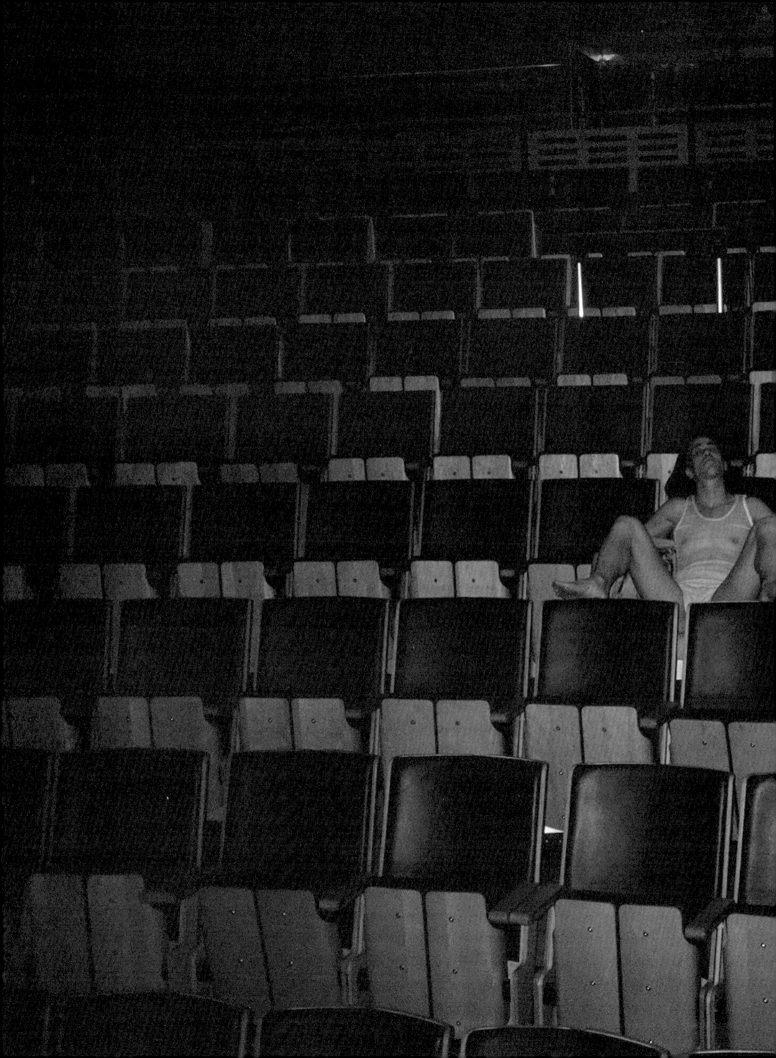

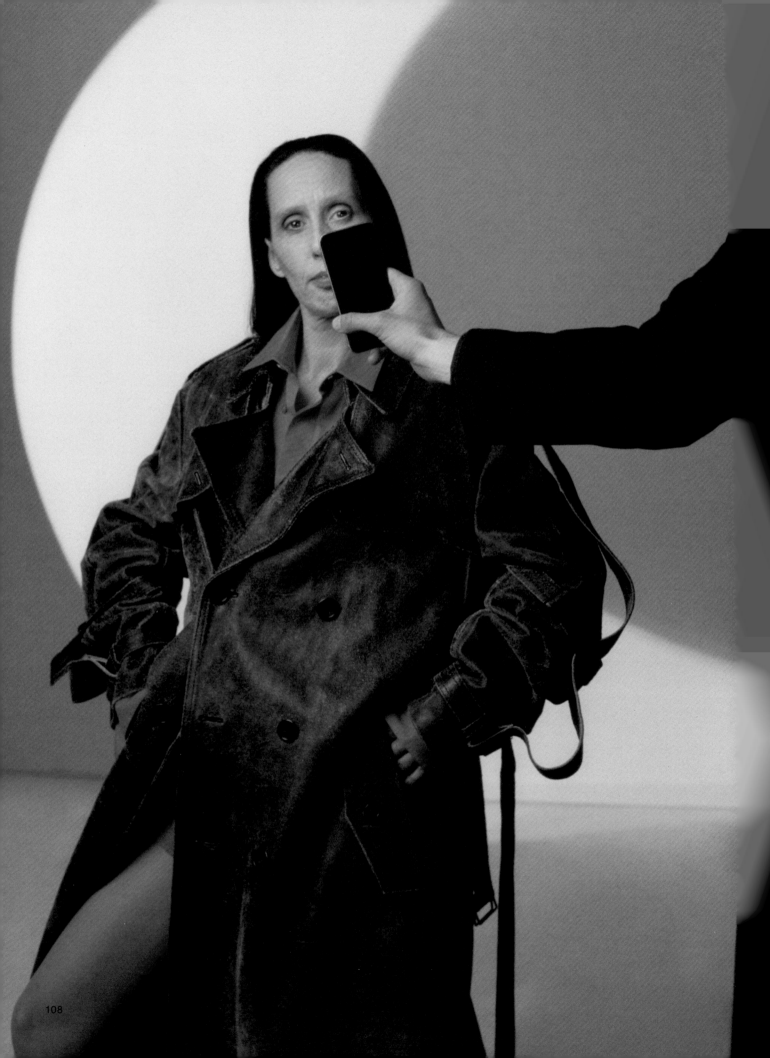

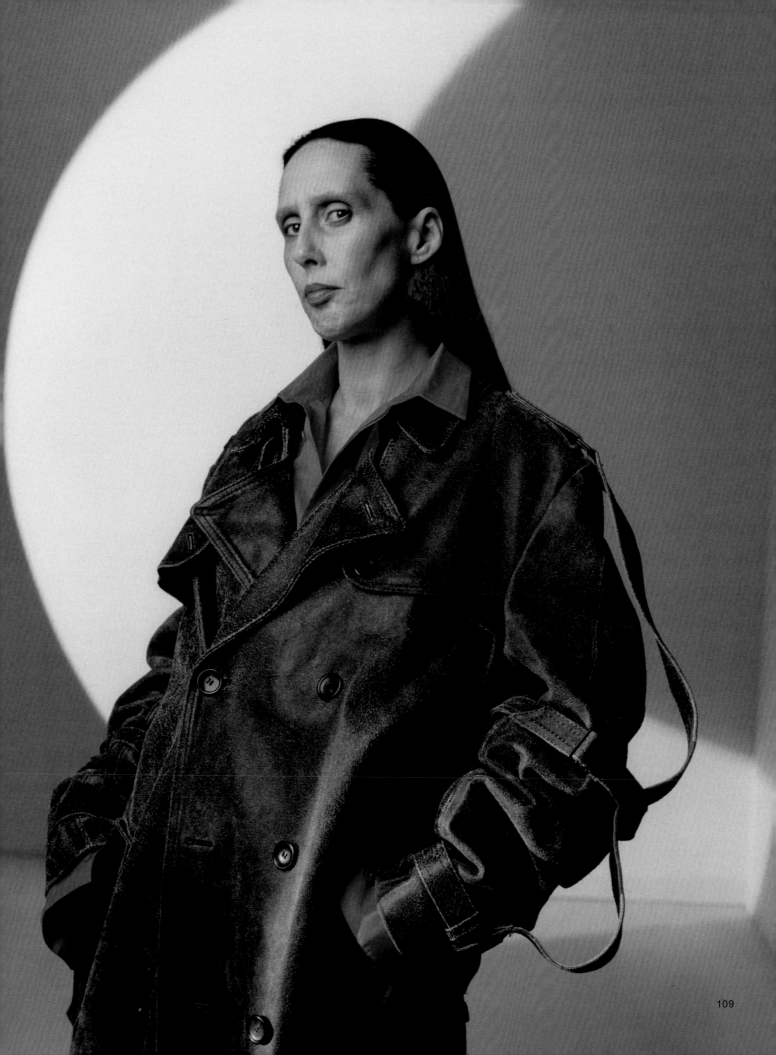

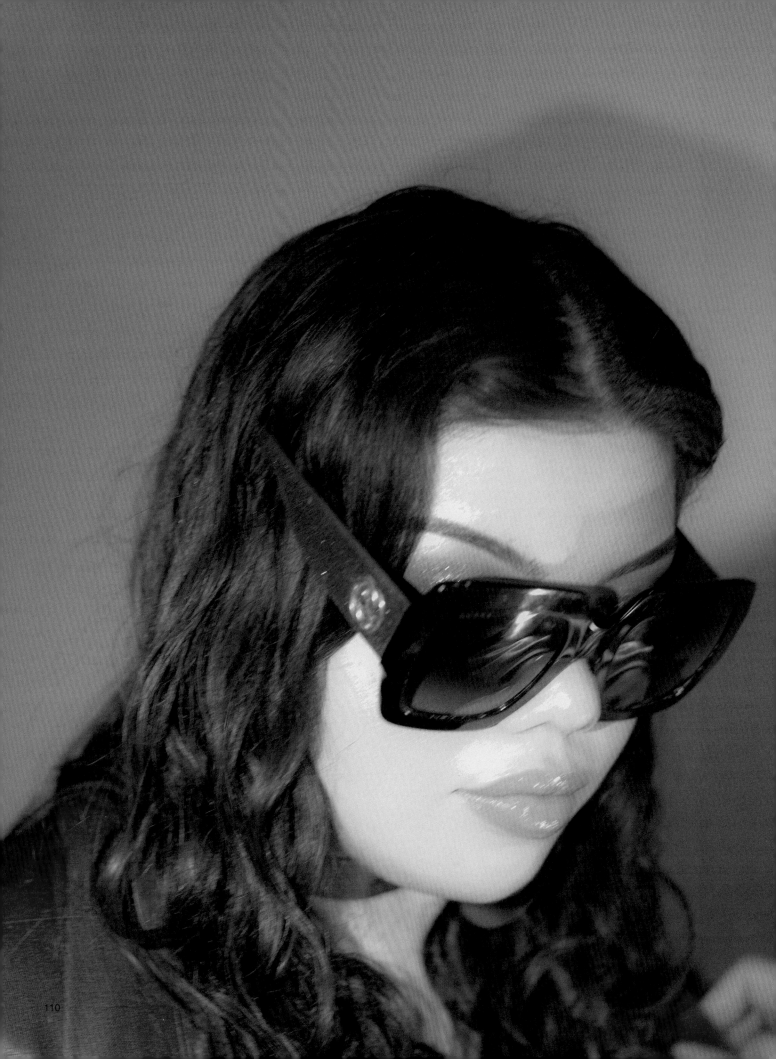

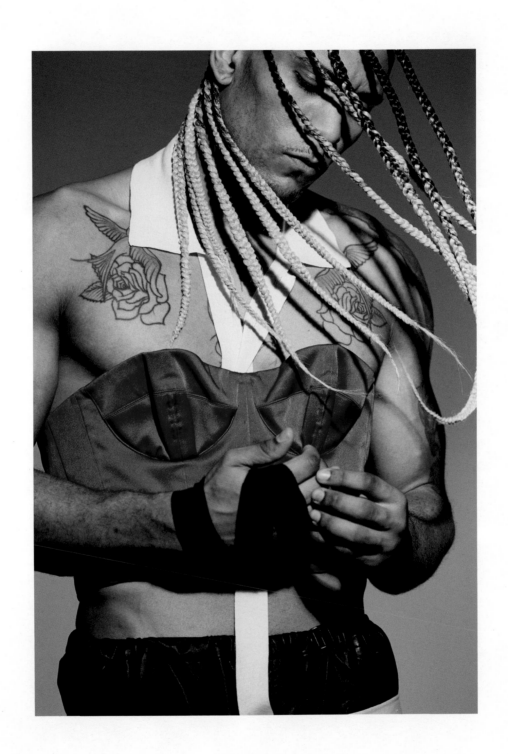

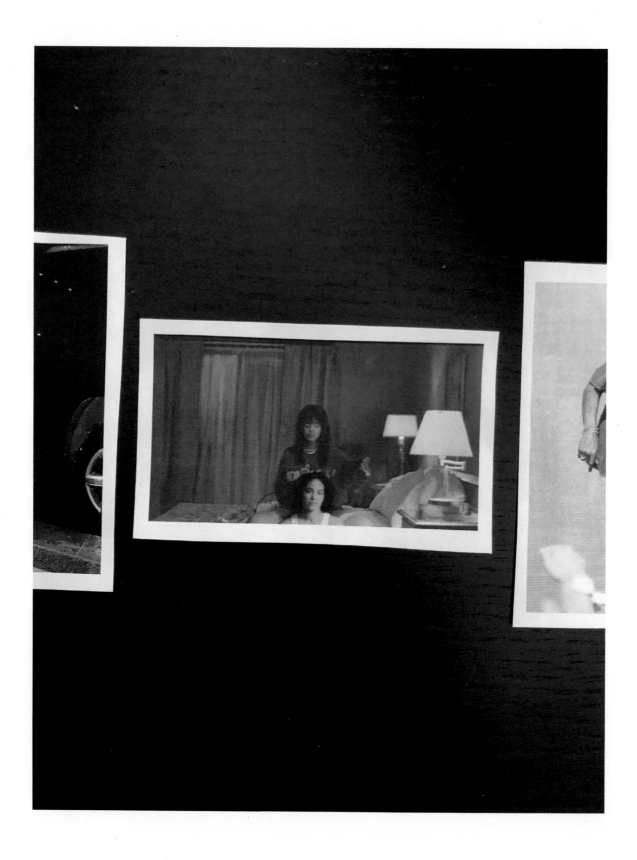

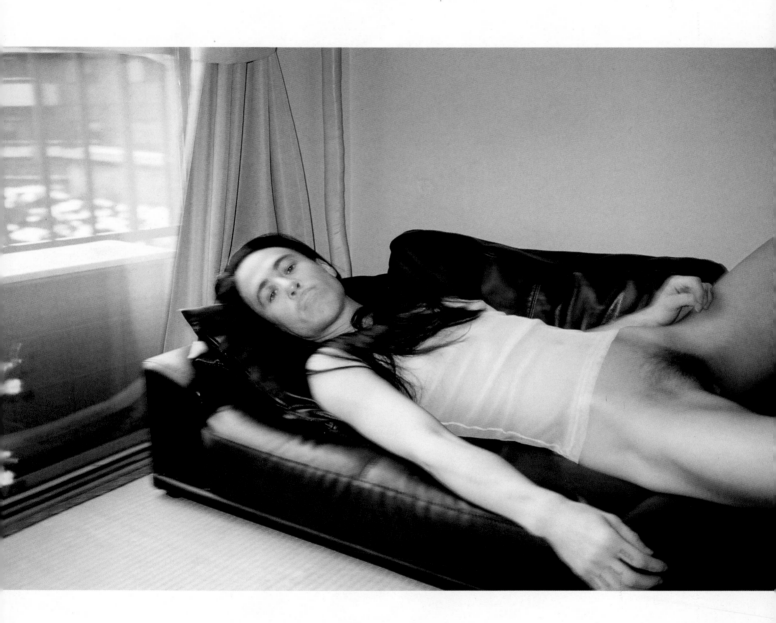

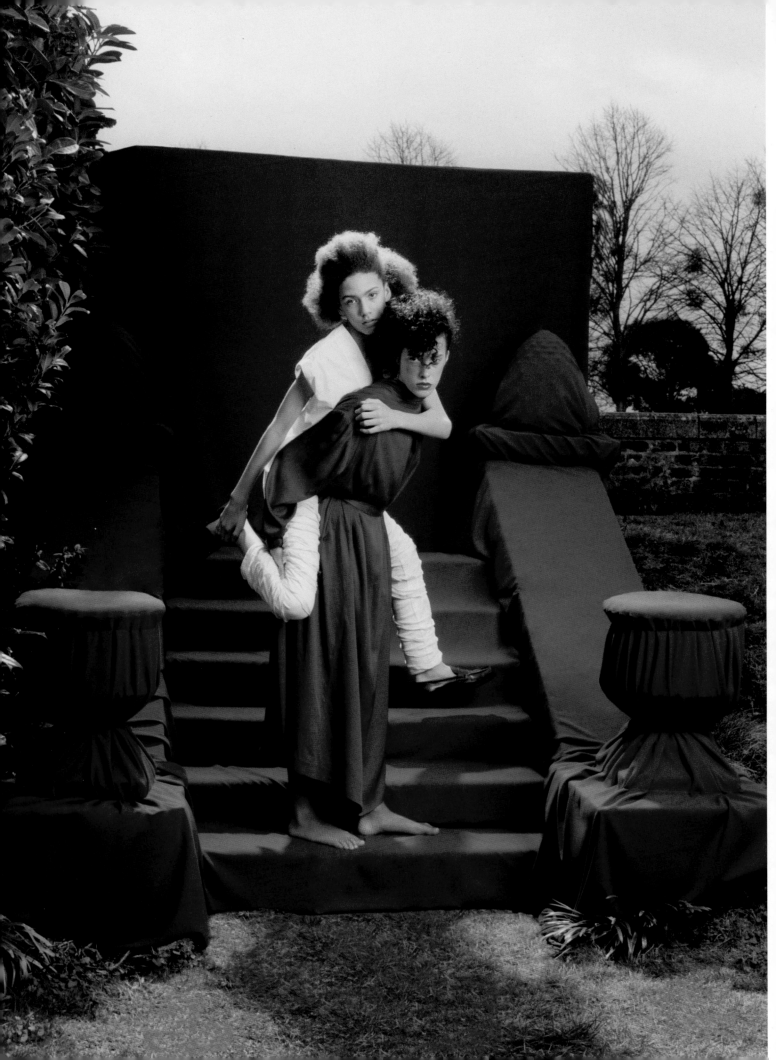

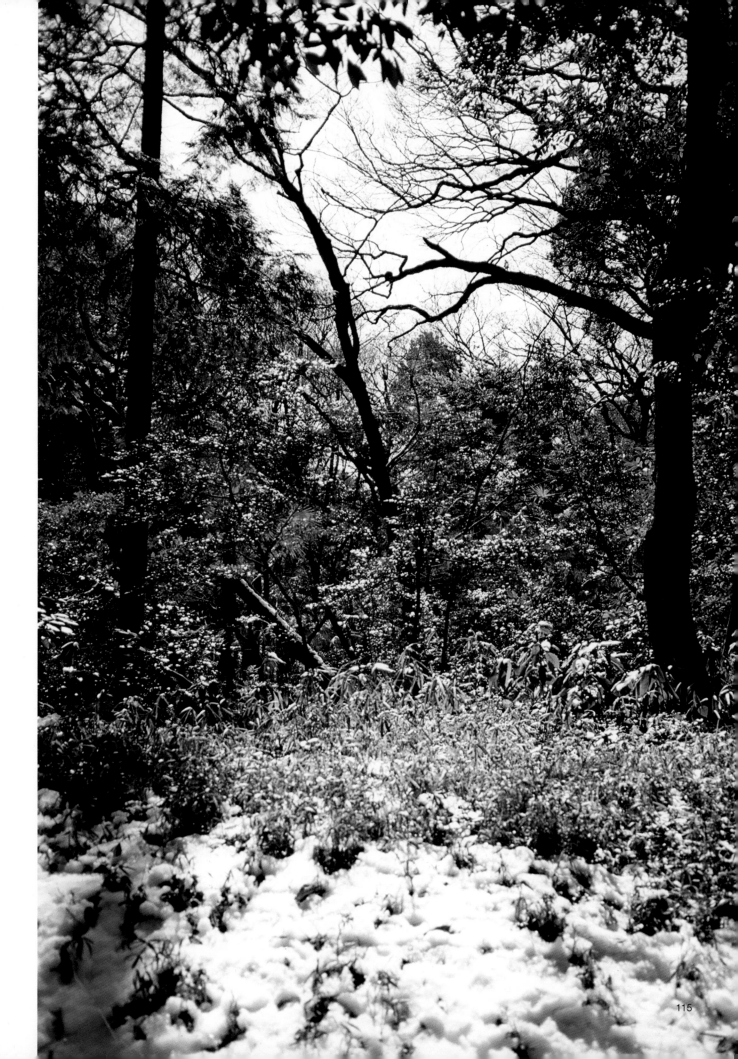

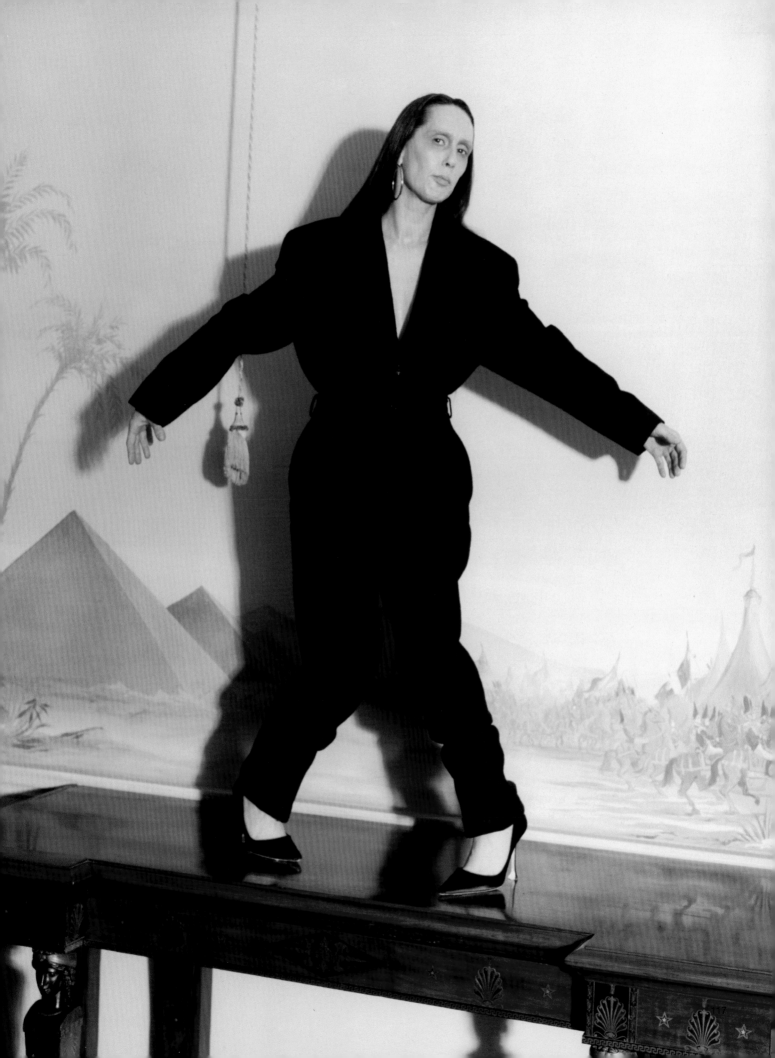

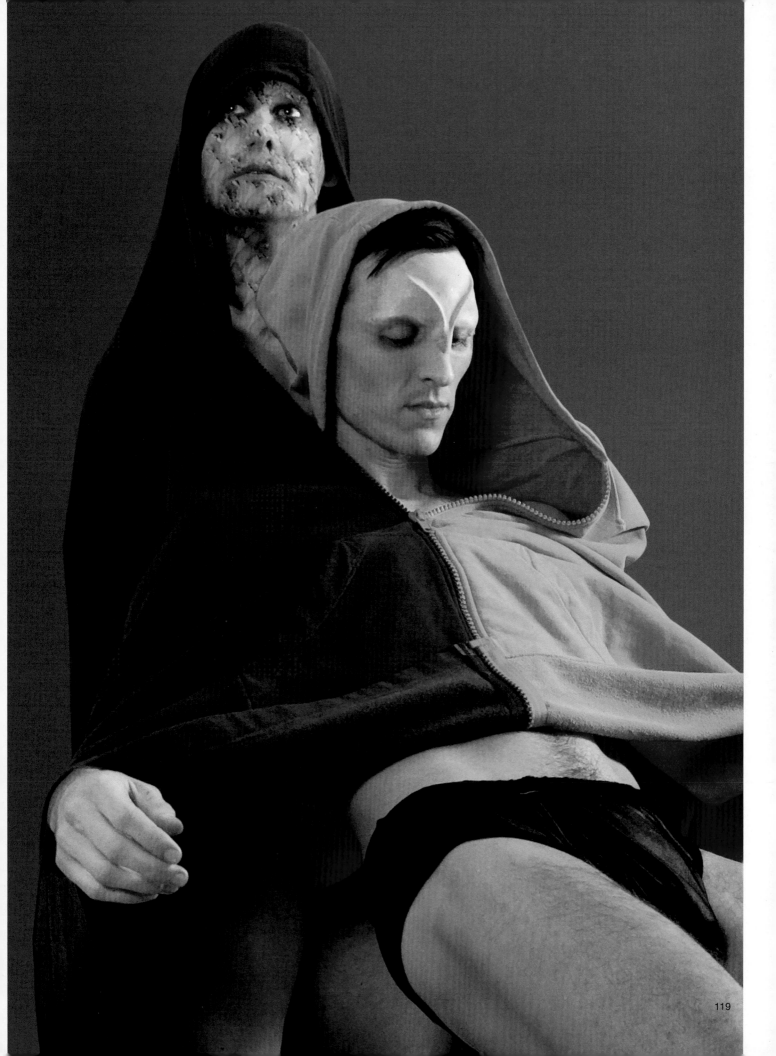

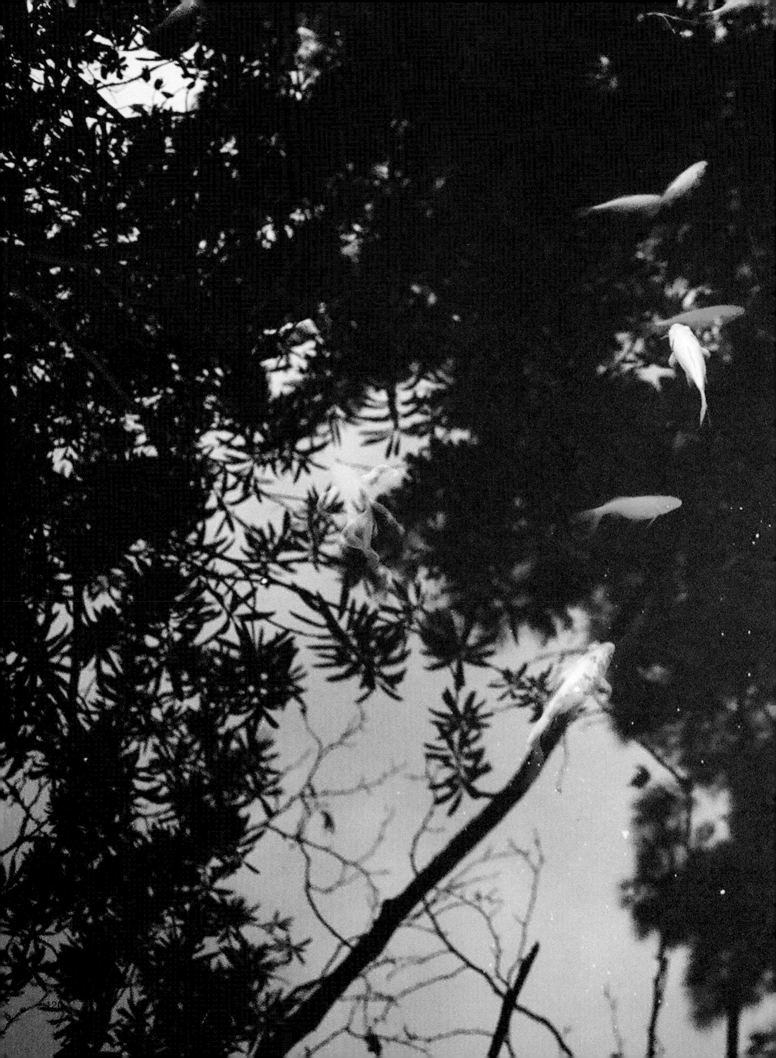

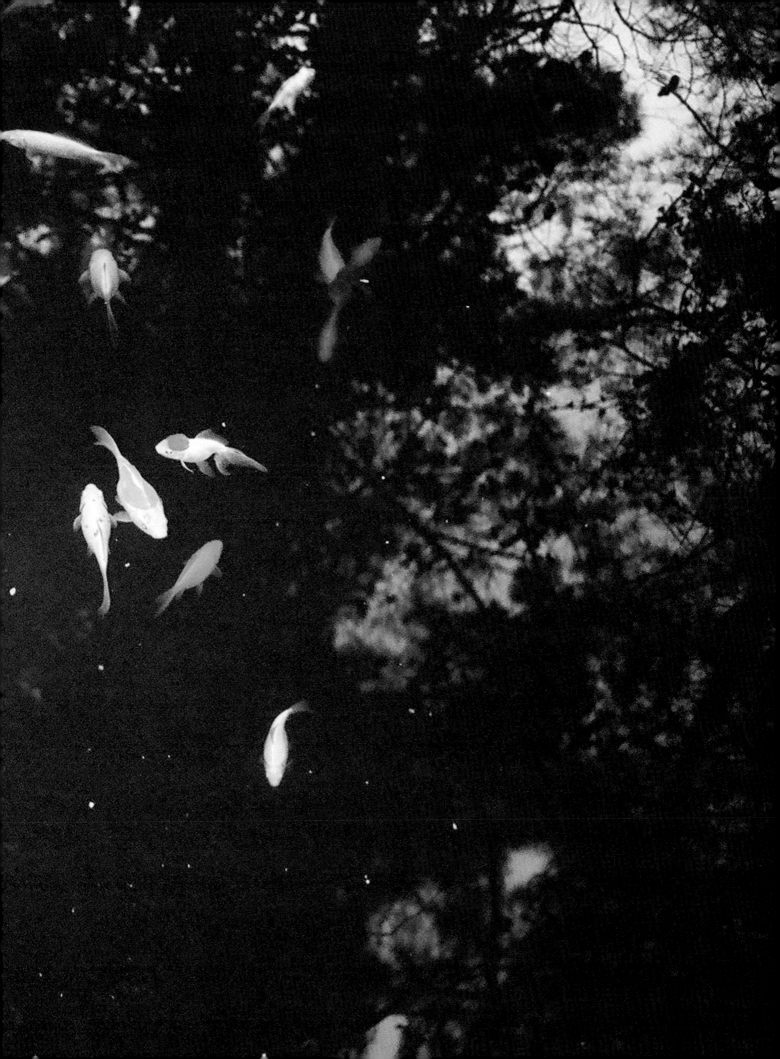

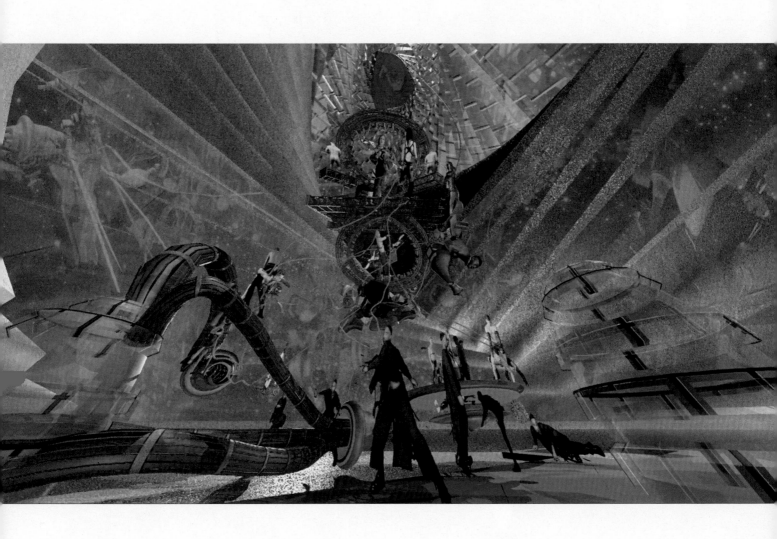

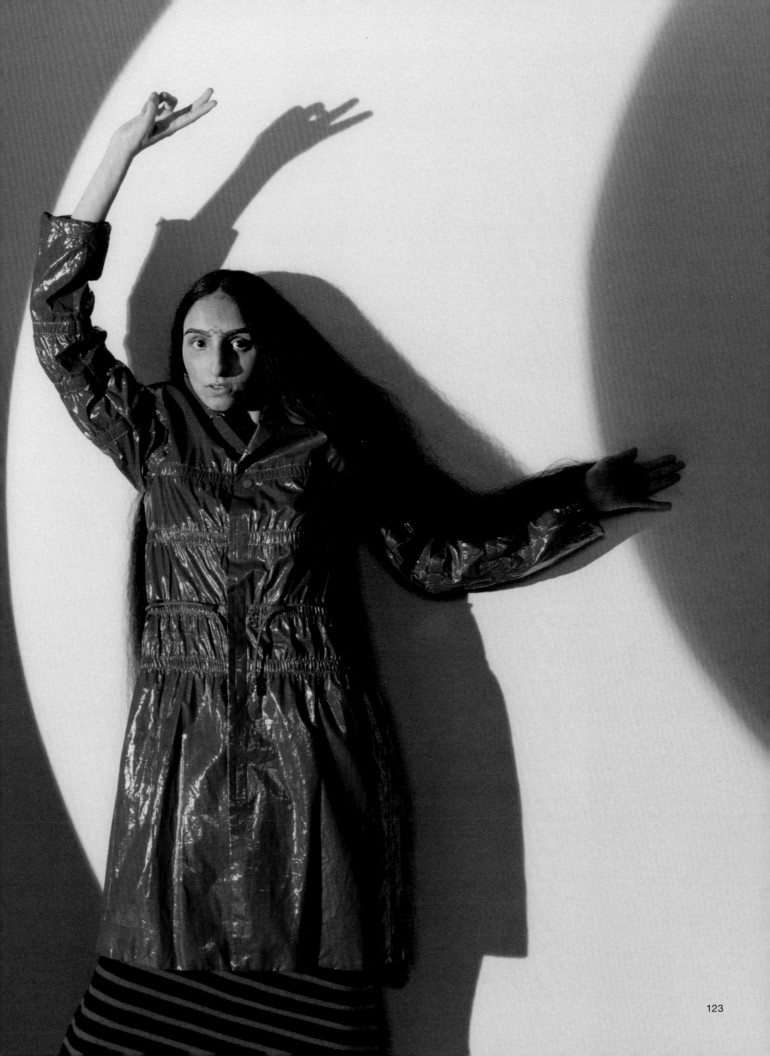

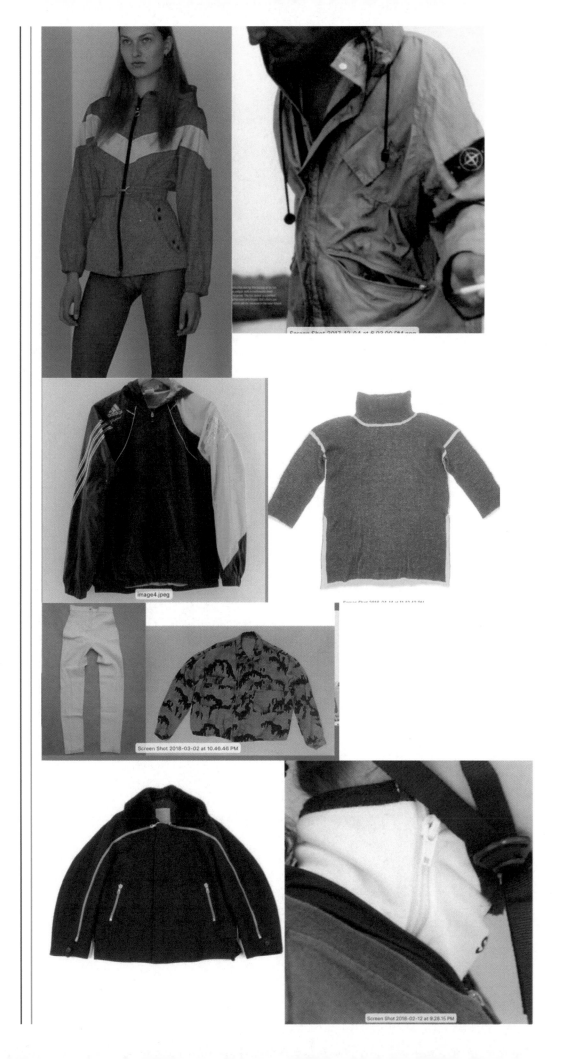

Screen Shot 2017-12-04 at 8.03.00 PM.png

image4.jpeg

Screen Shot 2018-04-14 at 11.42.42 PM

Screen Shot 2018-03-02 at 10.46.46 PM

Screen Shot 2018-02-12 at 9.28.15 PM

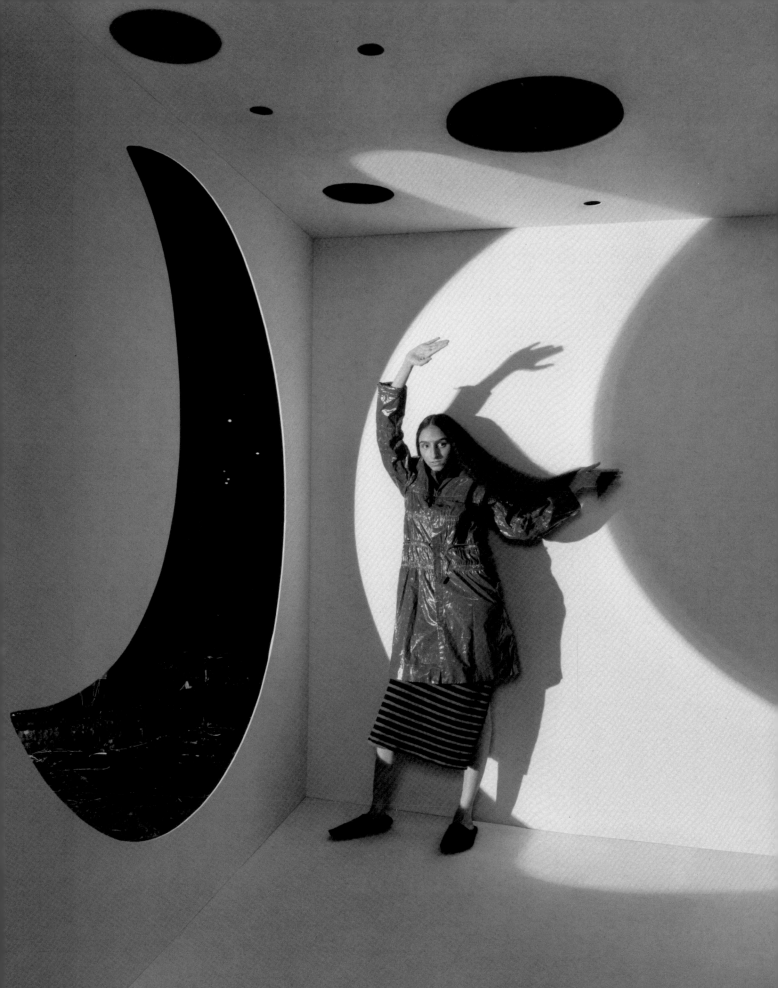

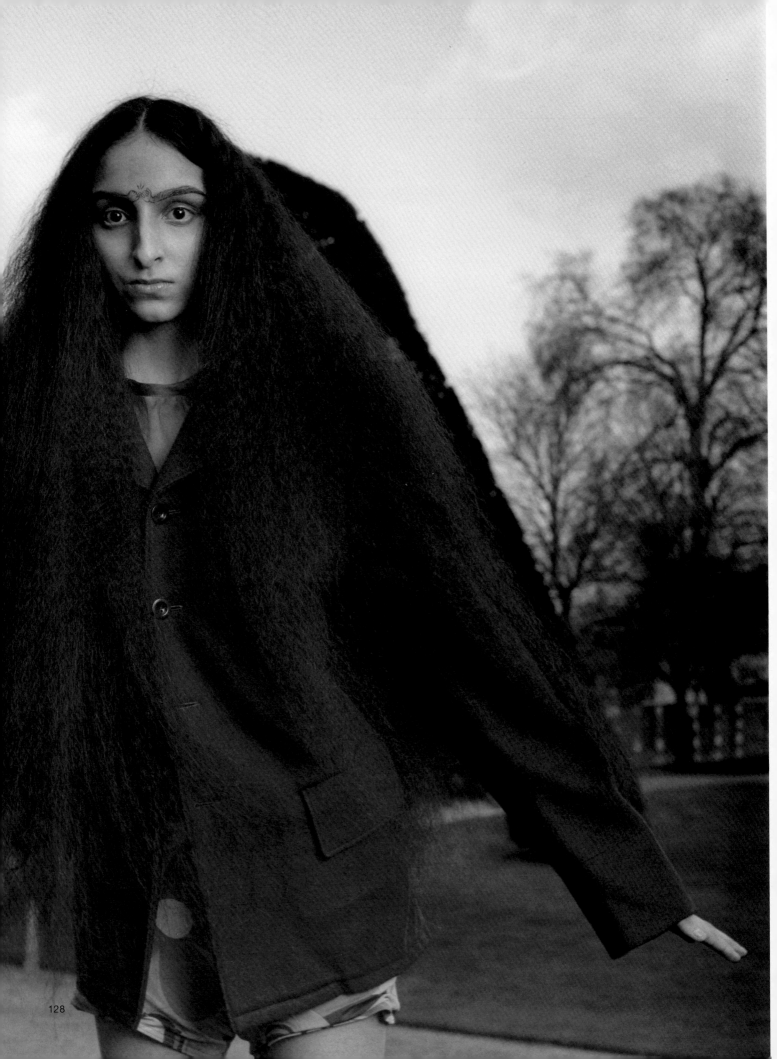

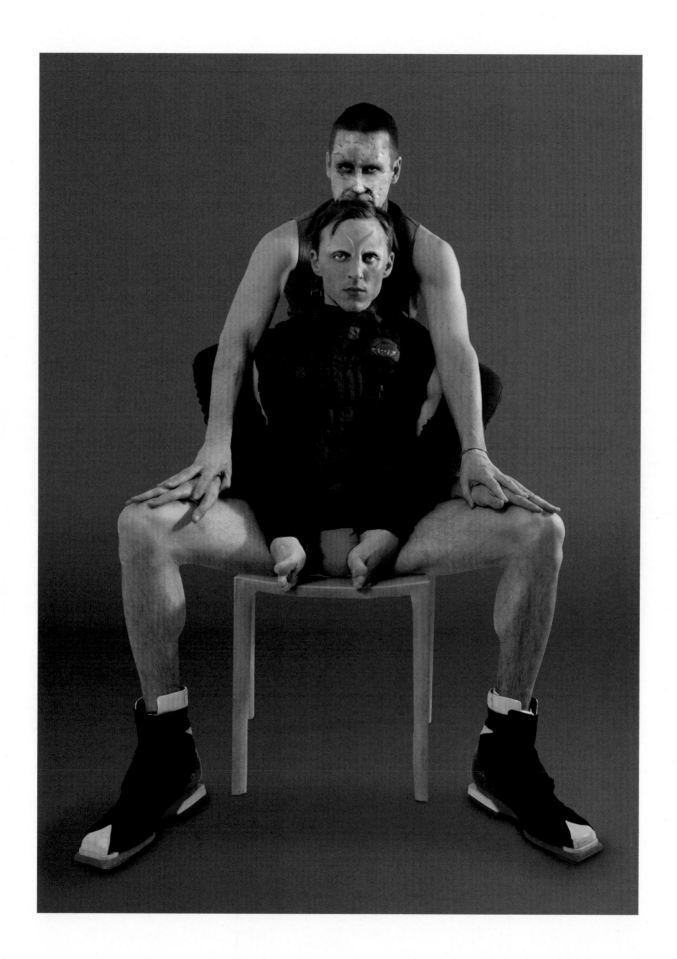

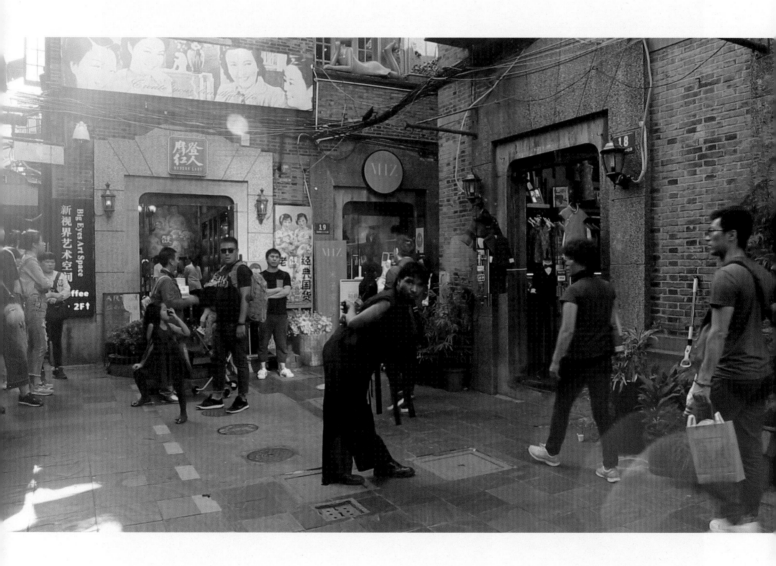

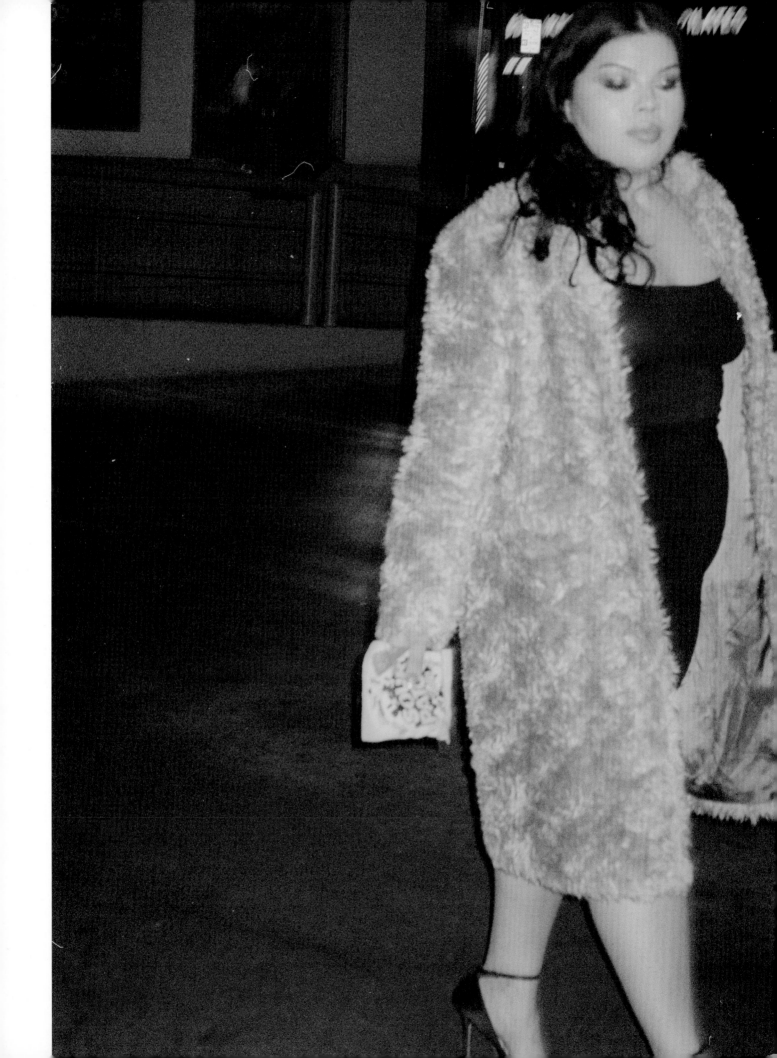

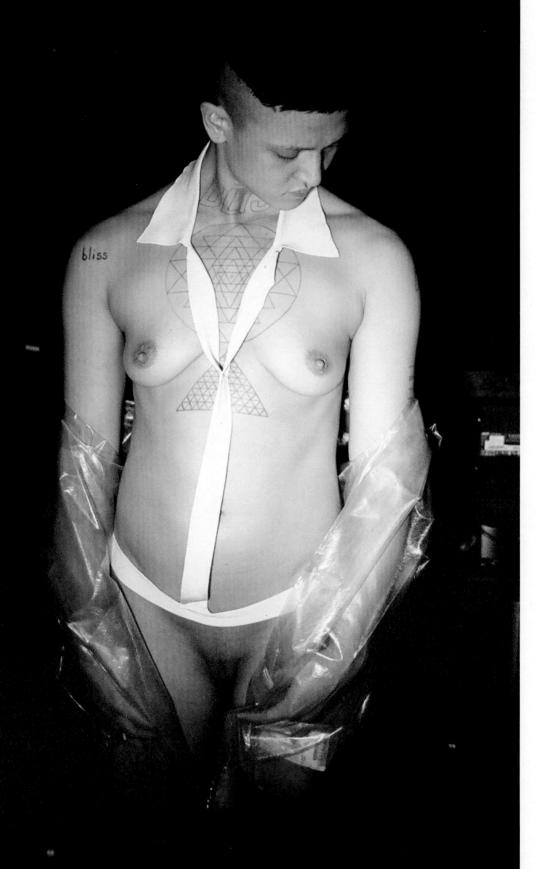

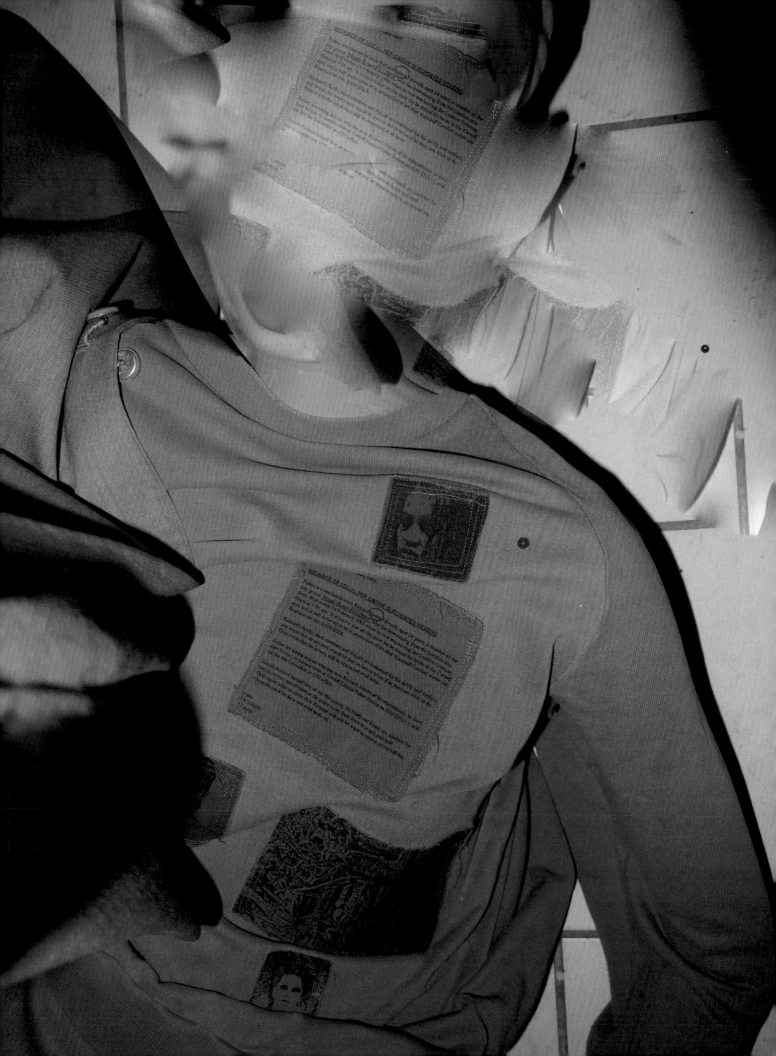

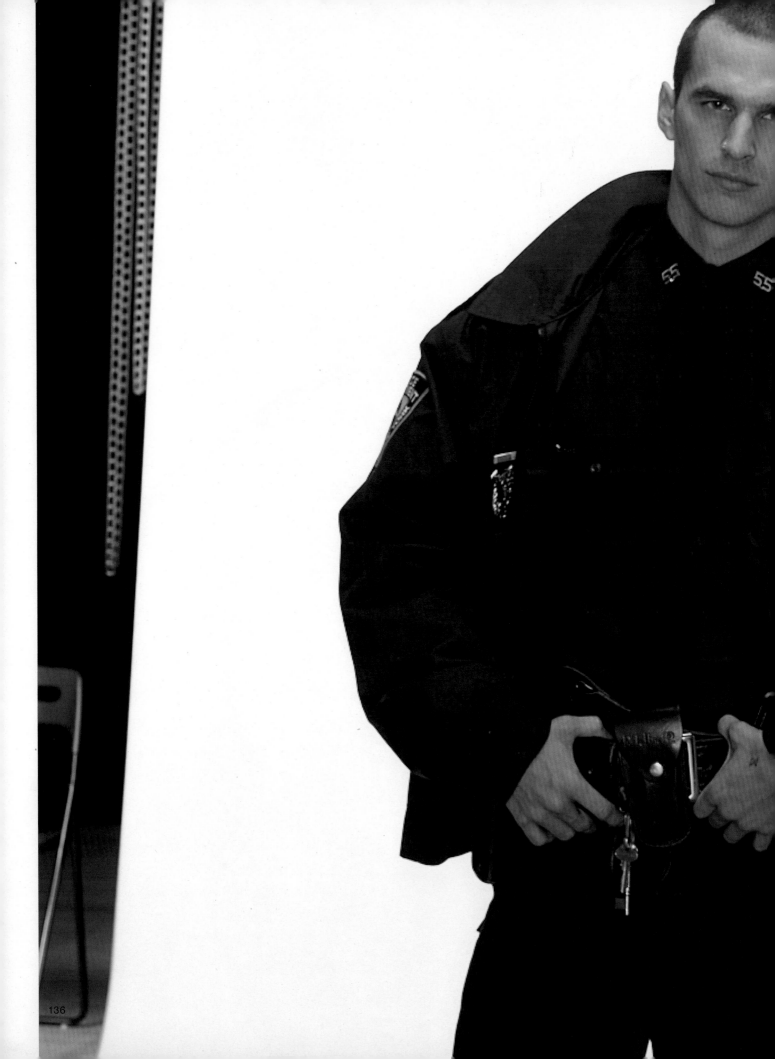

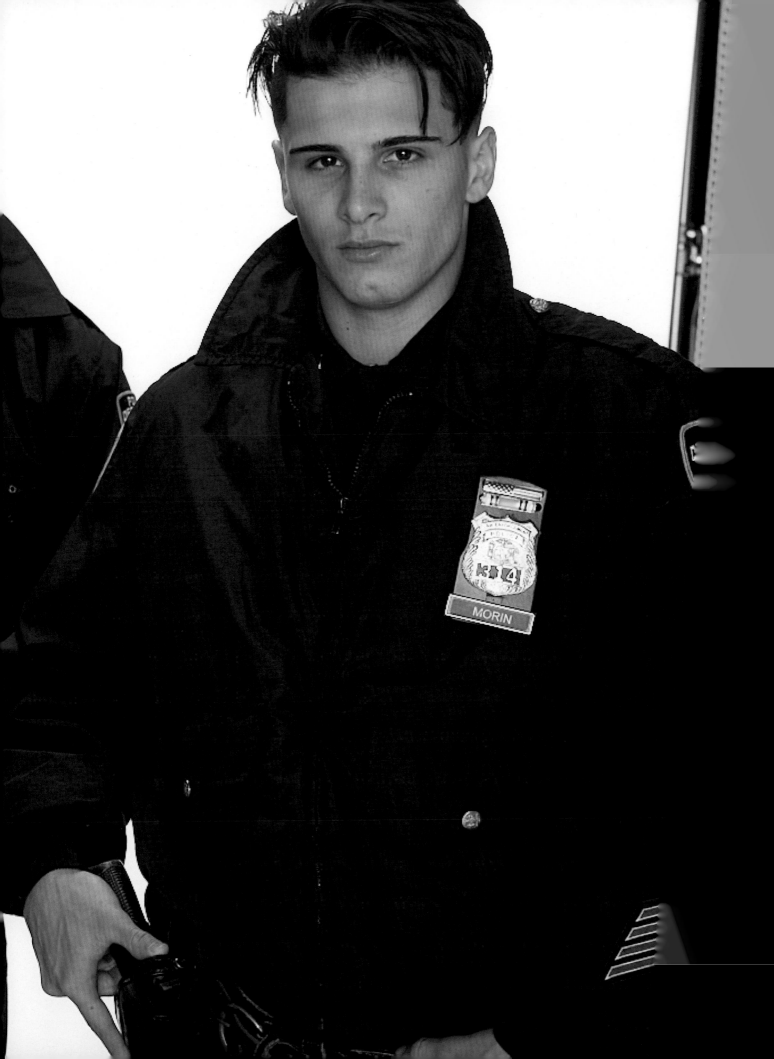

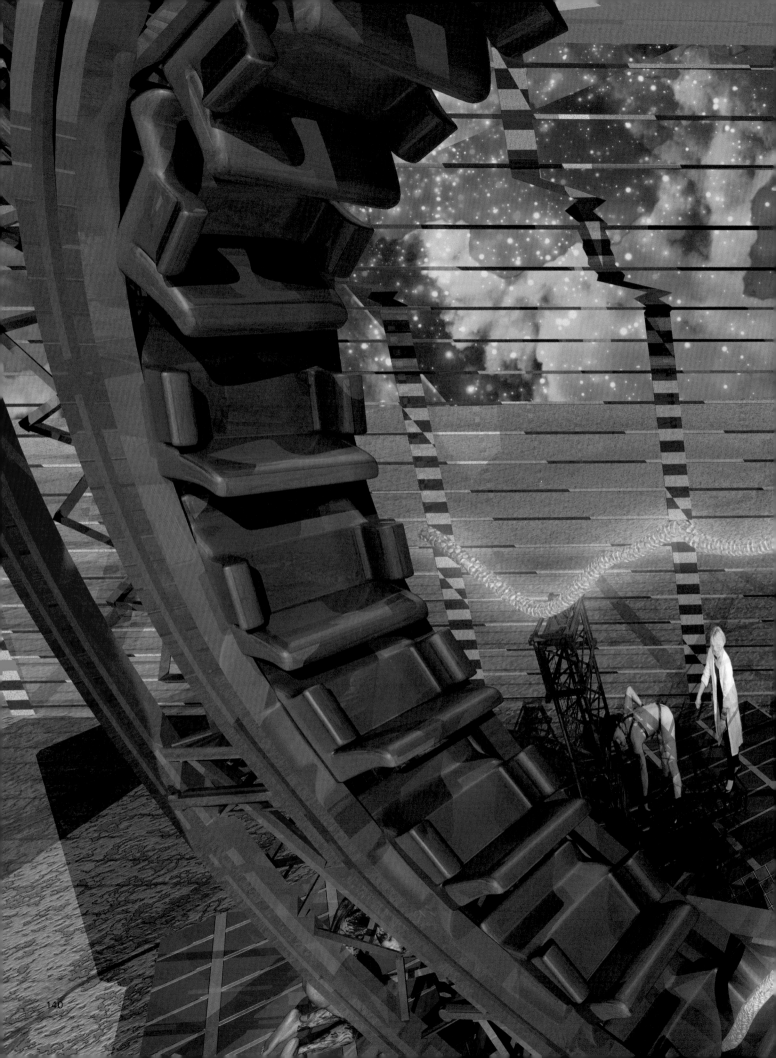

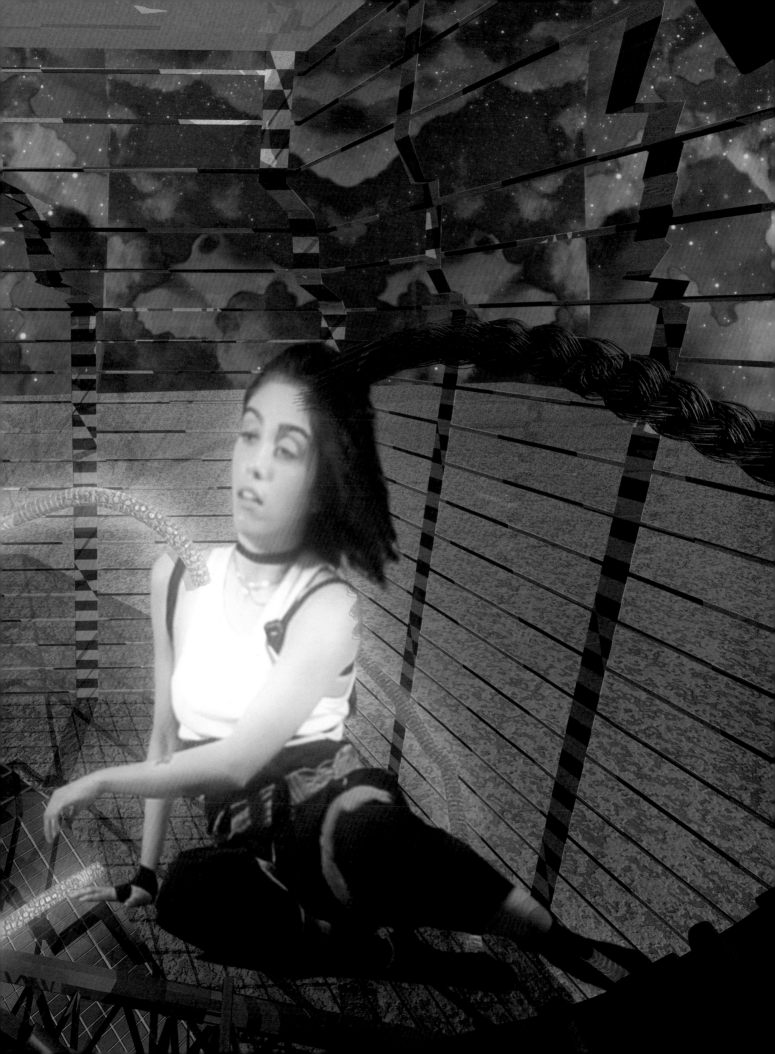

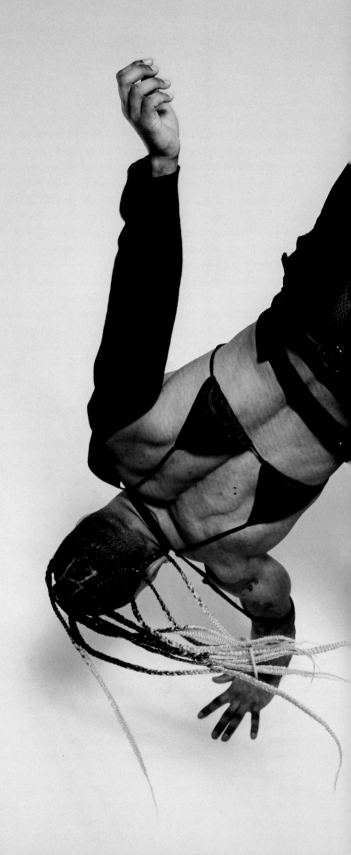

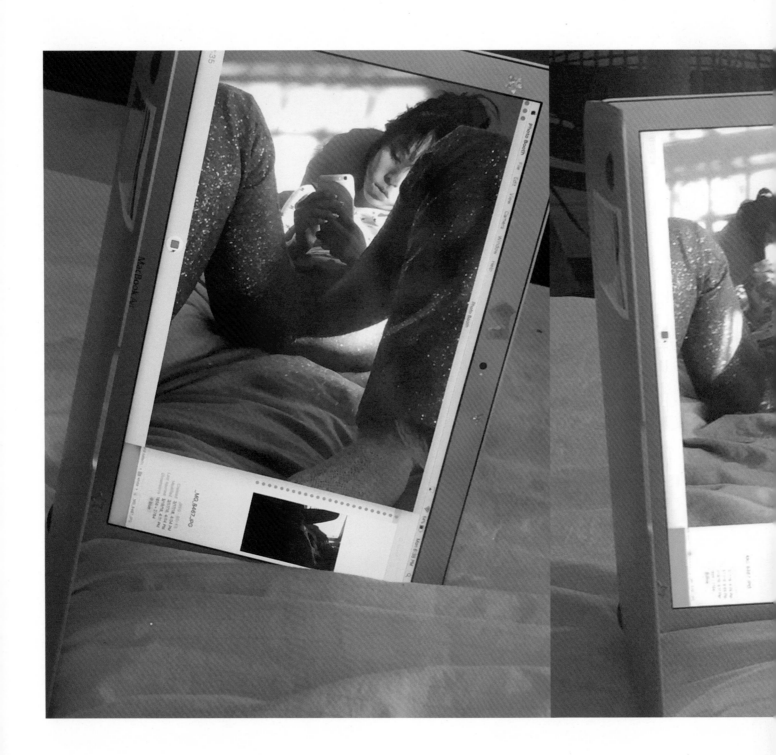

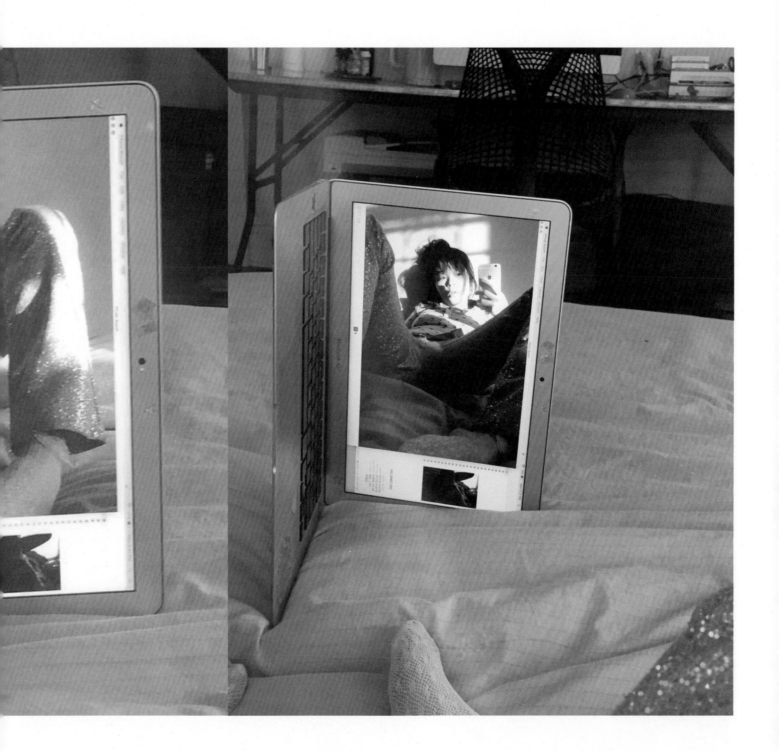

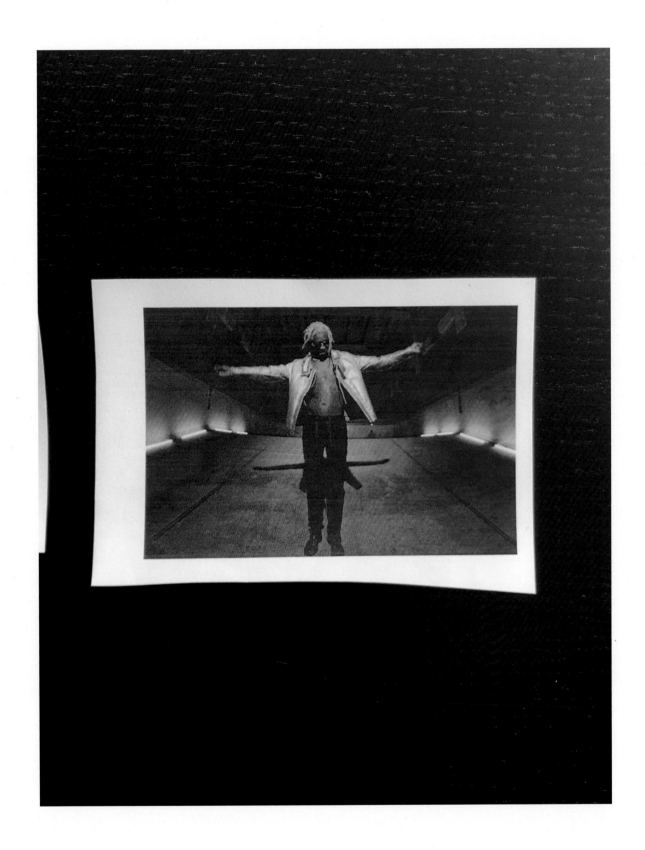

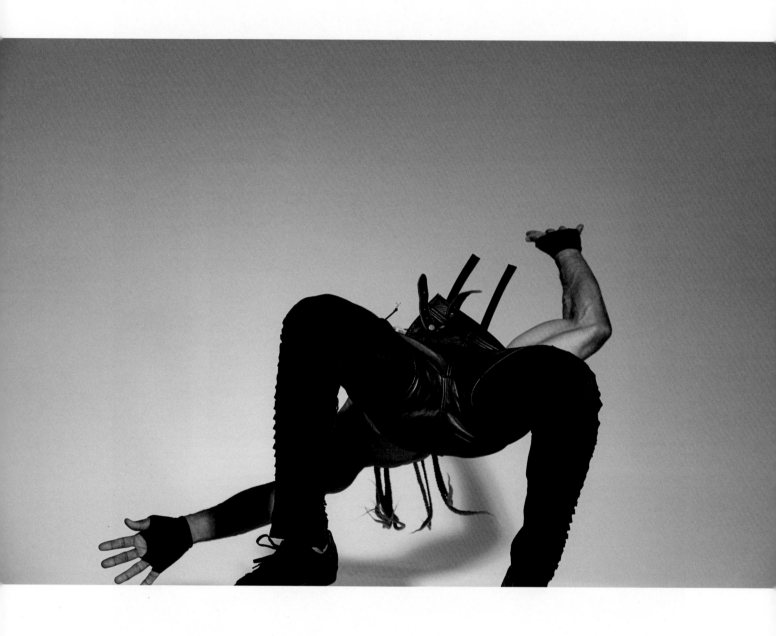

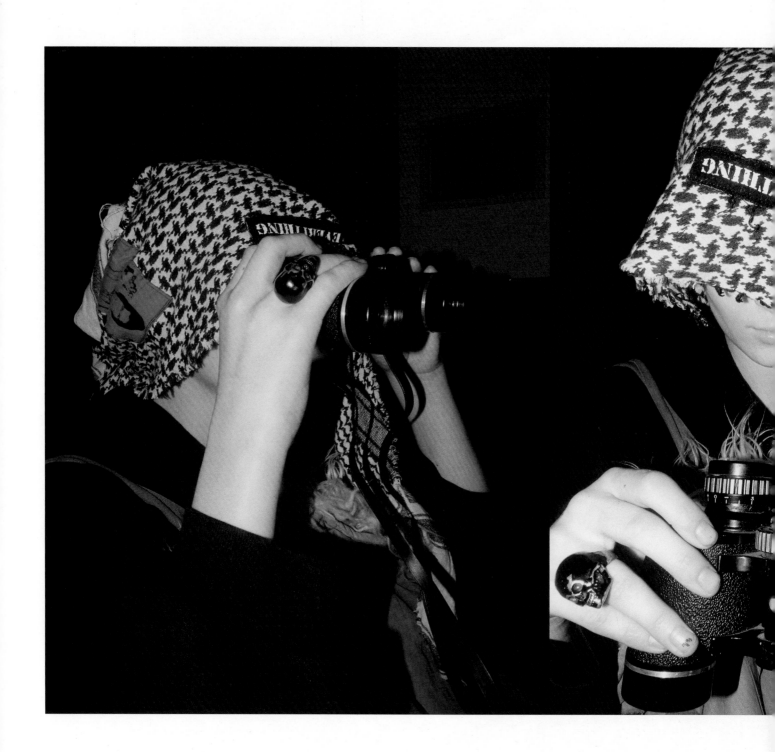

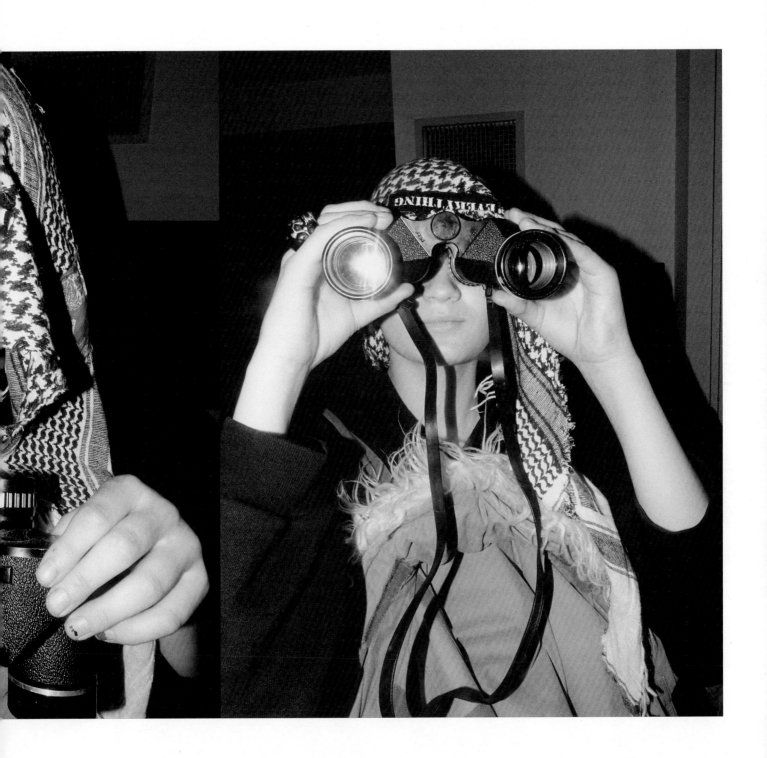

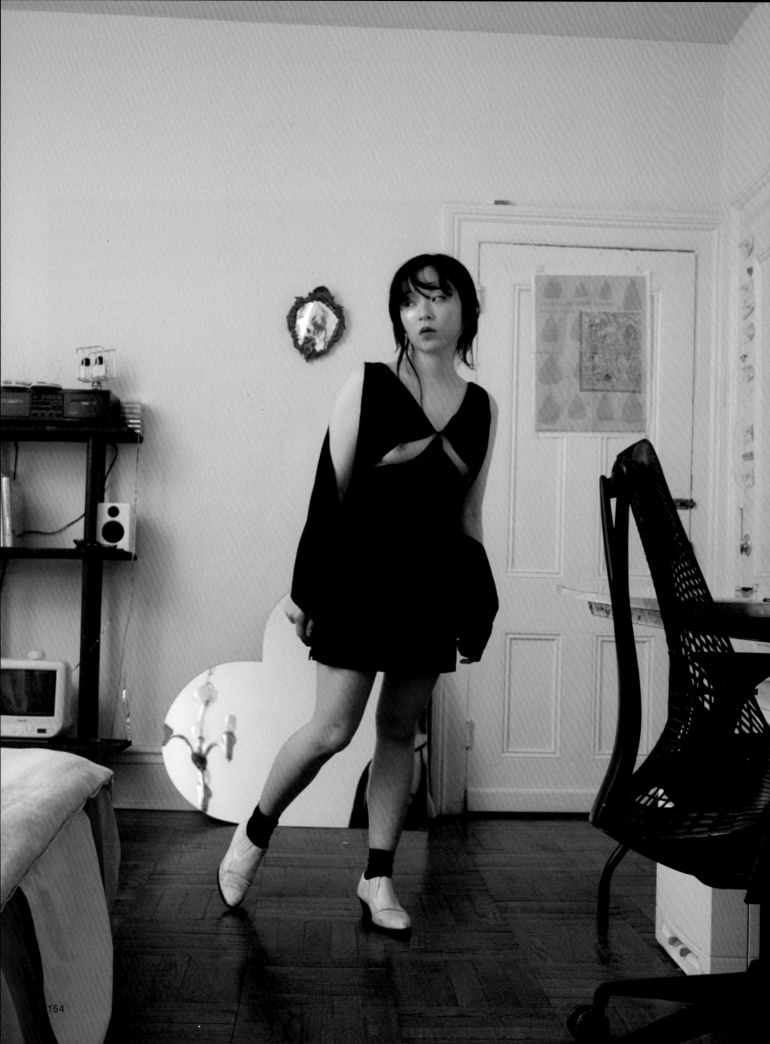

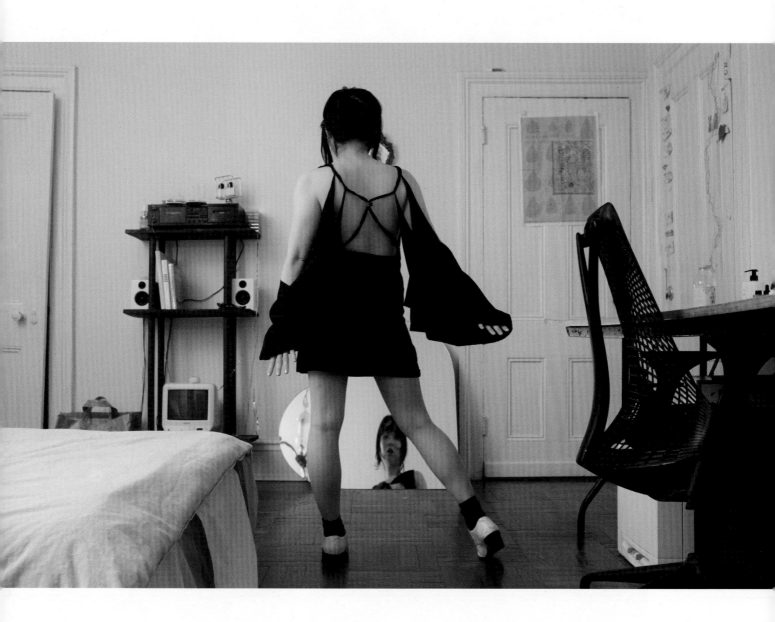

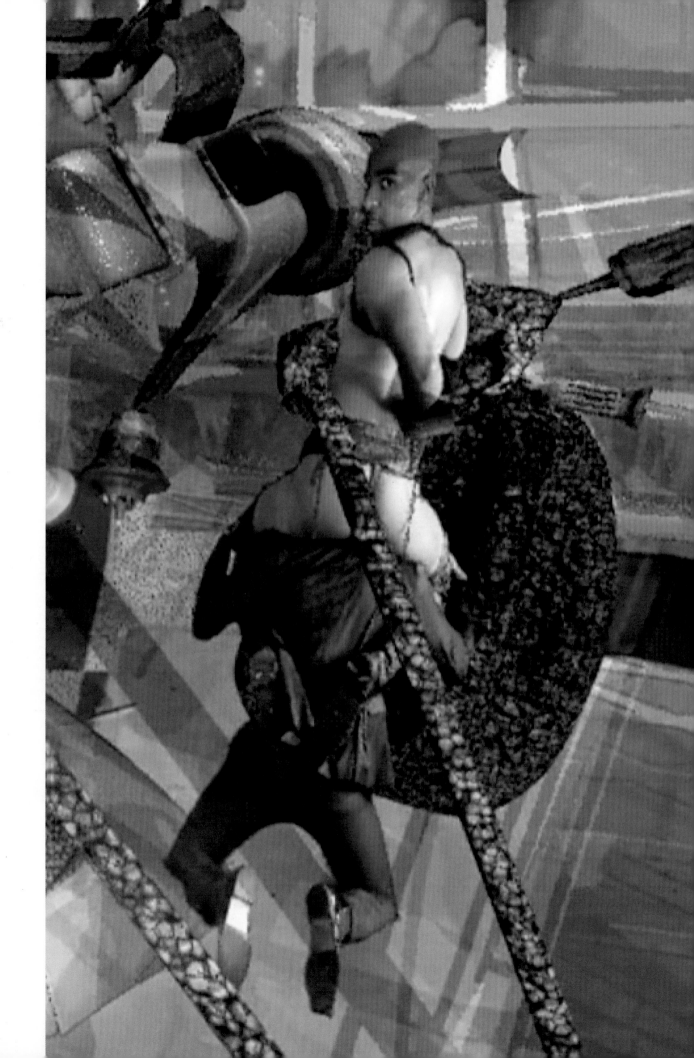

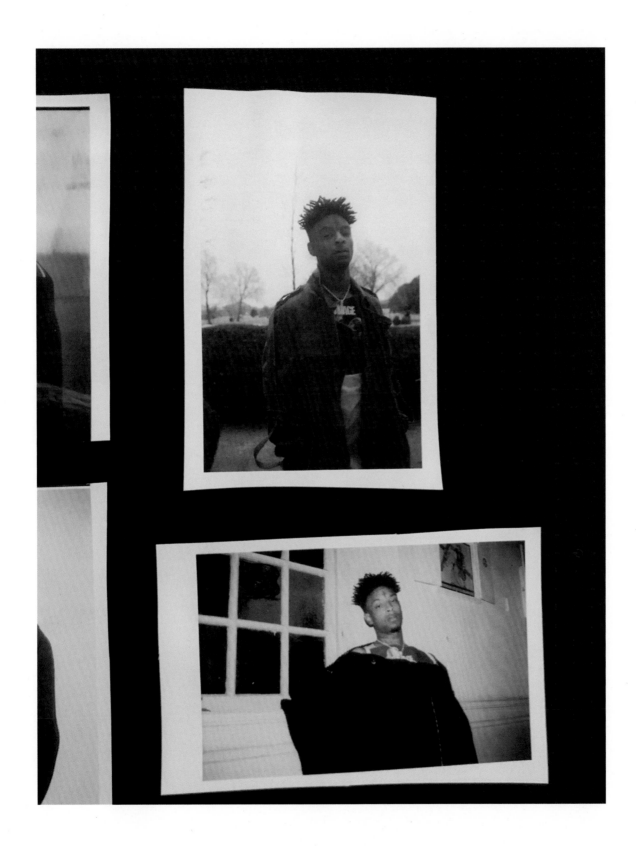

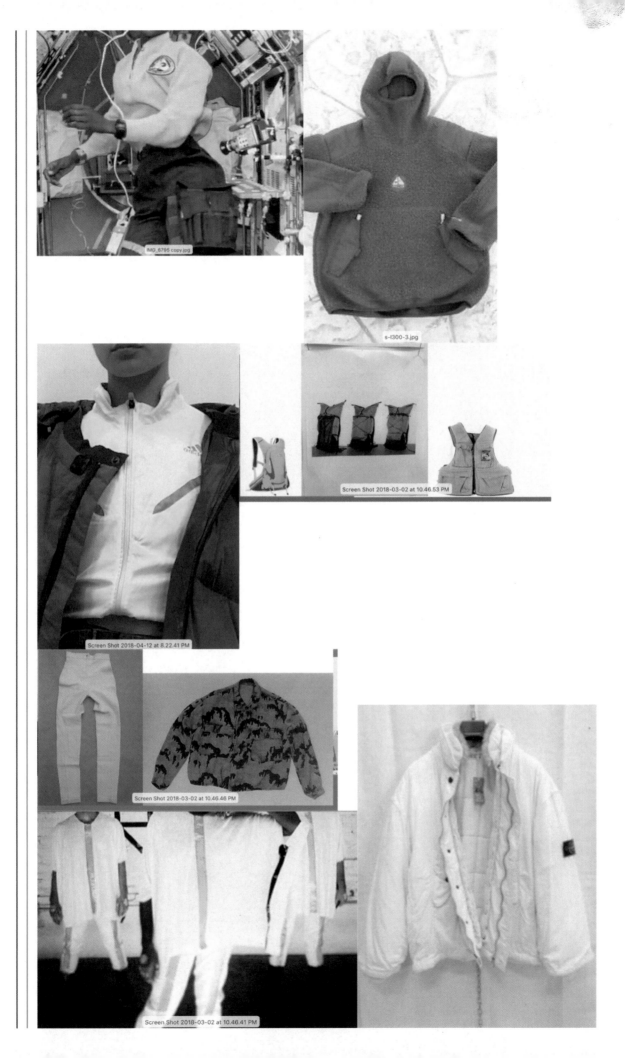

IMG_6795 copy.jpg

s-I300-3.jpg

Screen Shot 2018-03-02 at 10.46.53 PM

Screen Shot 2018-04-12 at 8.22.41 PM

Screen Shot 2018-03-02 at 10.46.46 PM

Screen Shot 2018-03-02 at 10.46.41 PM

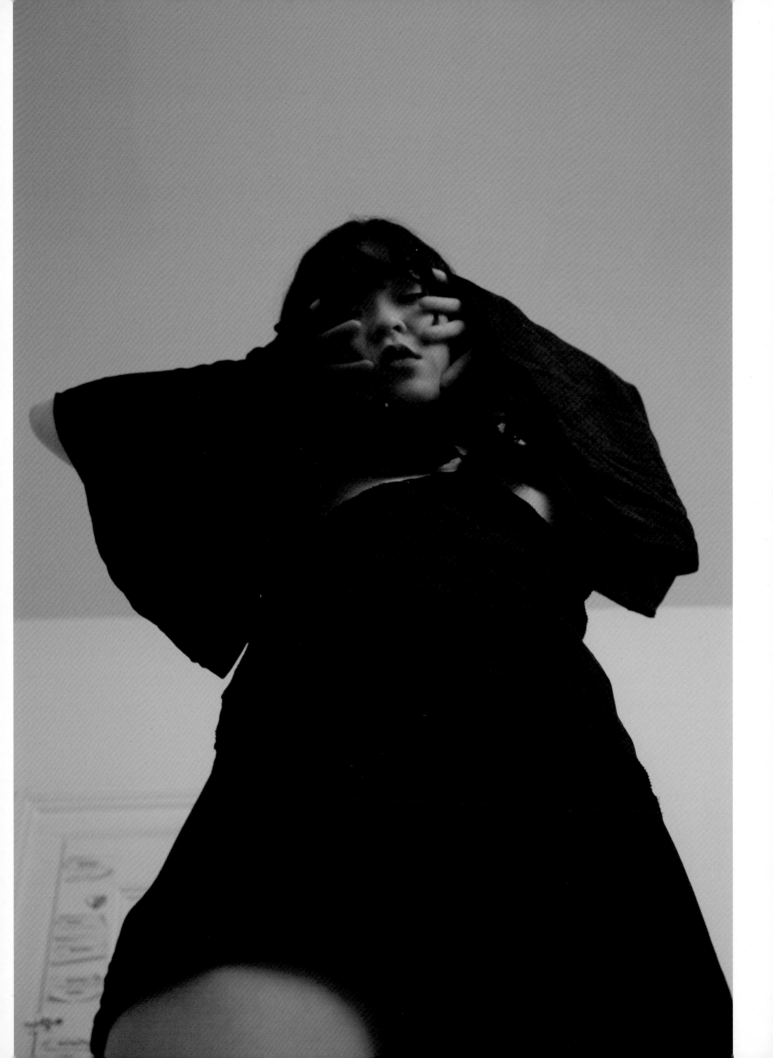

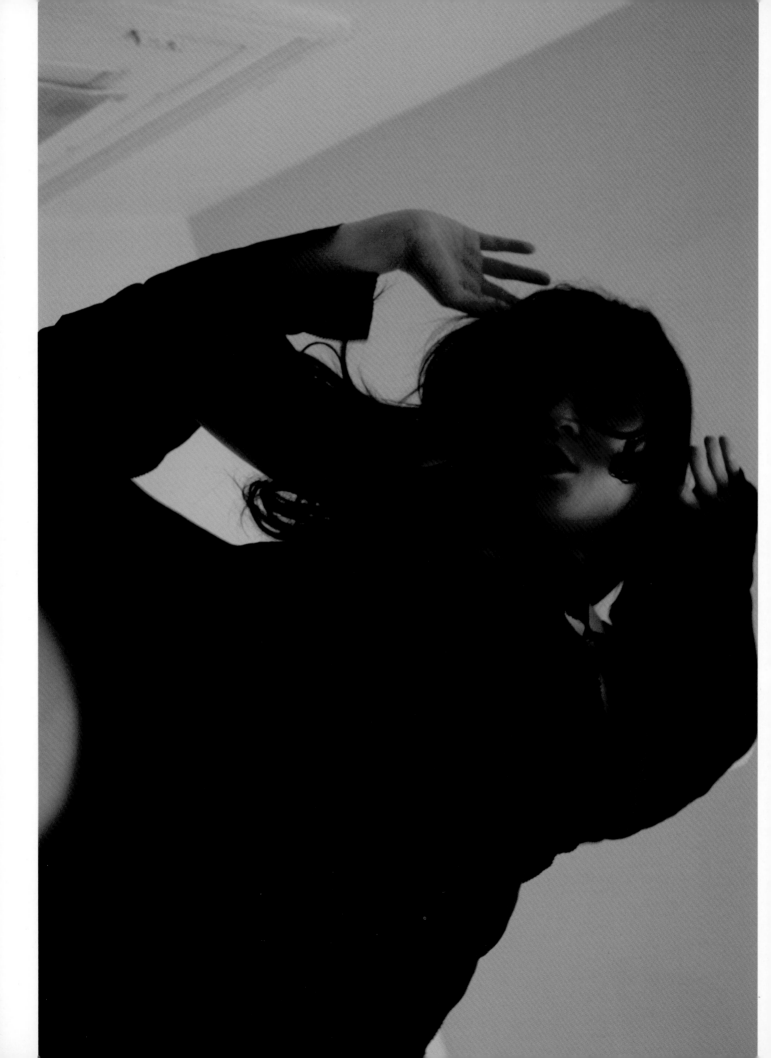

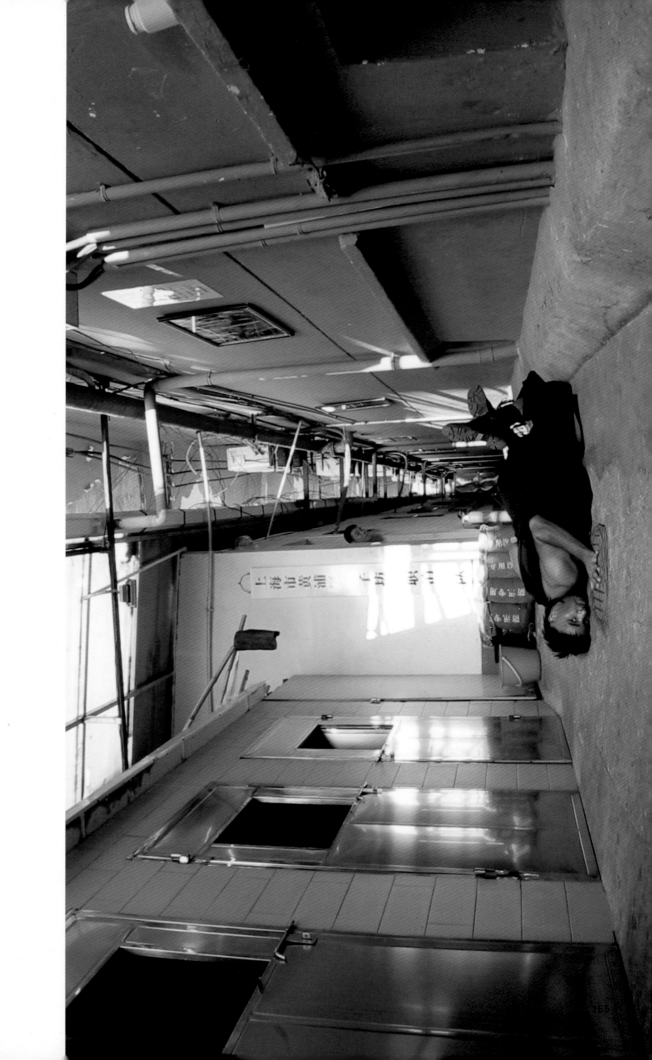

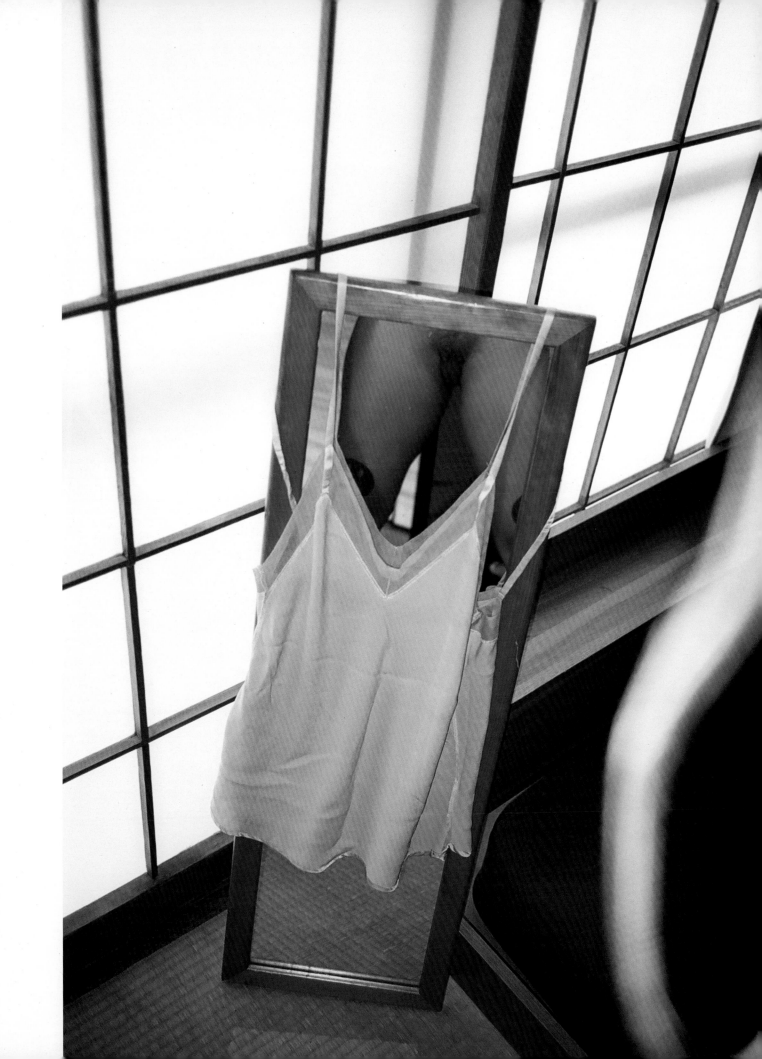

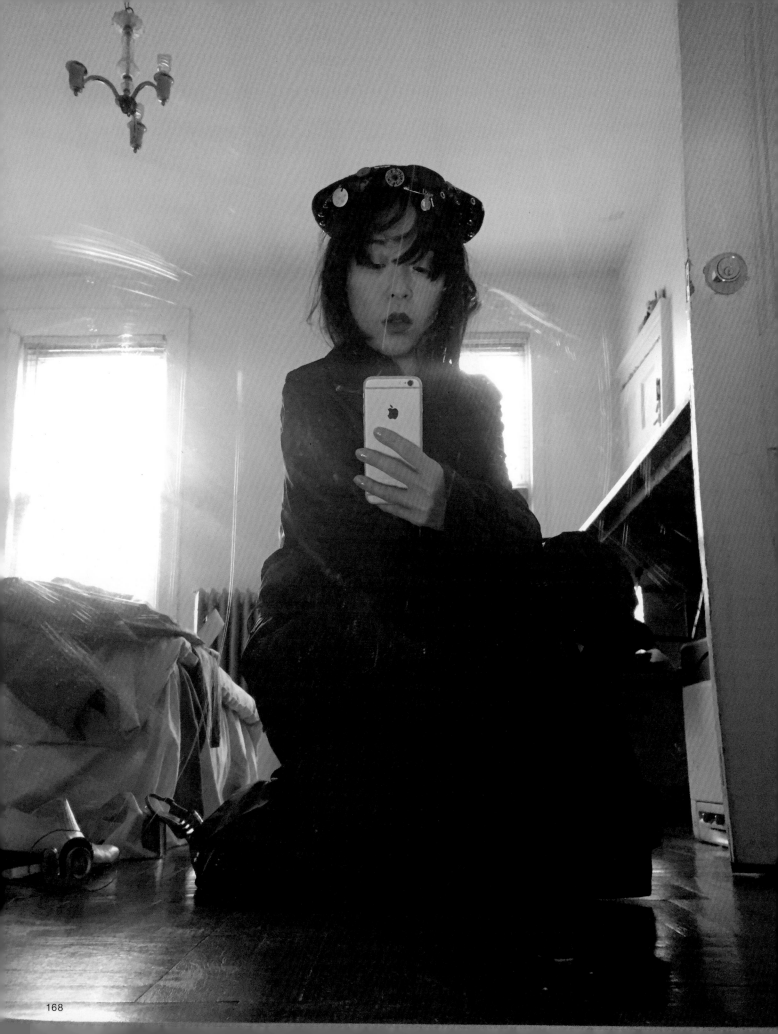

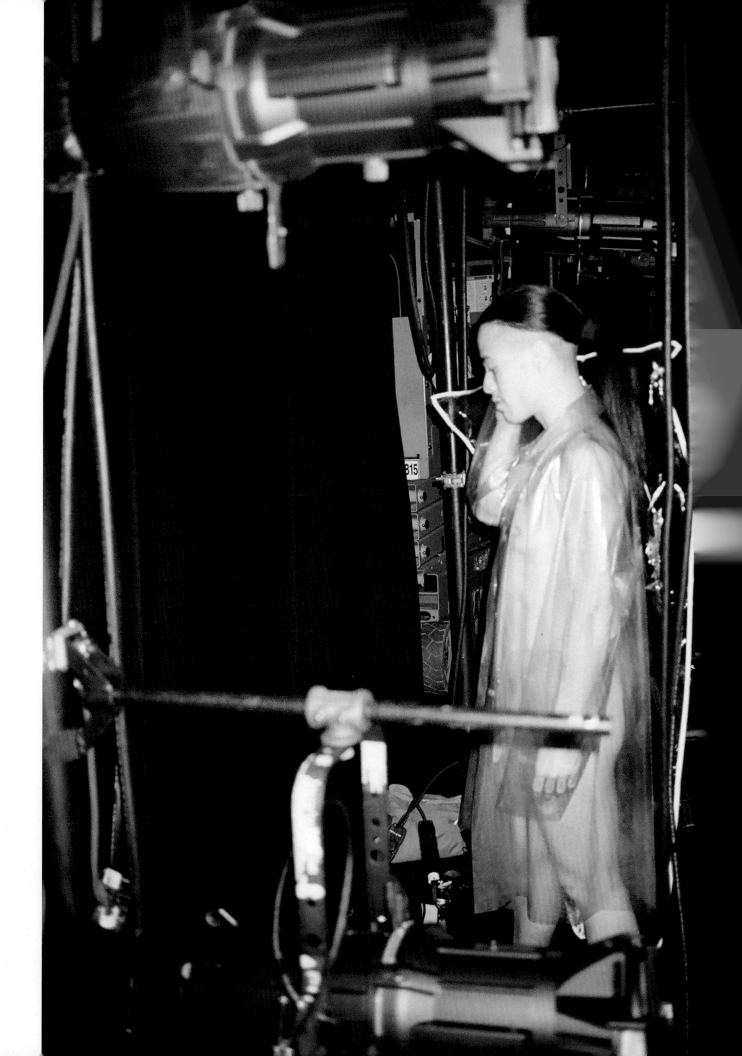

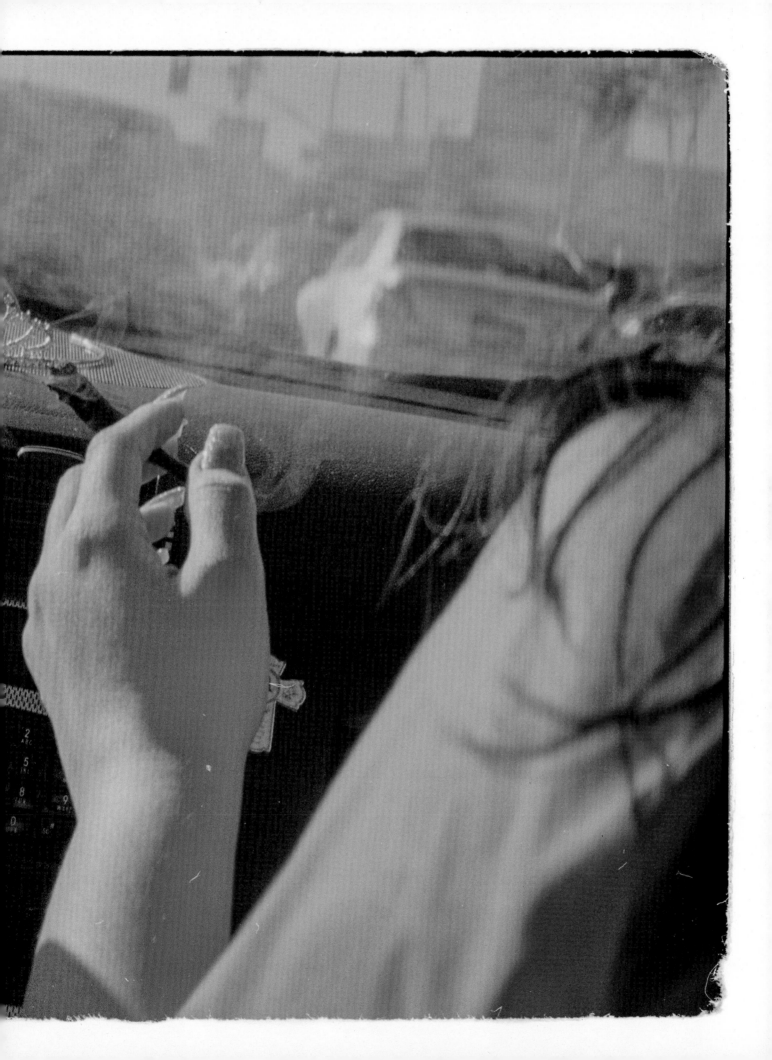

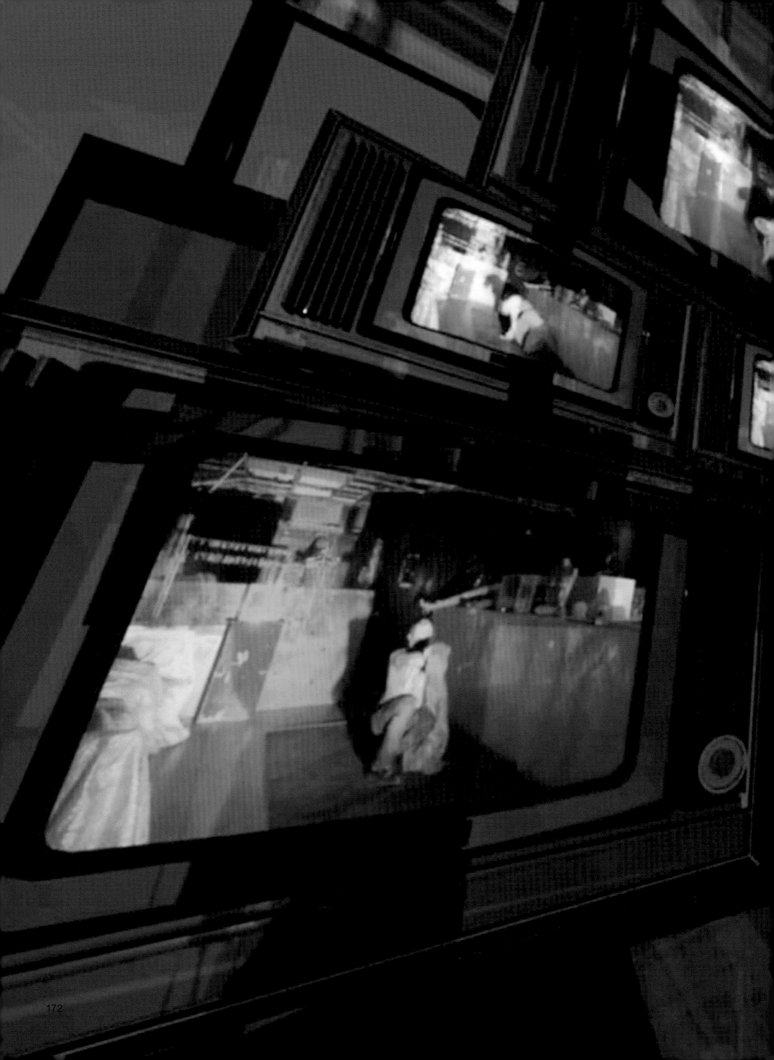

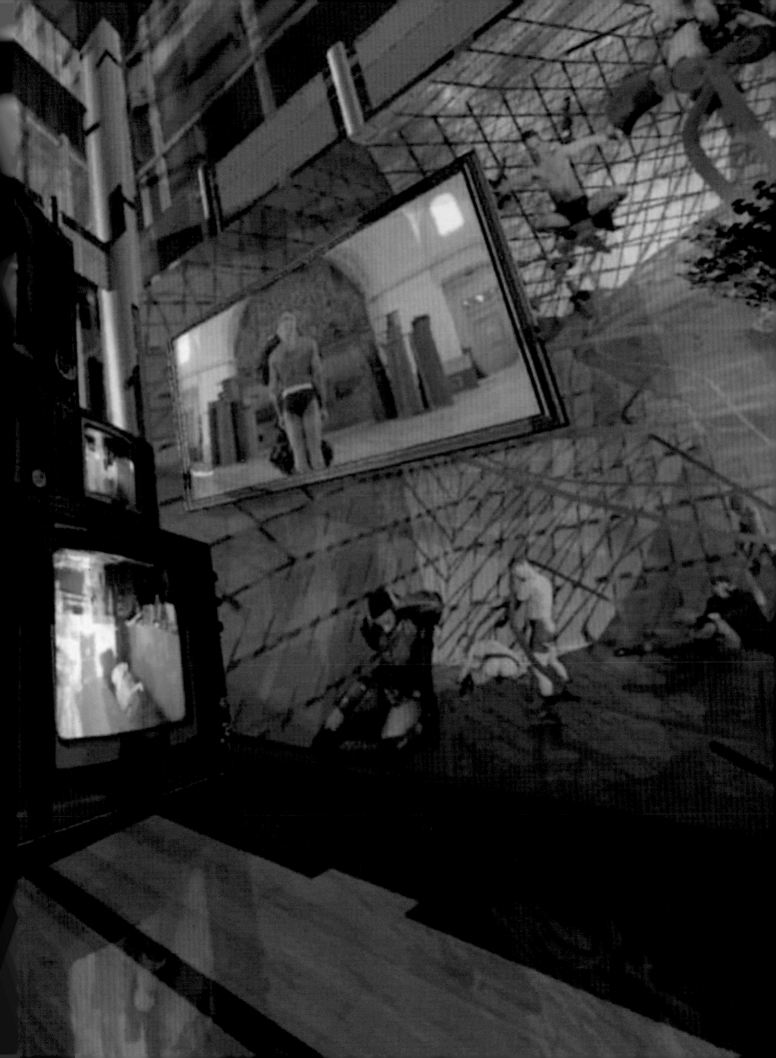

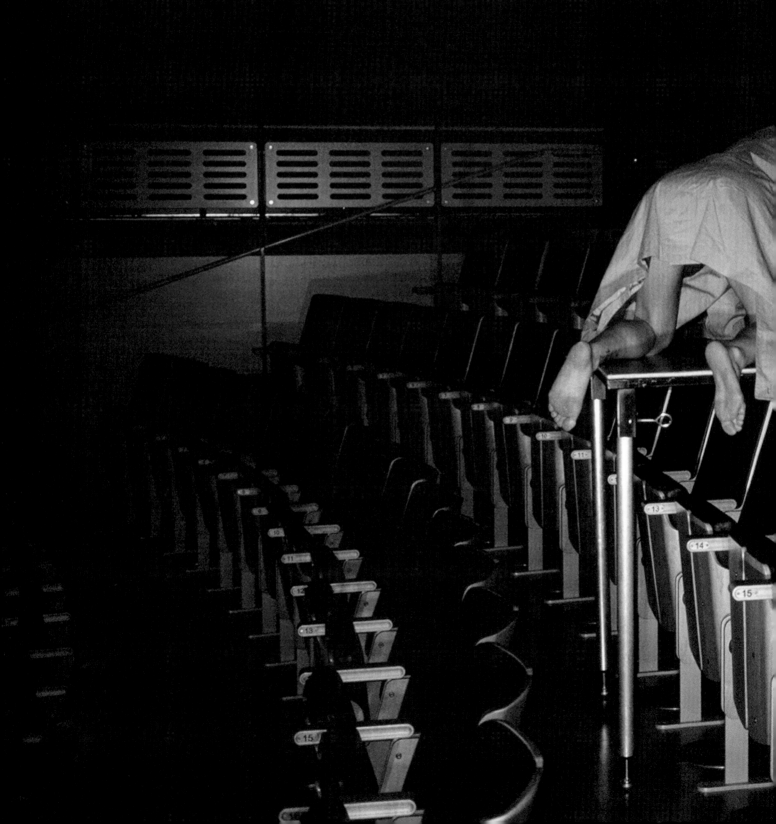

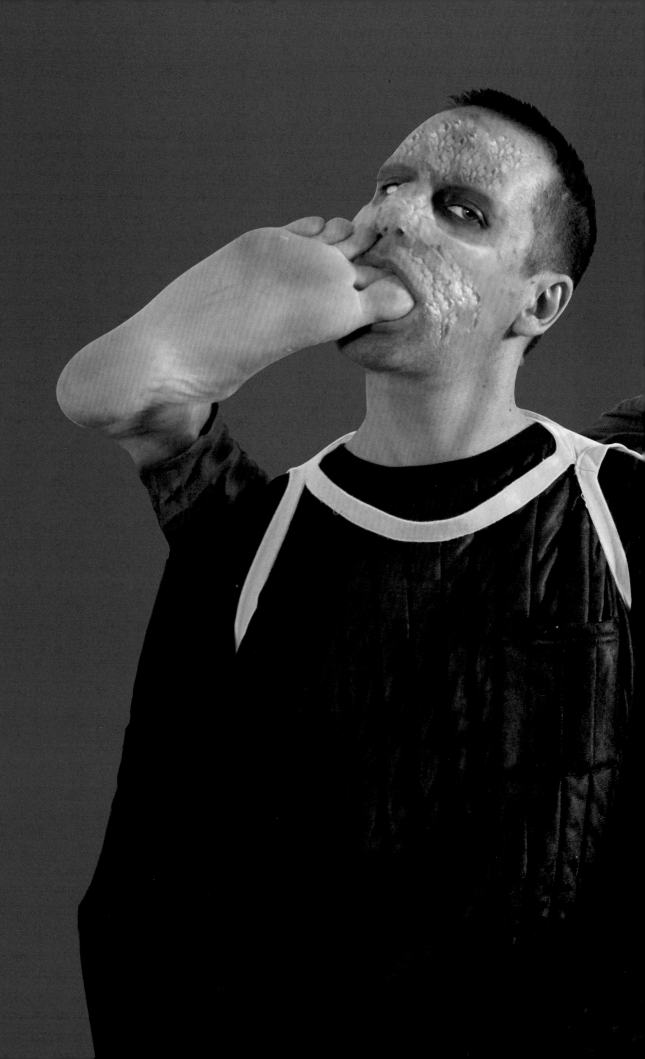

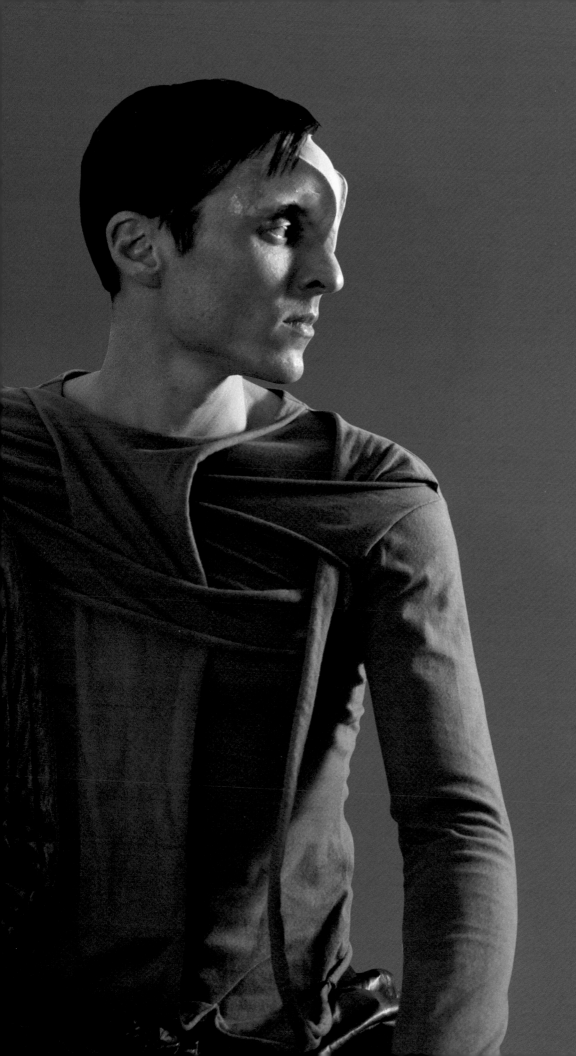

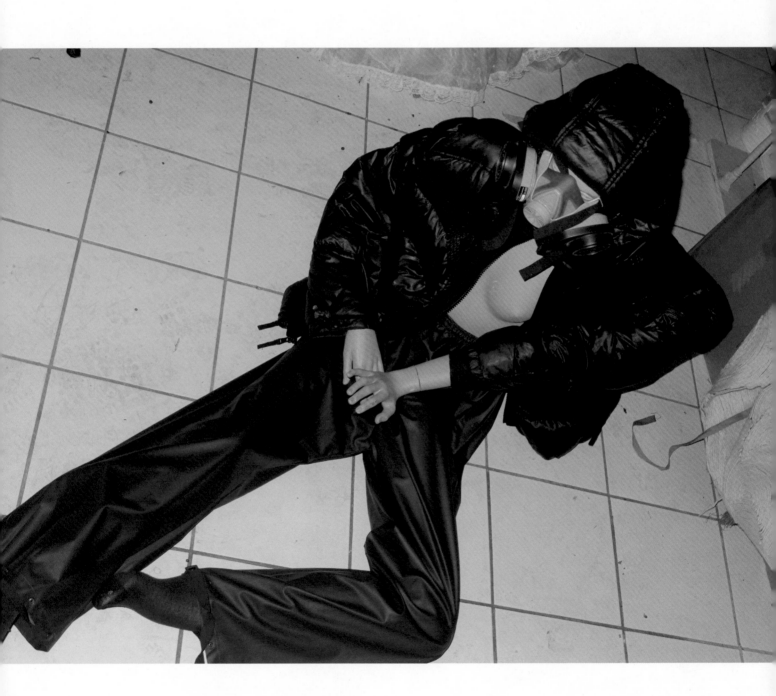

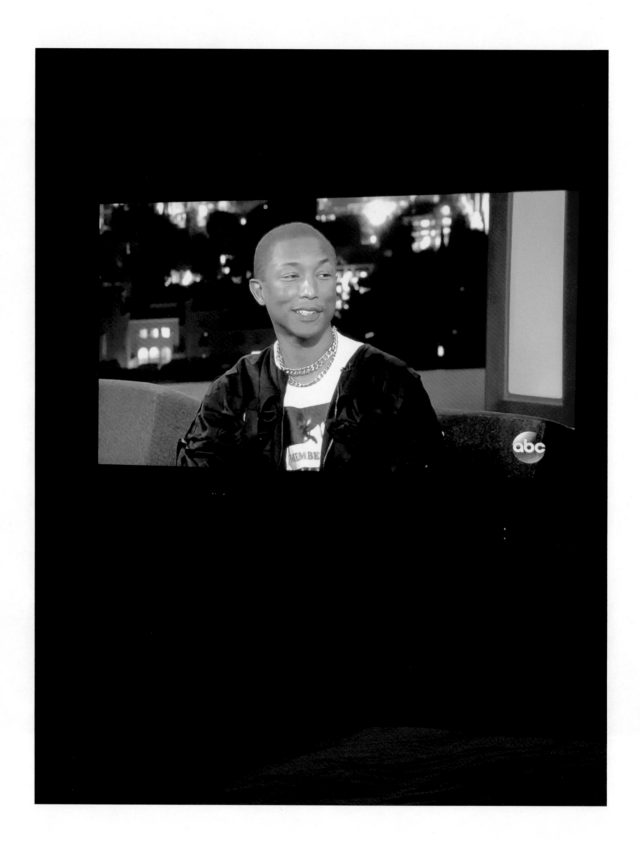

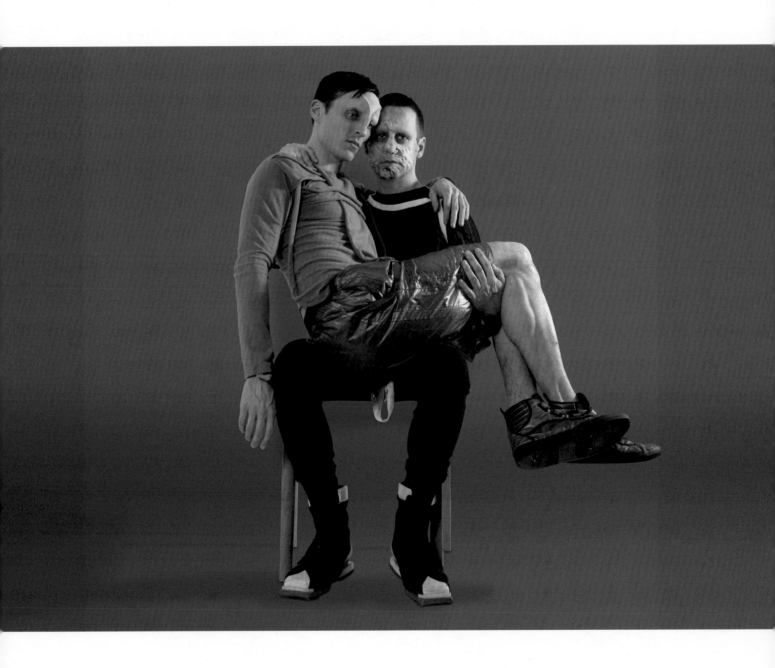

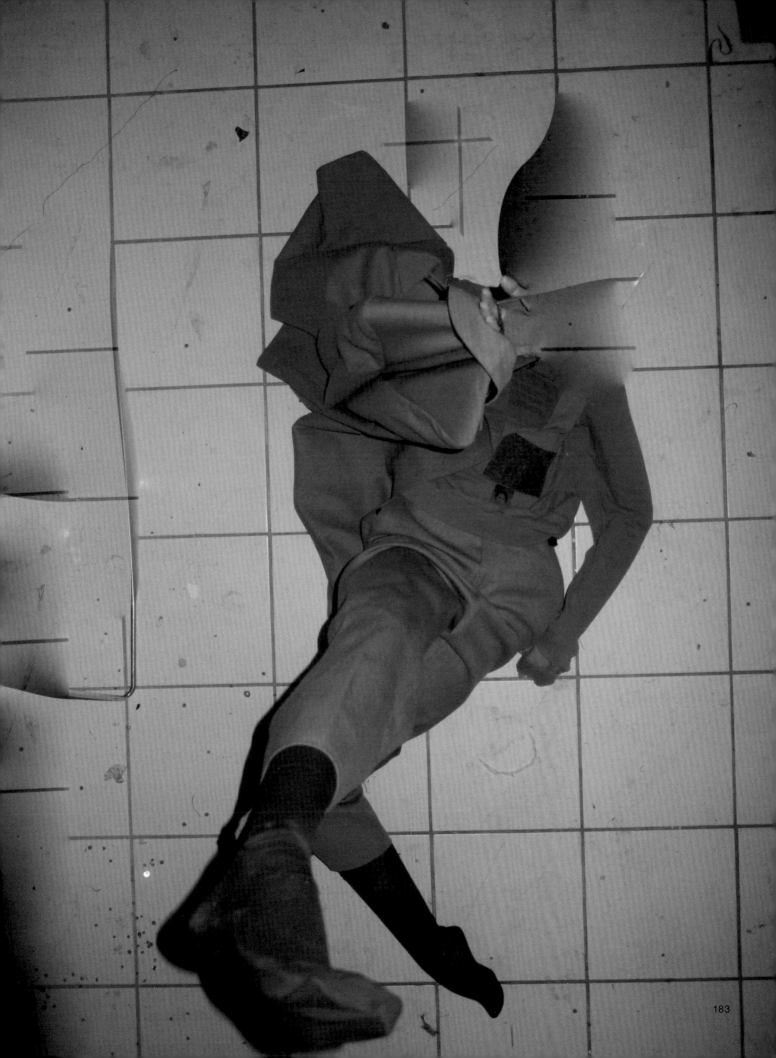

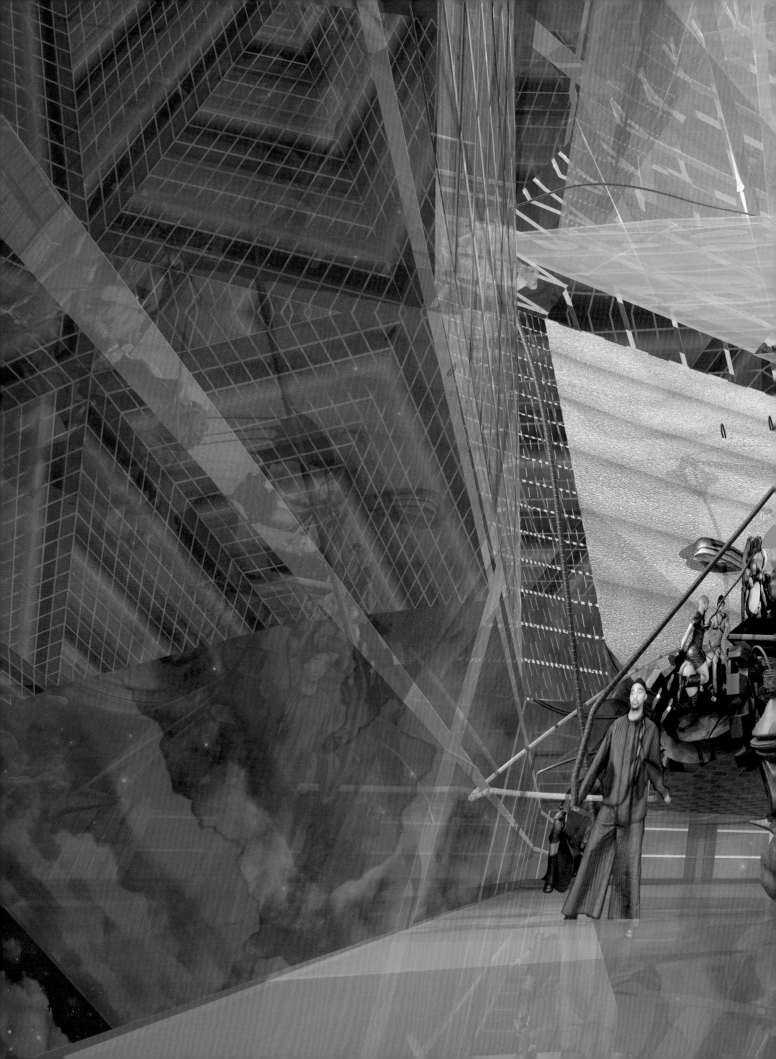

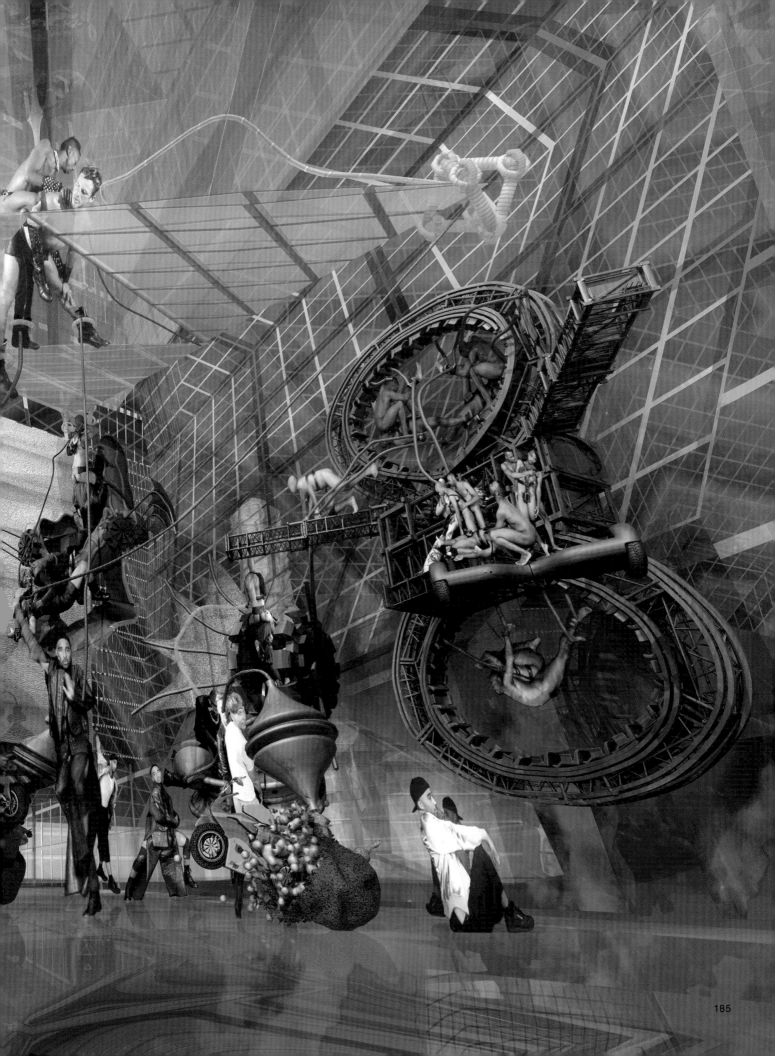

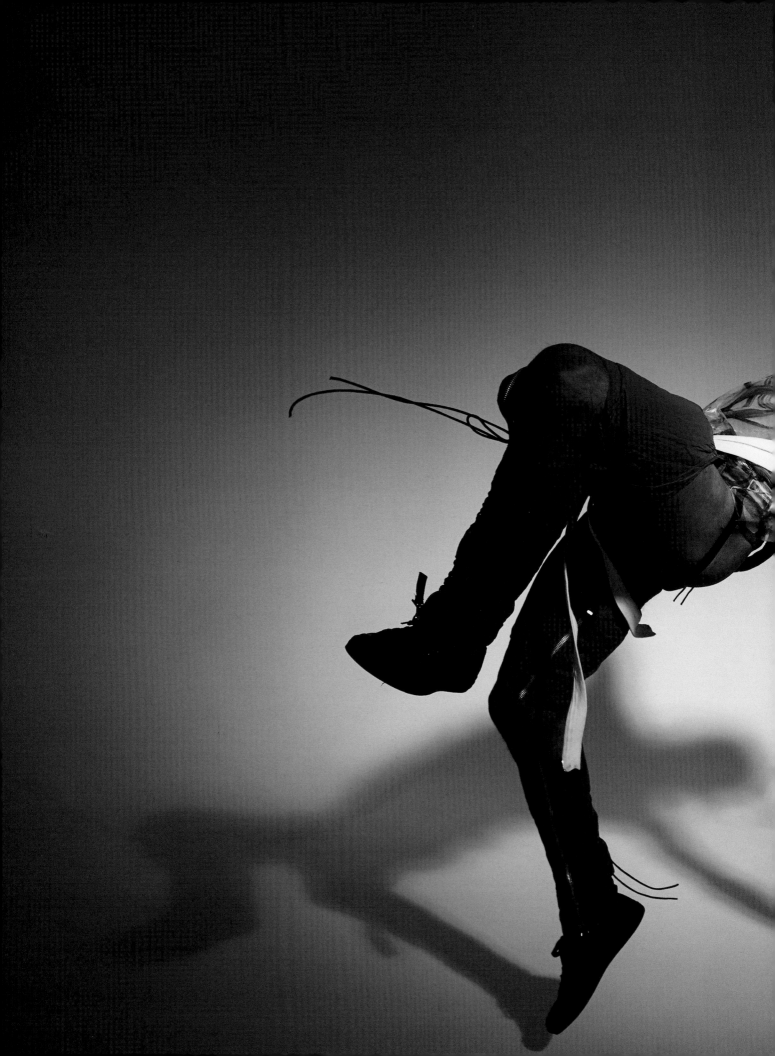

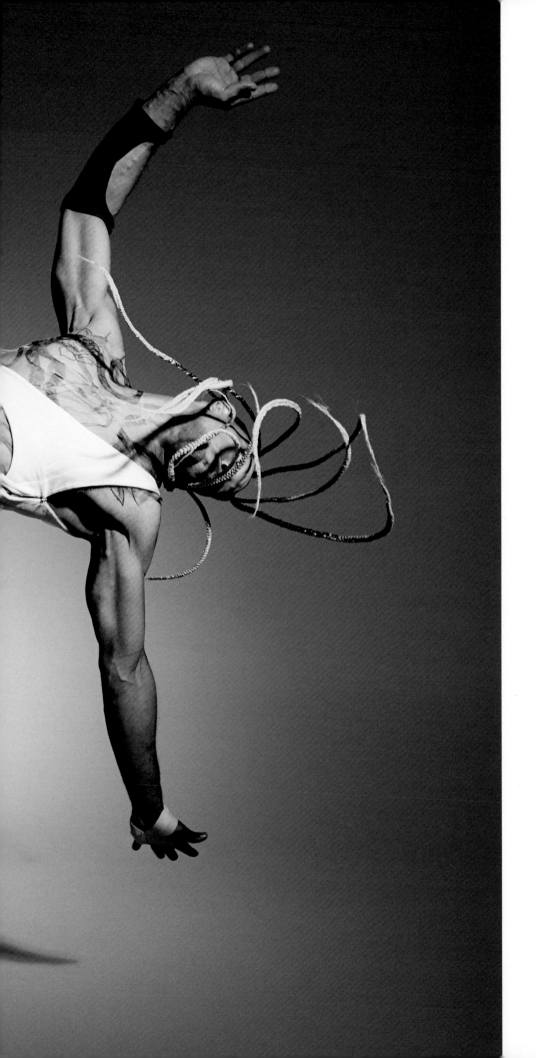

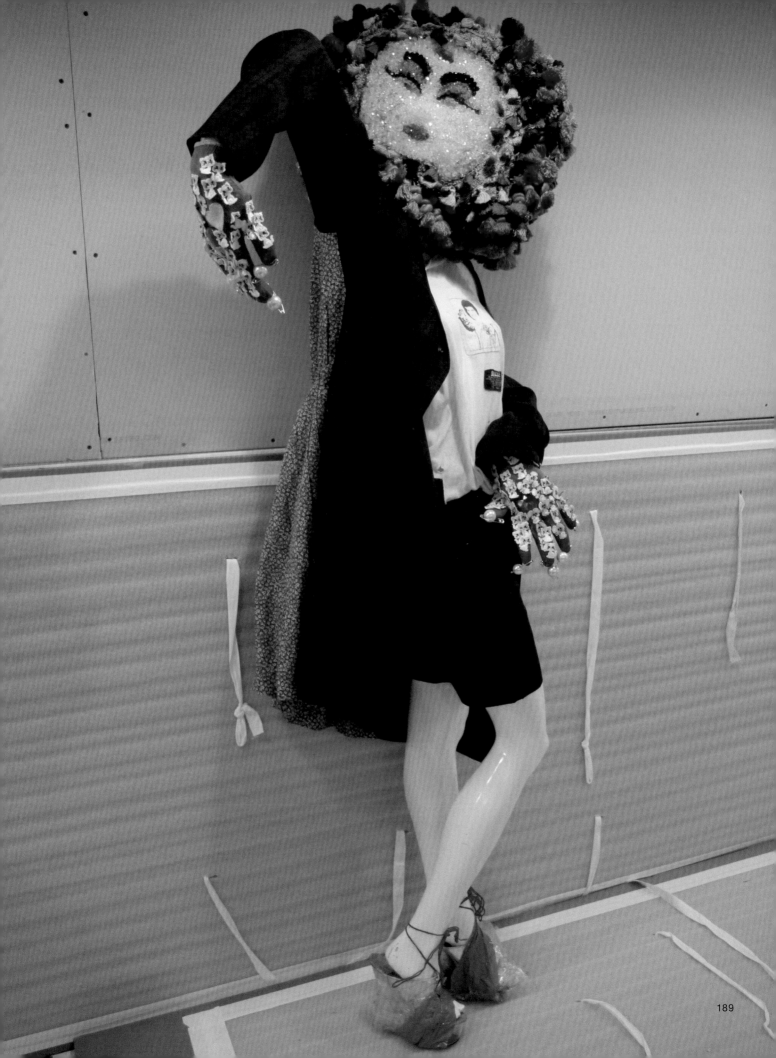

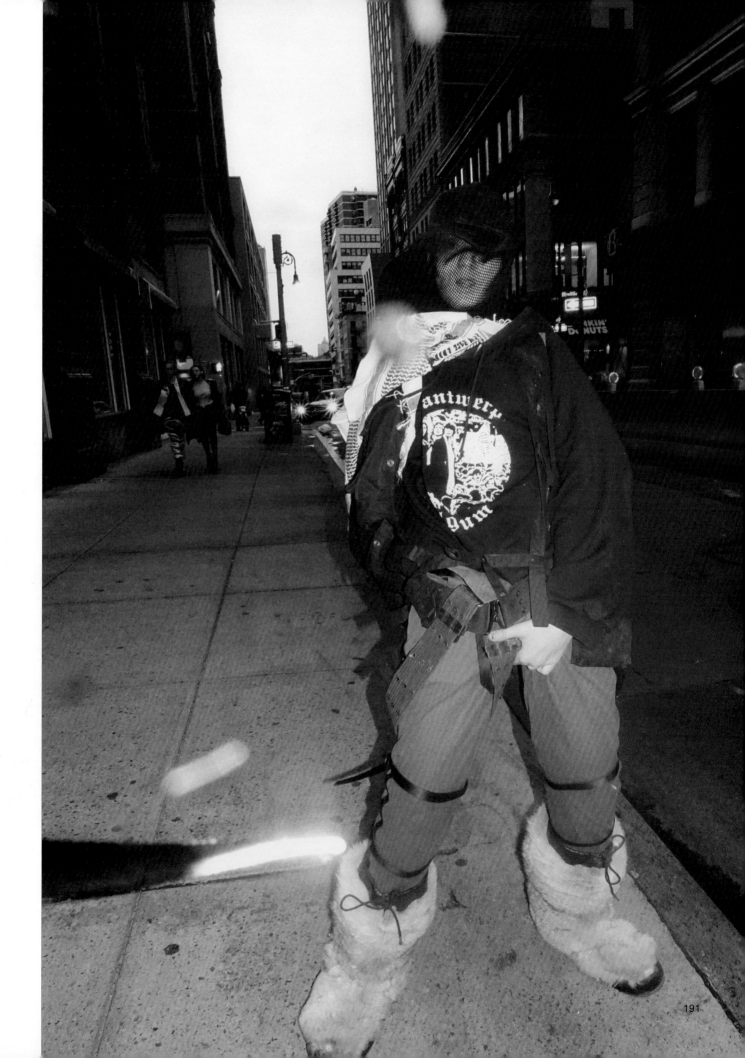

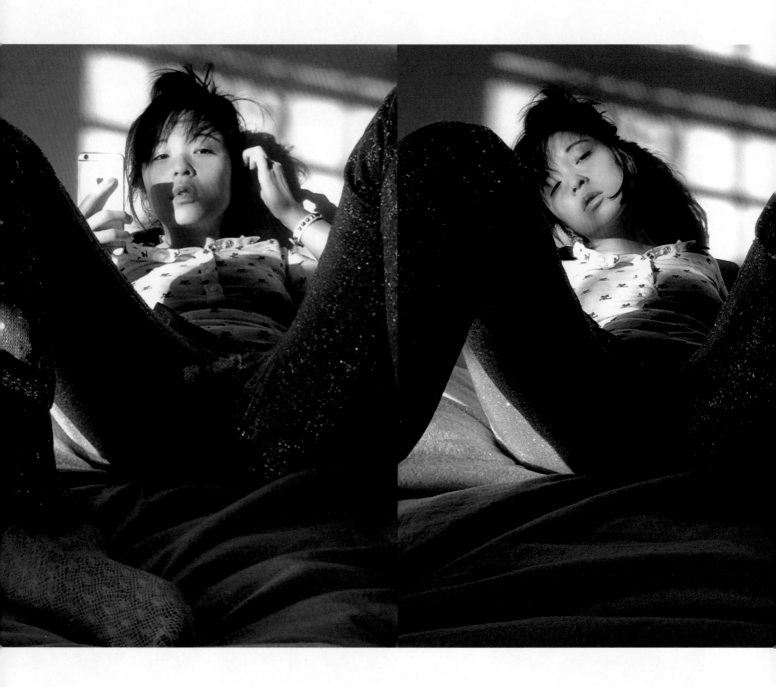

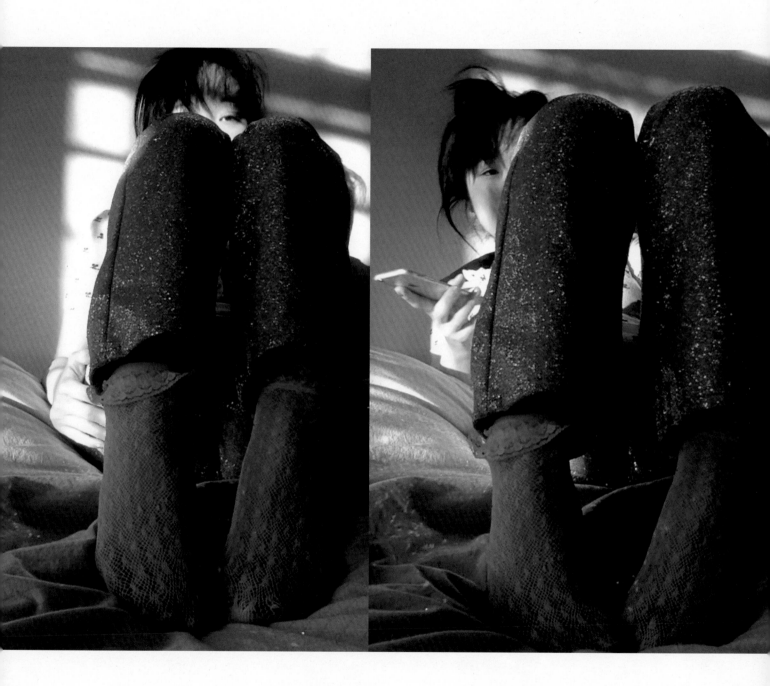

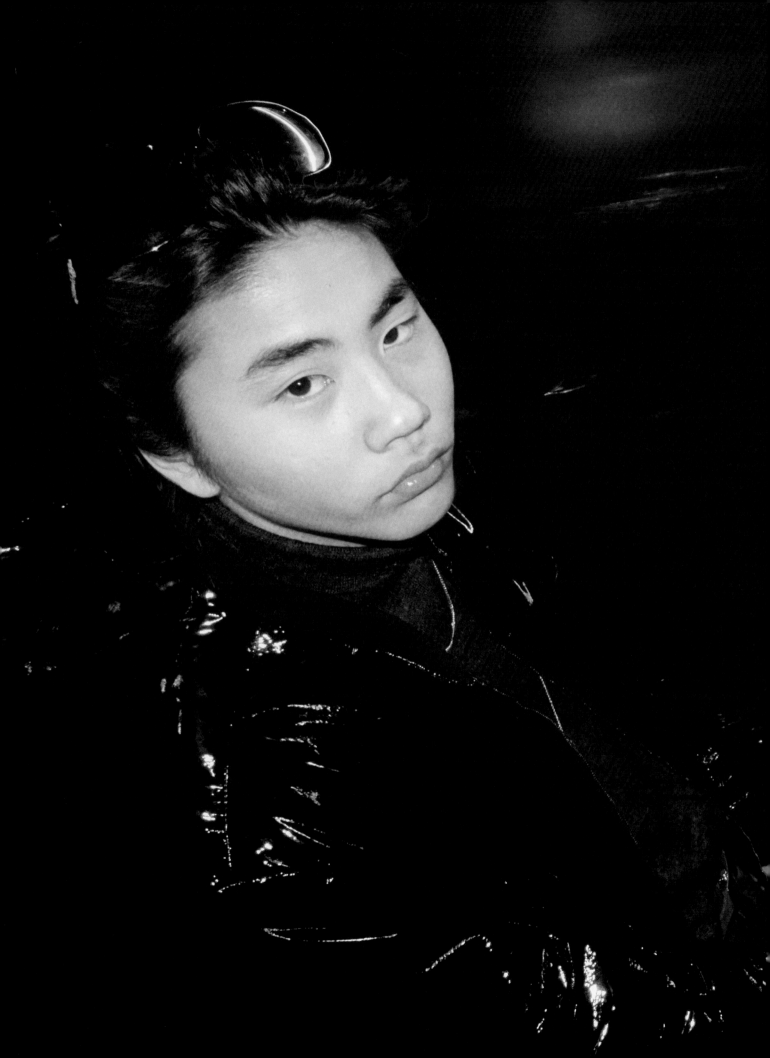

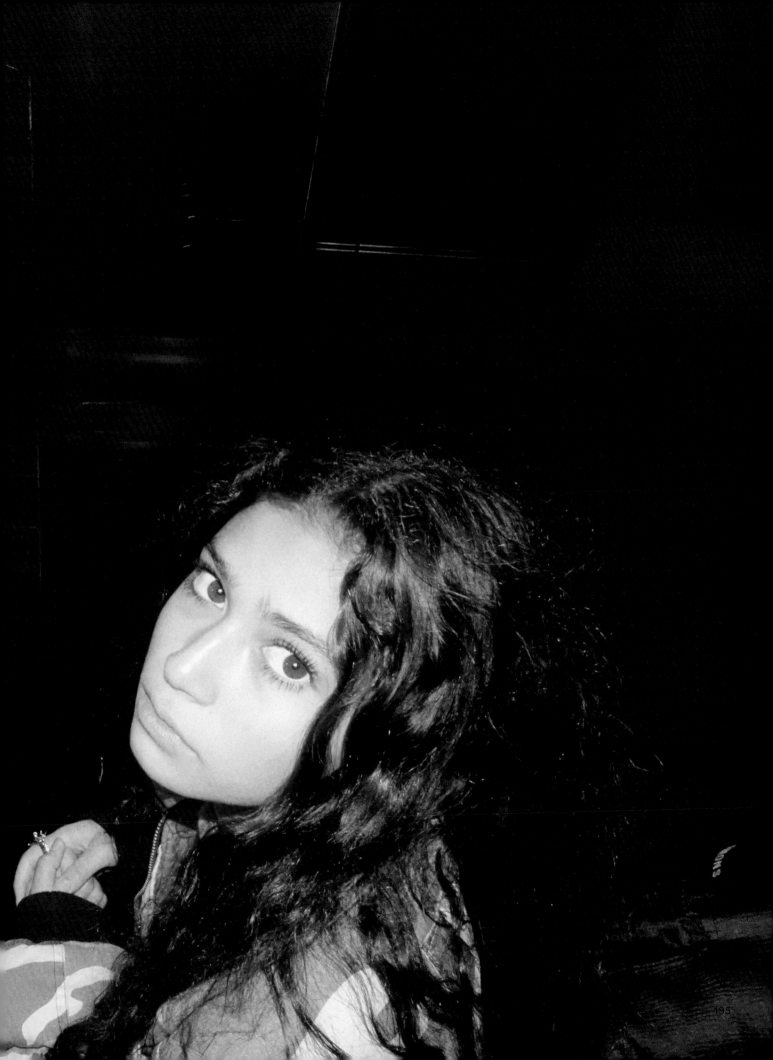

the candid
photographer
who captured
this moment
never wears
clothing.

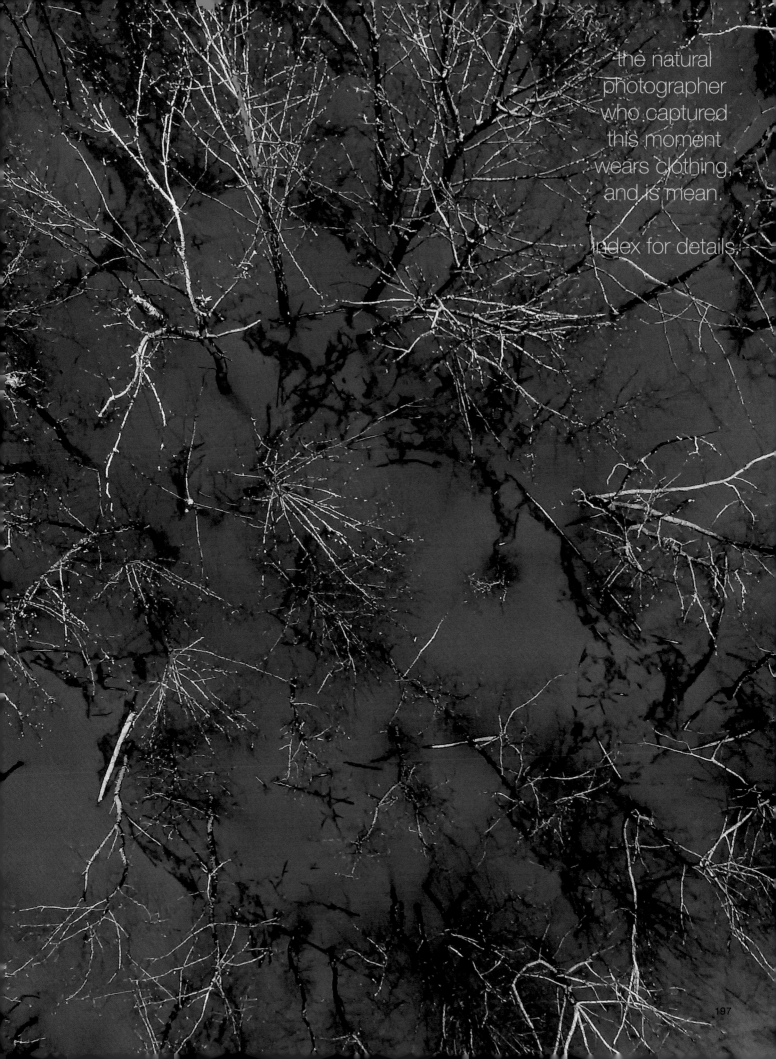

the natural
photographer
who captured
this moment
wears clothing,
and is mean.

index for details.

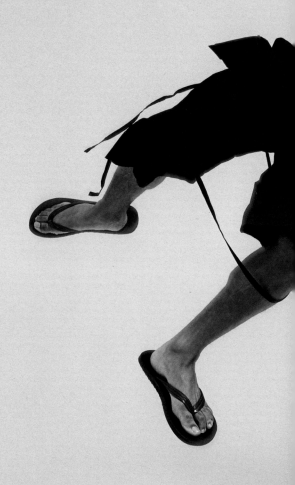

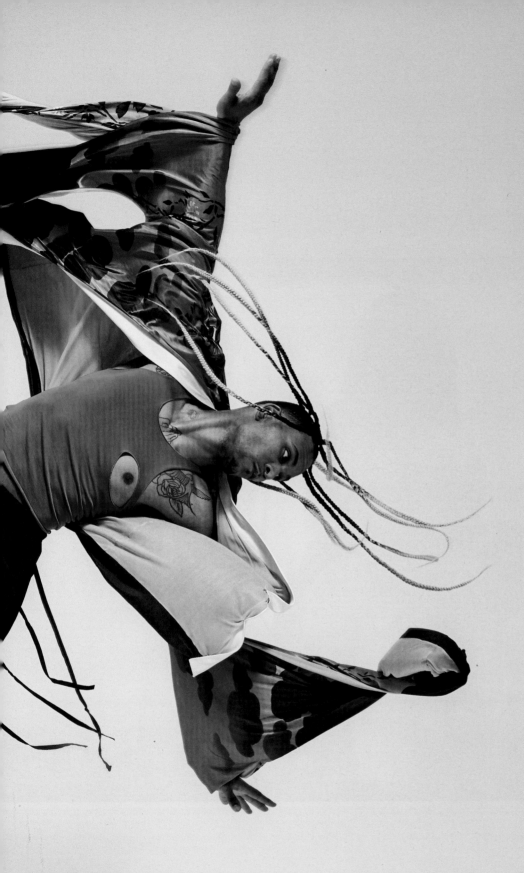

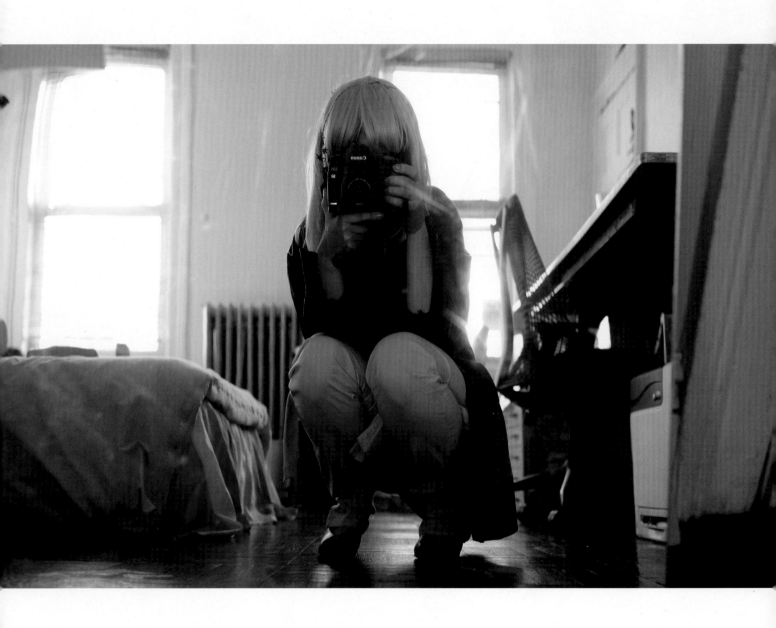

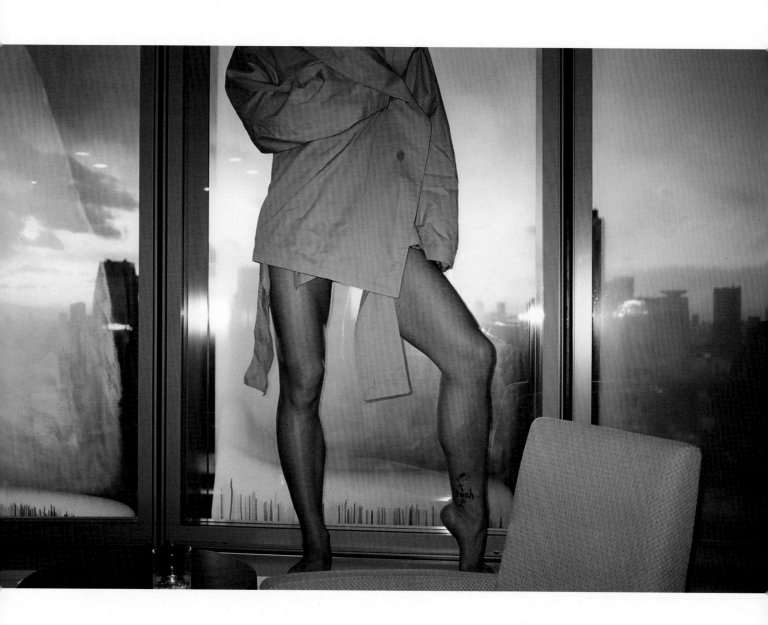

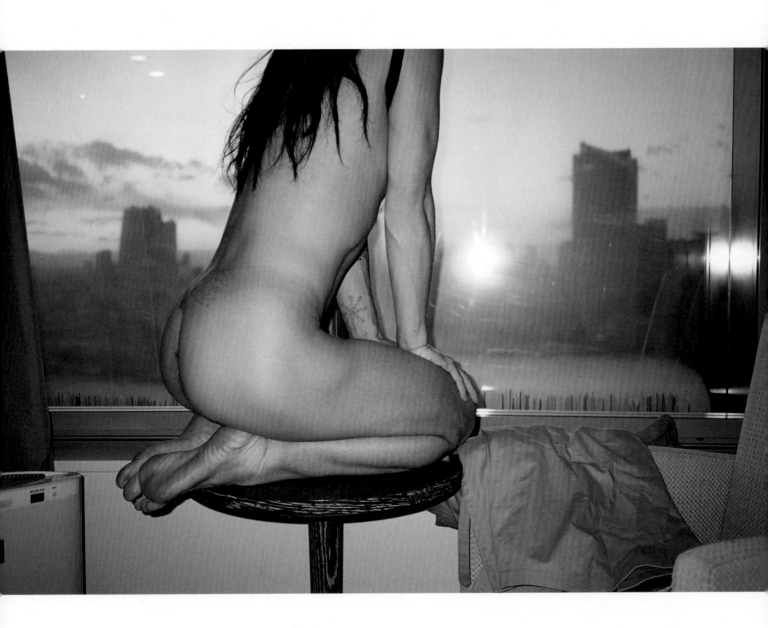

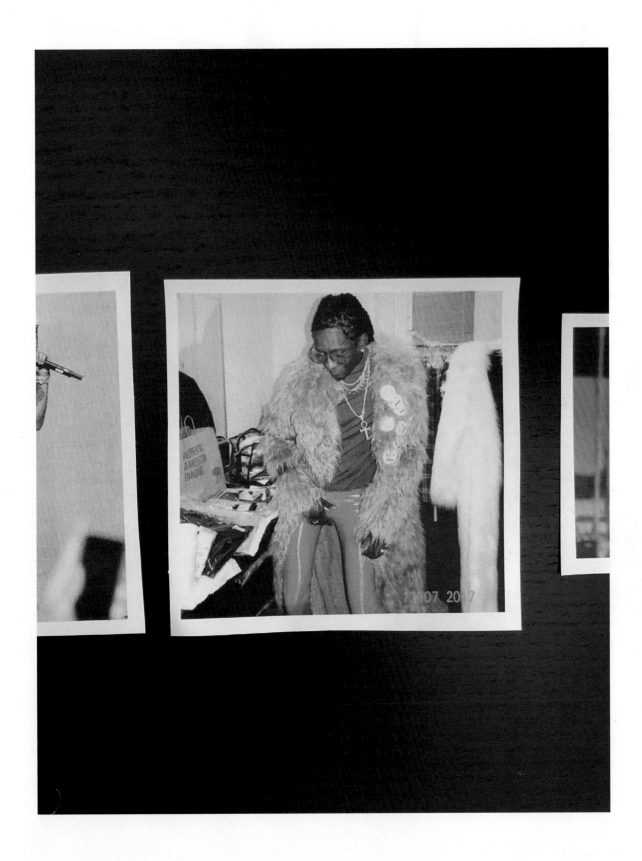

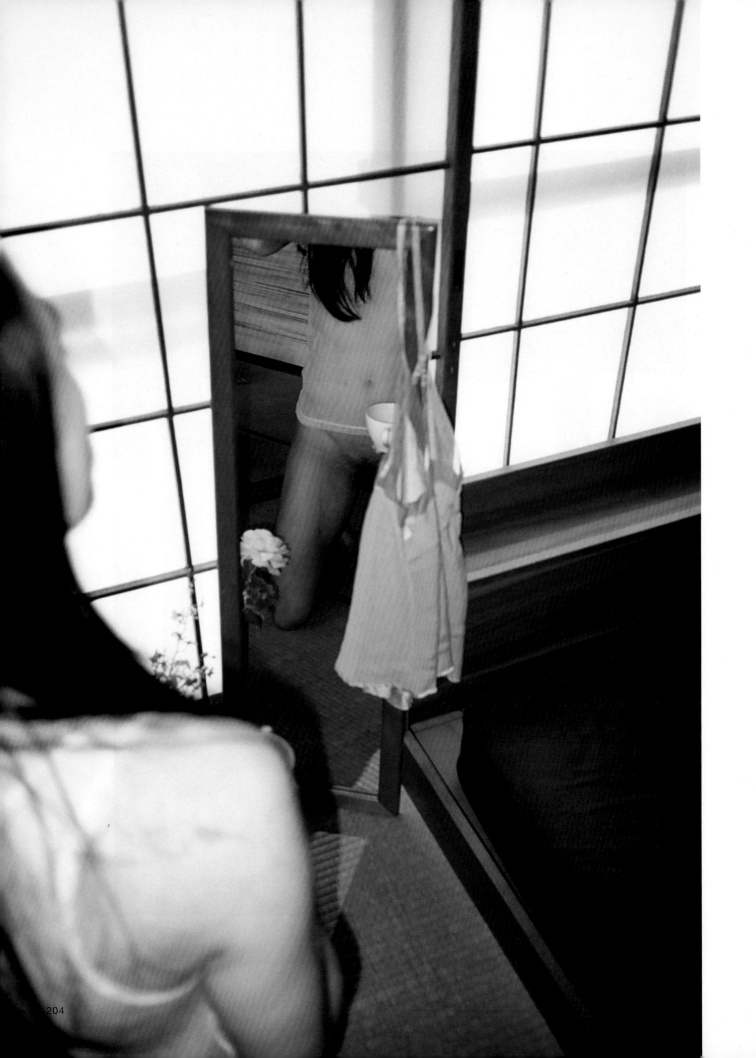

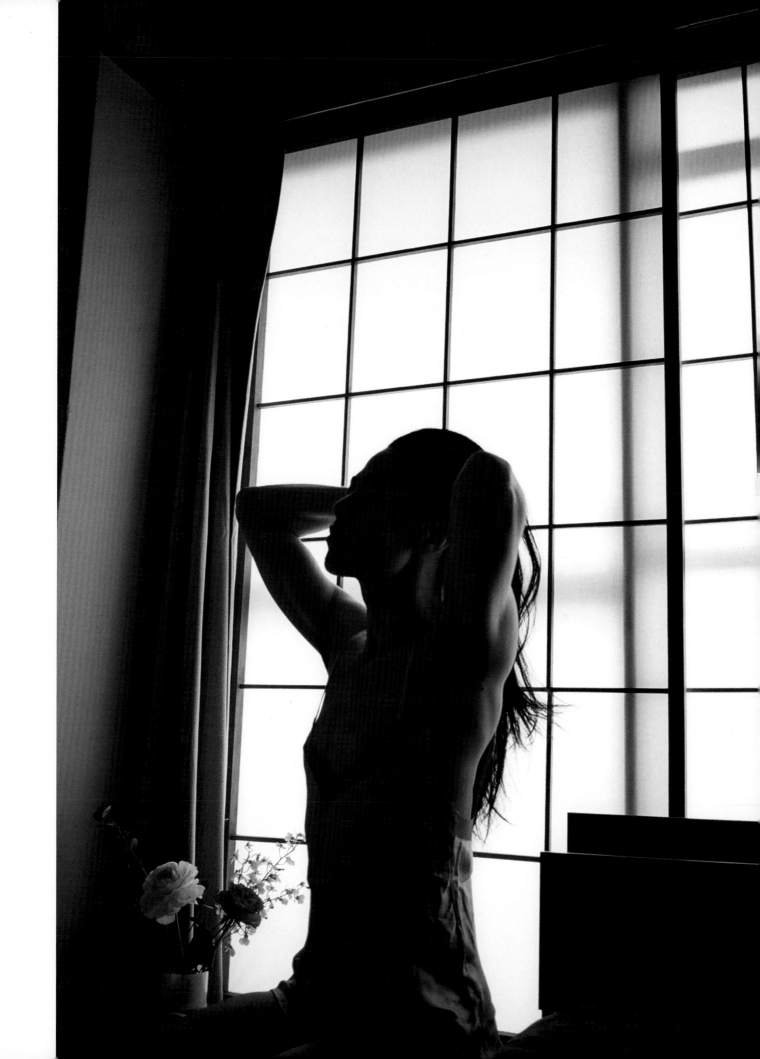

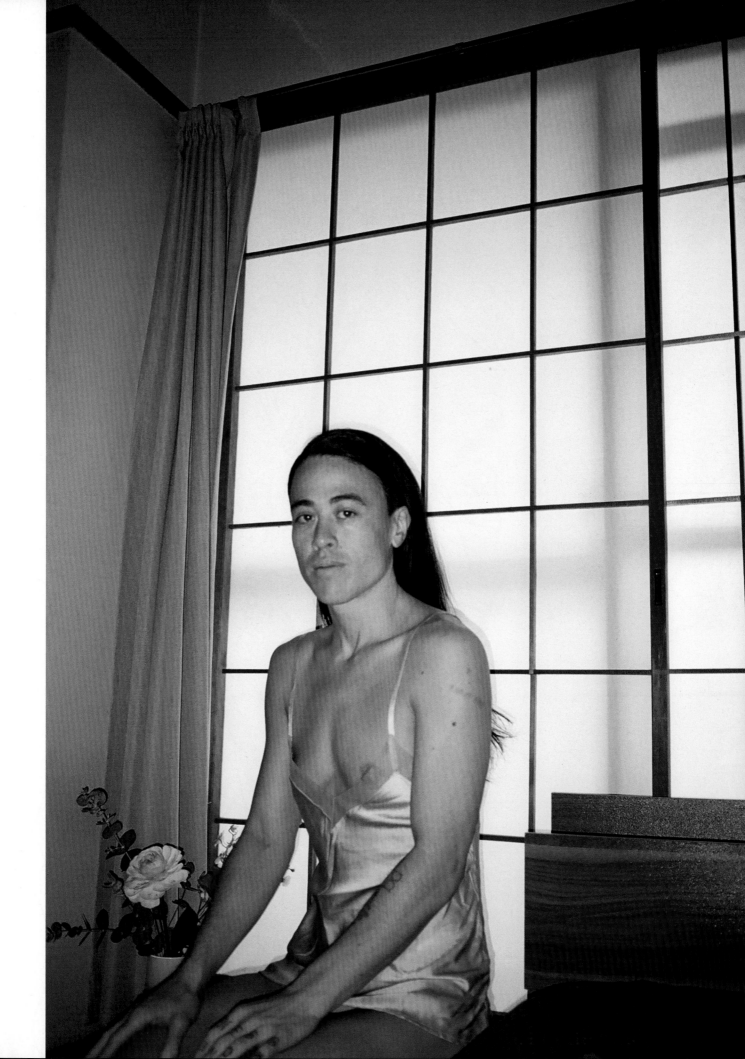

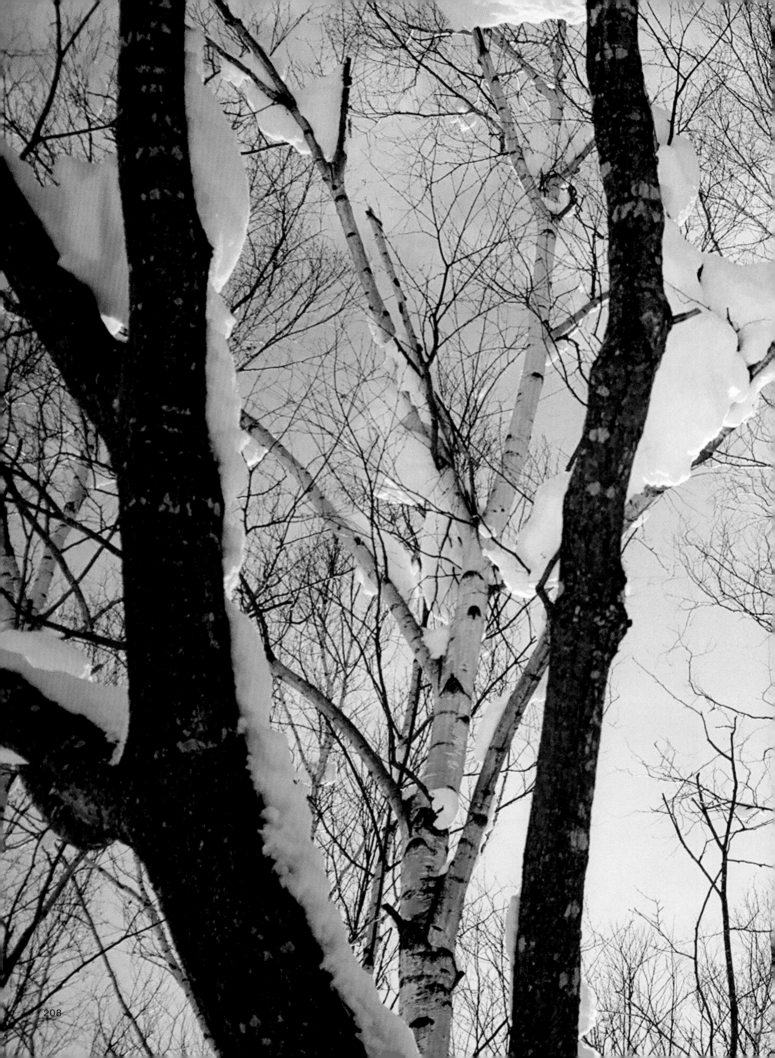

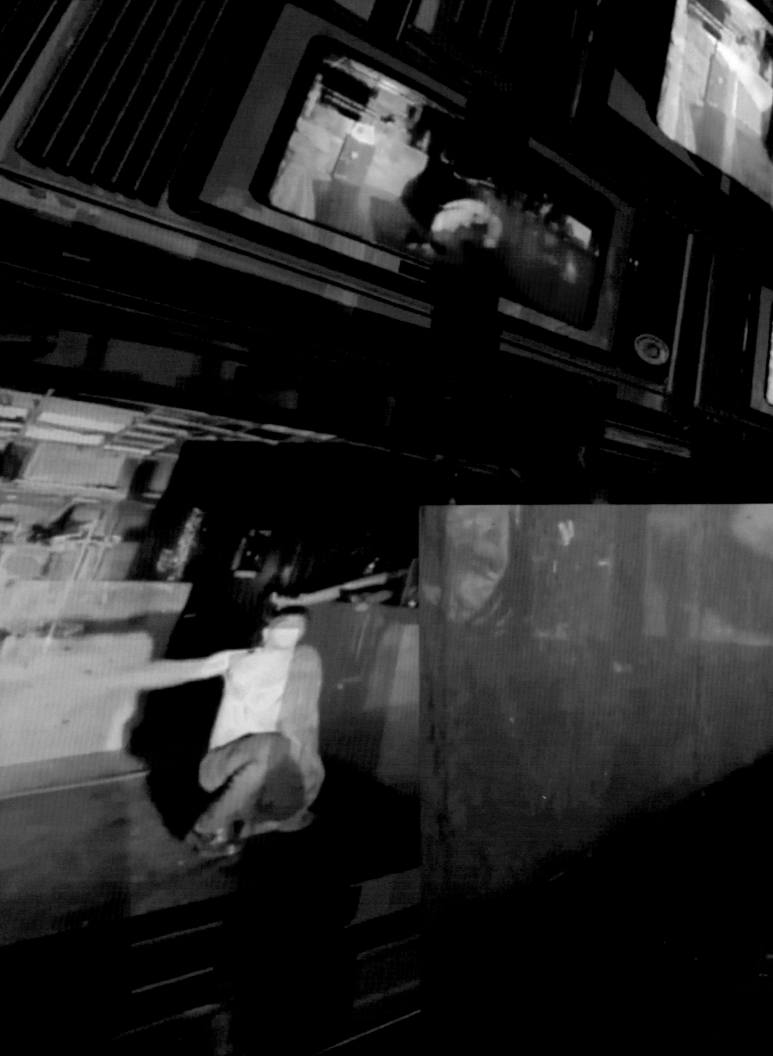

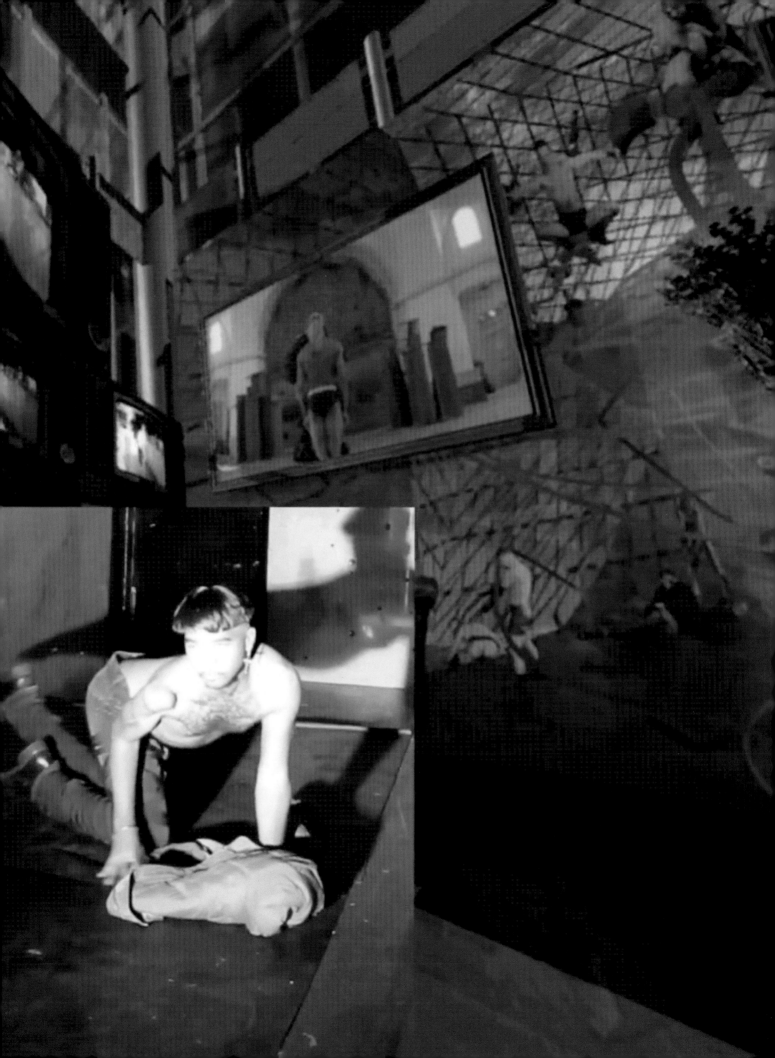

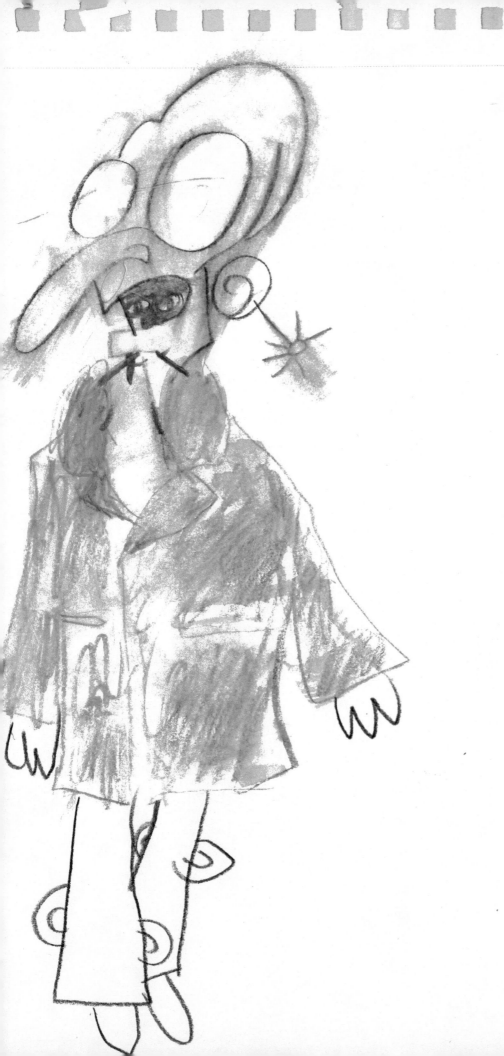

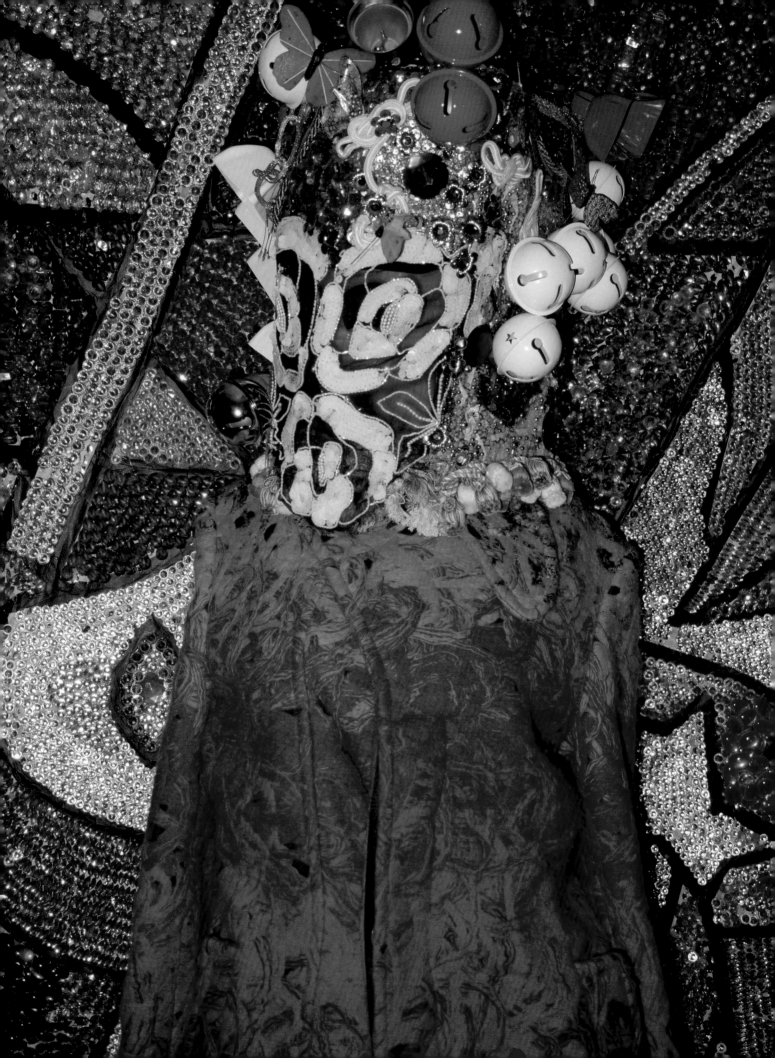

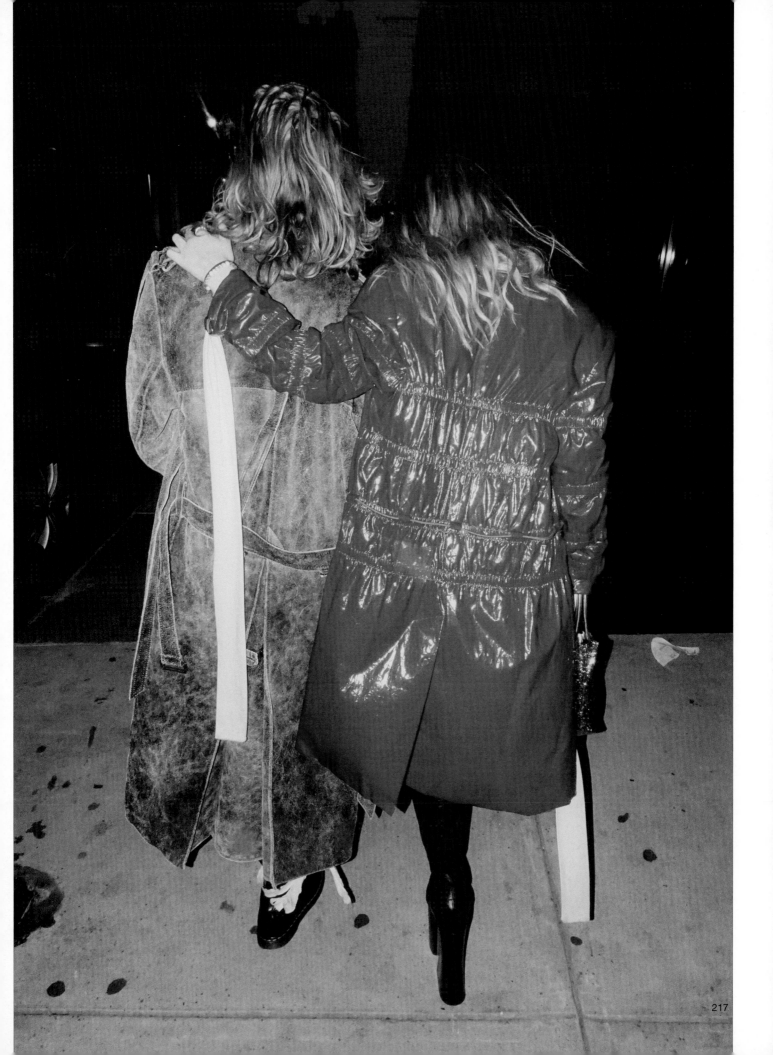

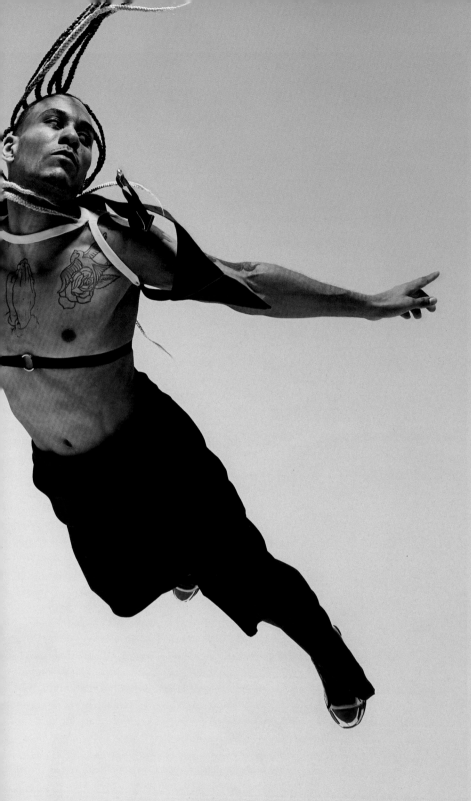

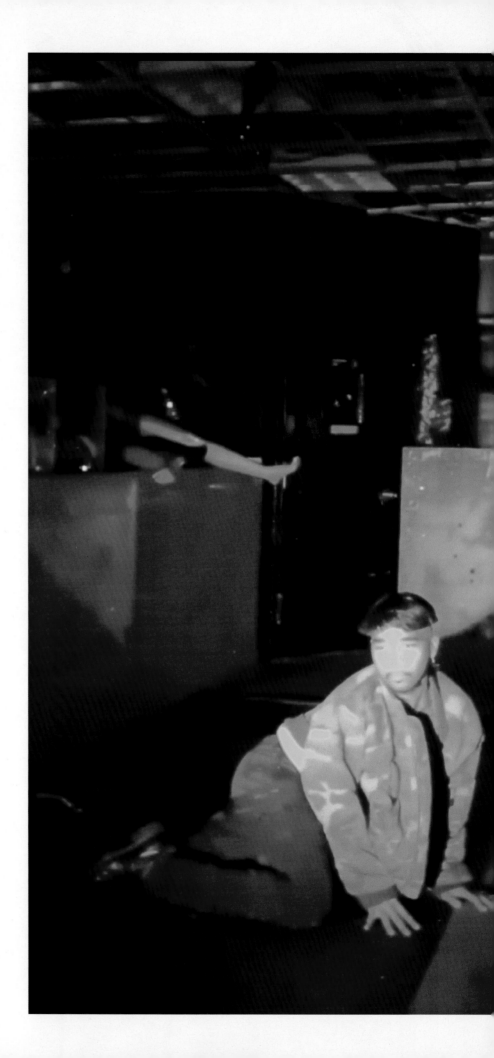

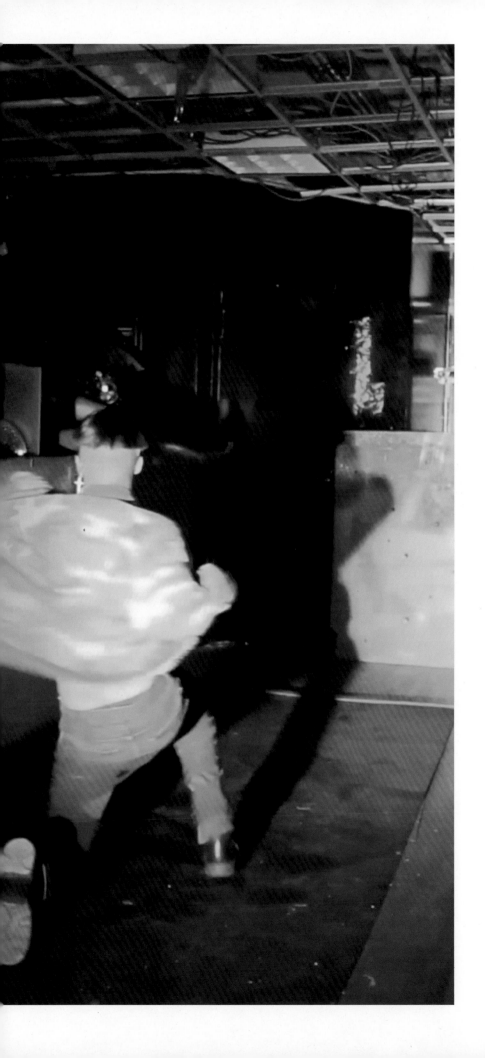

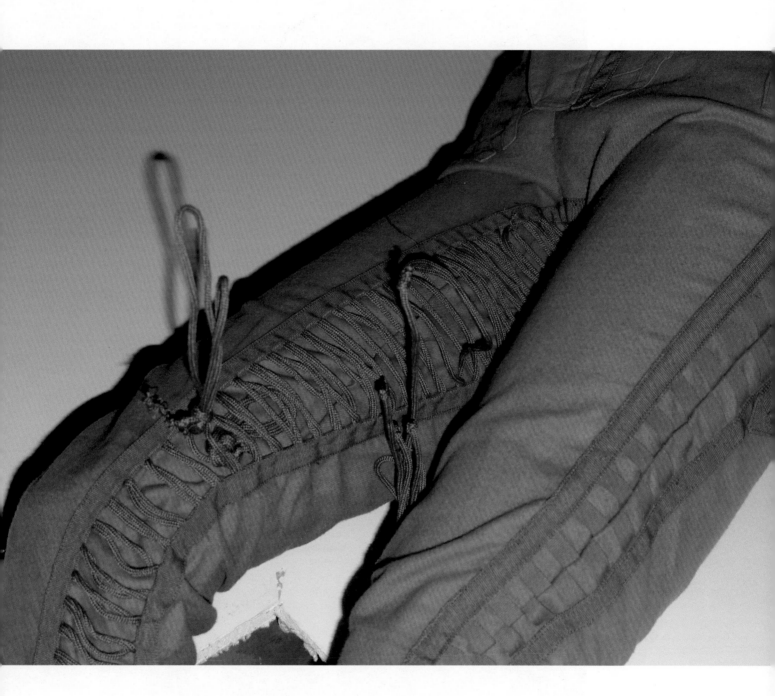

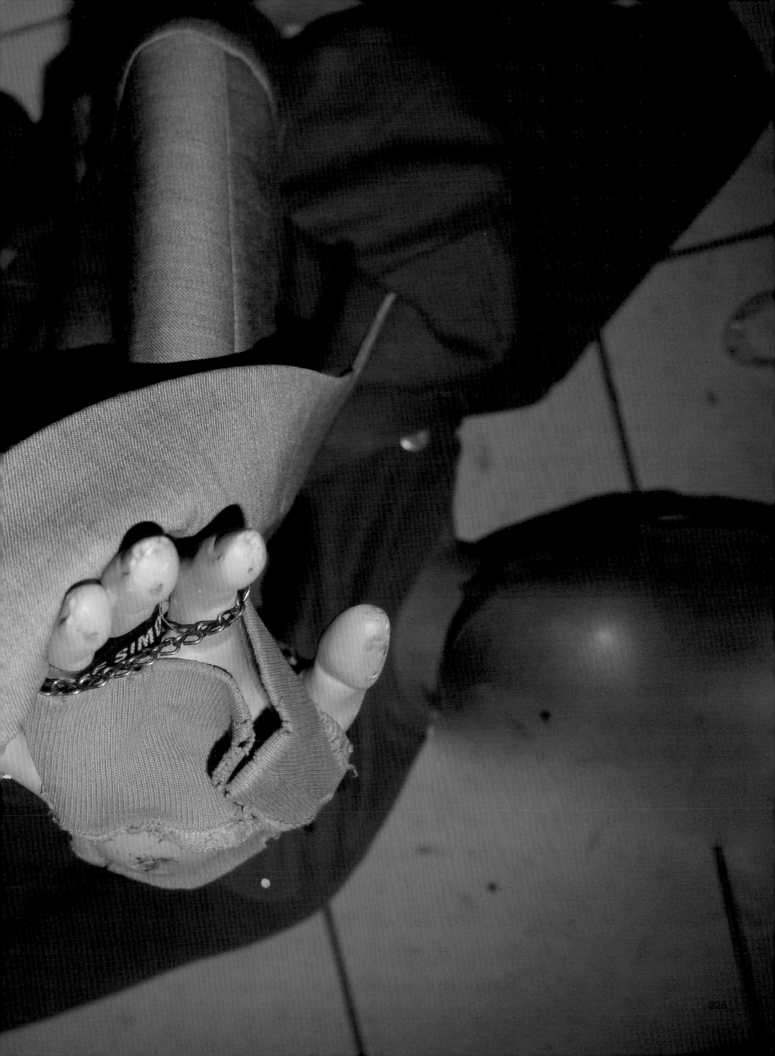

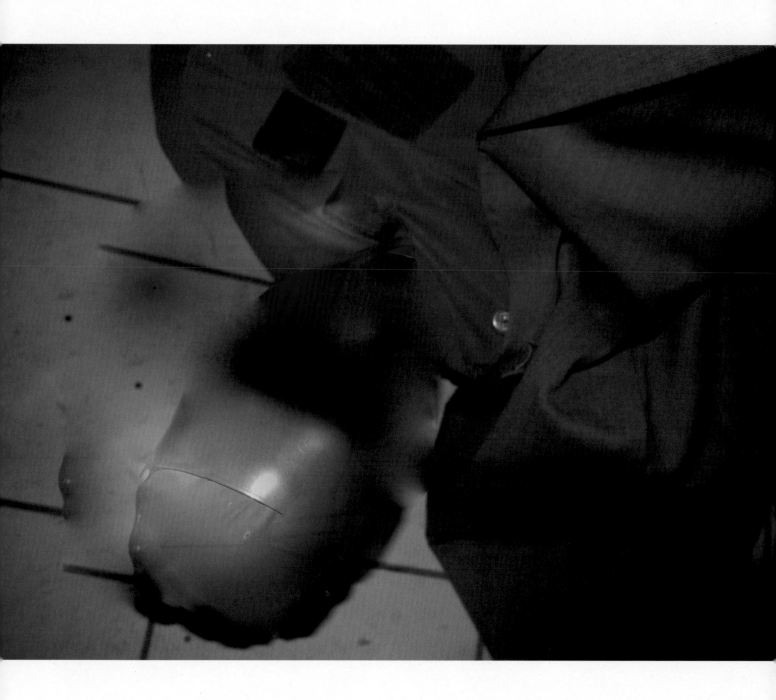

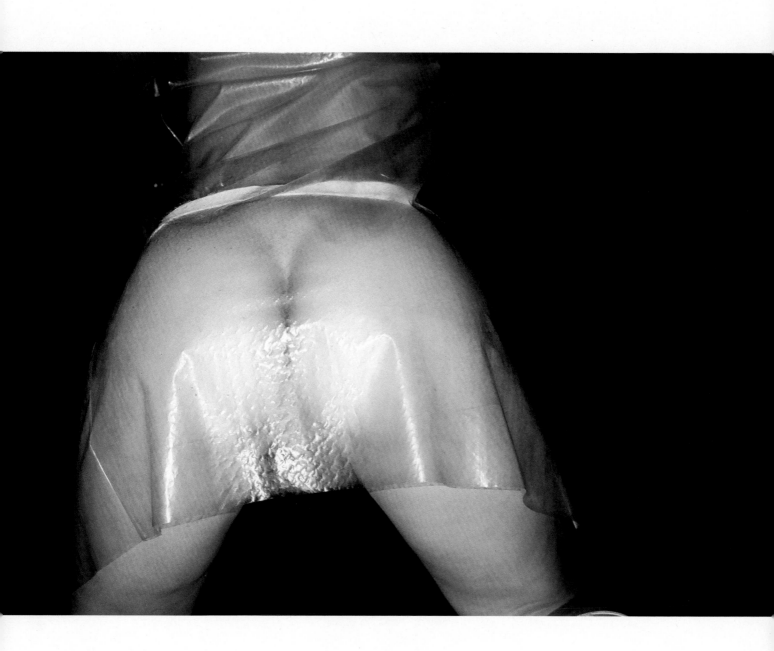

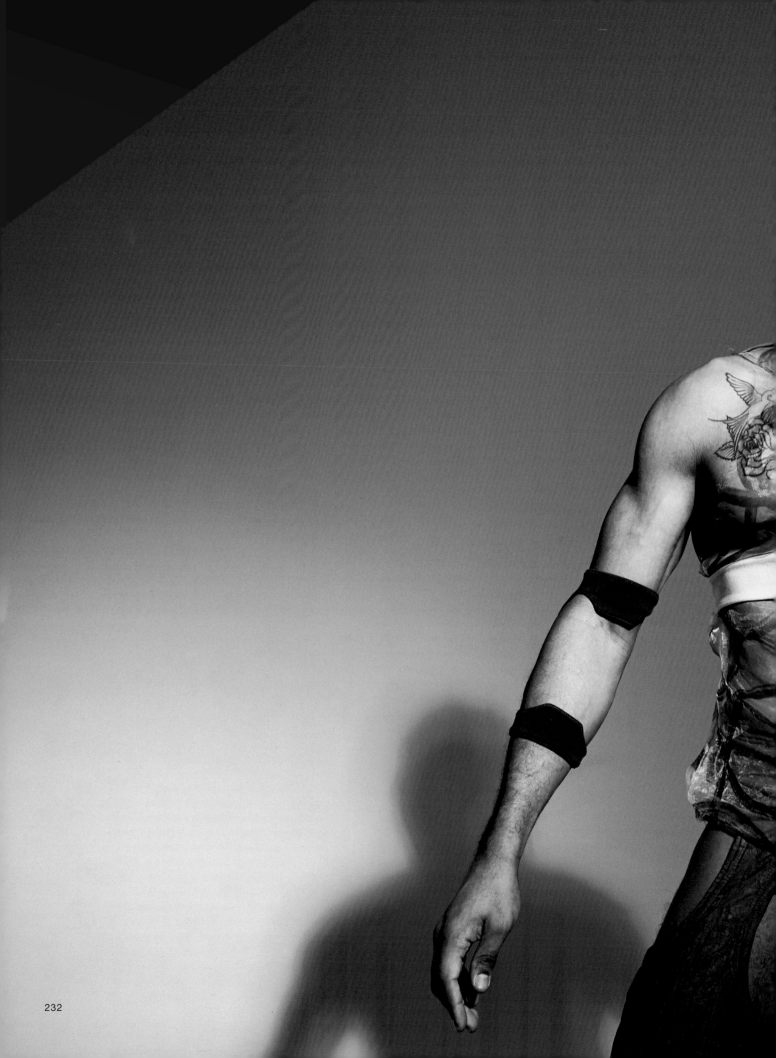

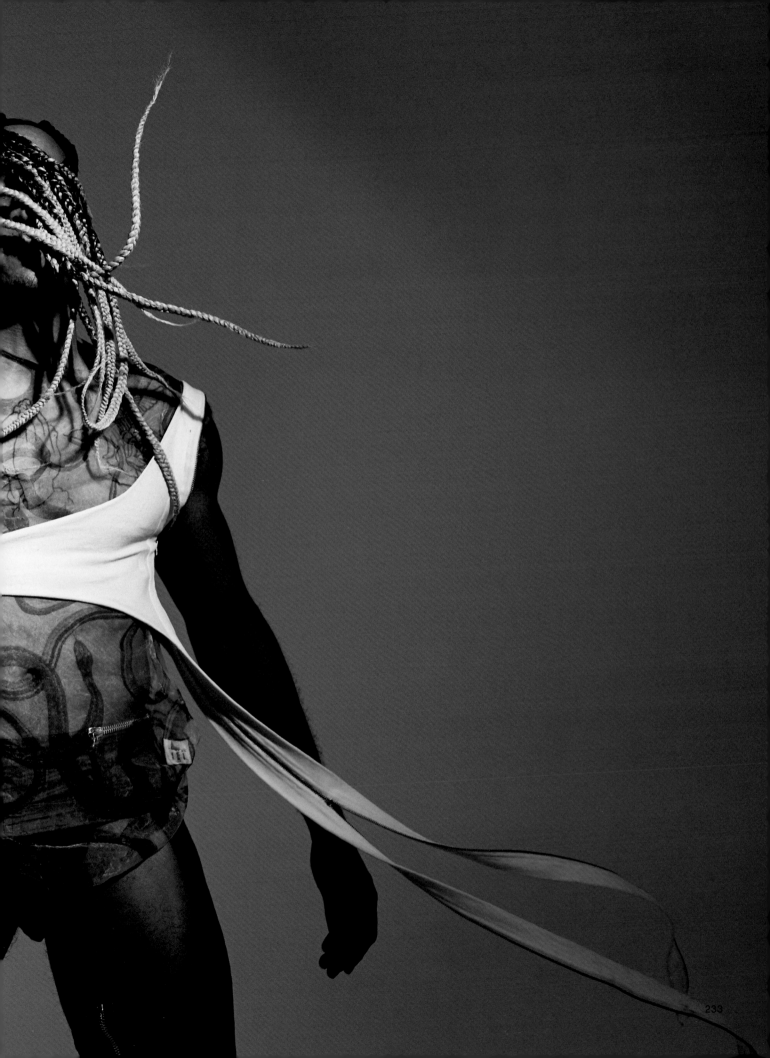

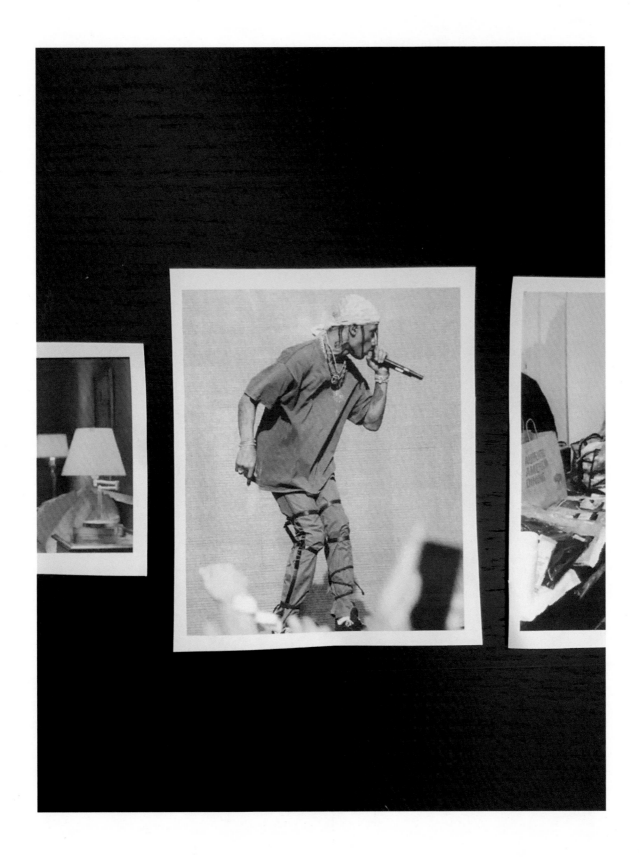

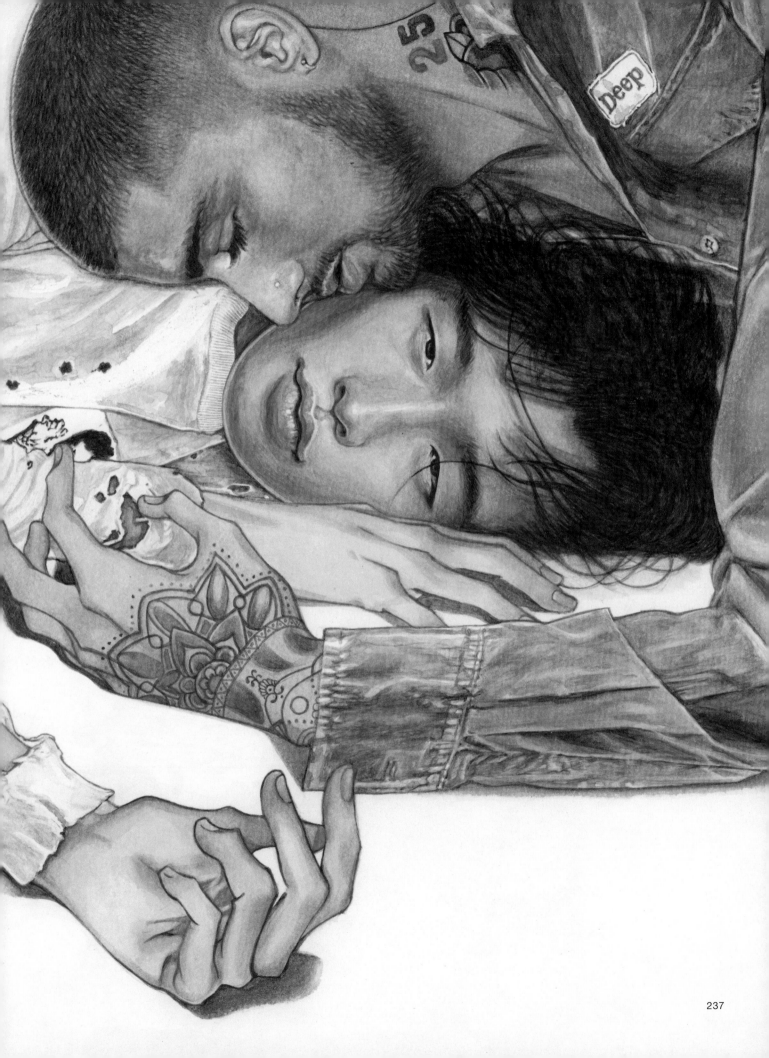

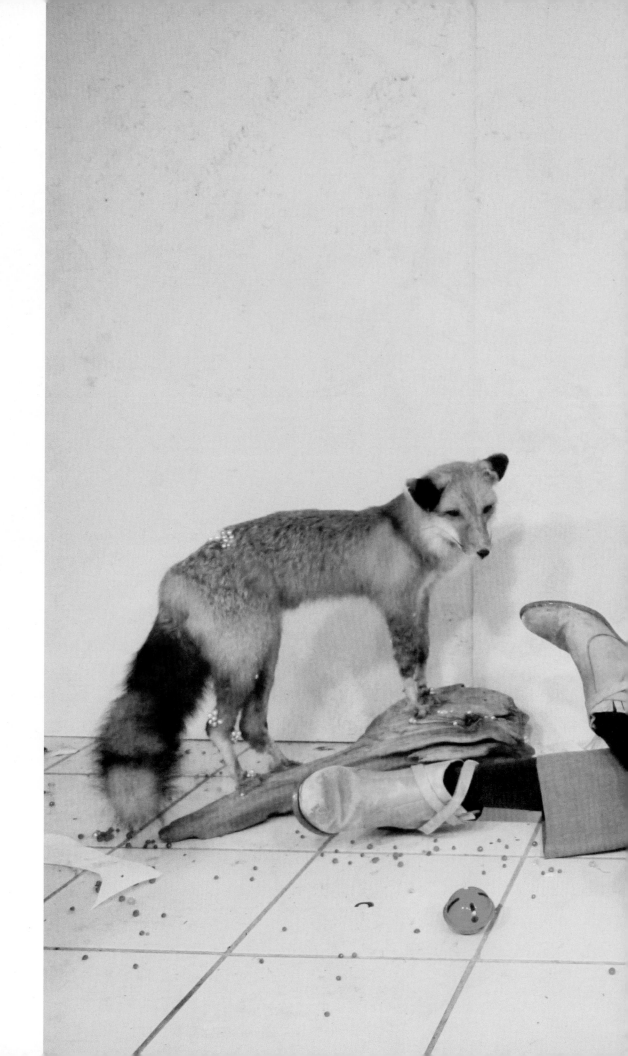

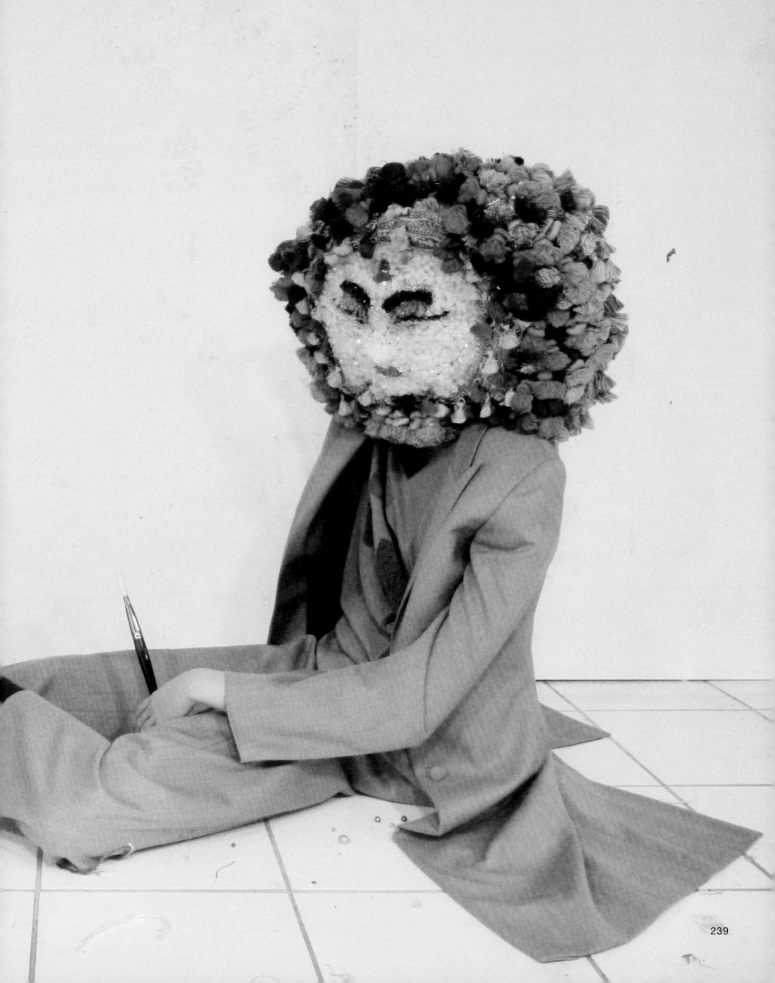

tumblr_o87ds9wzm11raqlx0o1_500.png

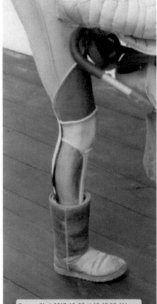
Screen Shot 2017-12-29 at 12.45.39 AM.png

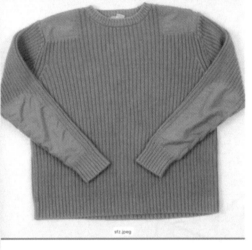
sfz.jpeg

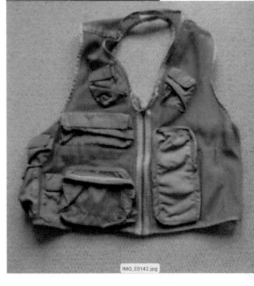
IMG_E9142.jpg

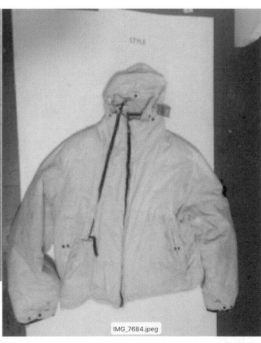
IMG_7684.jpeg

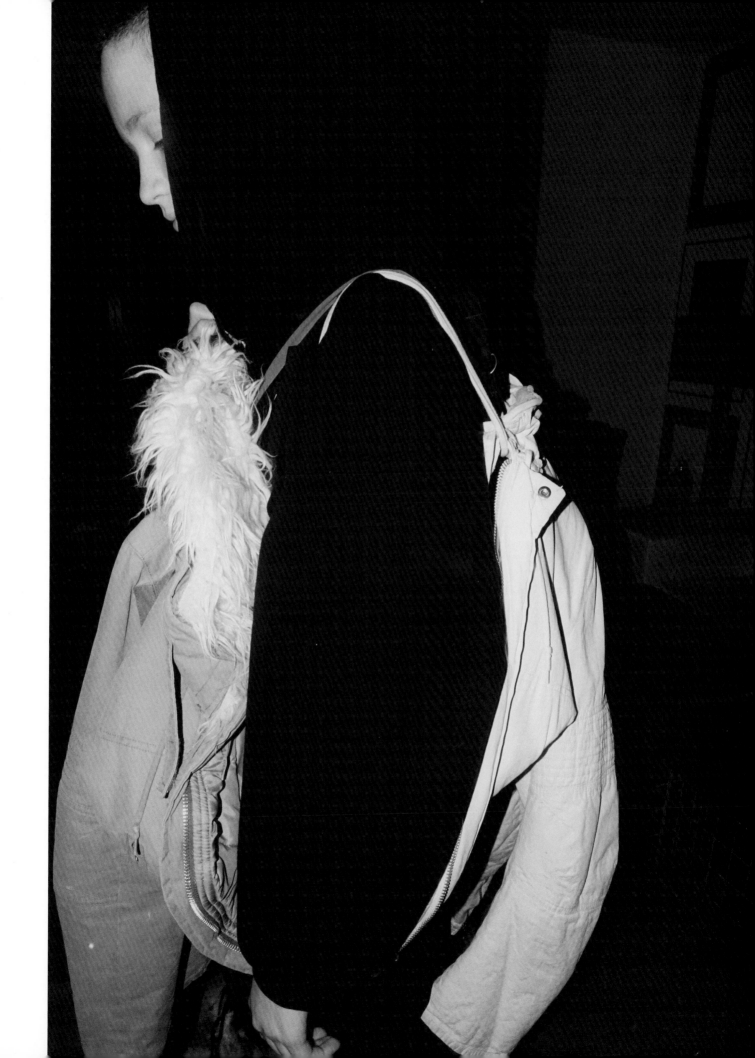

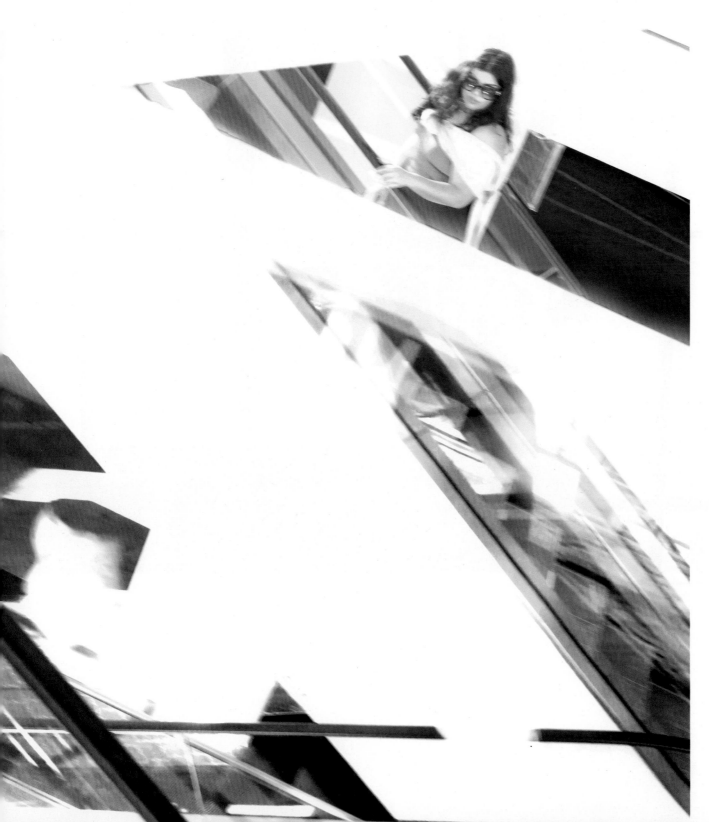

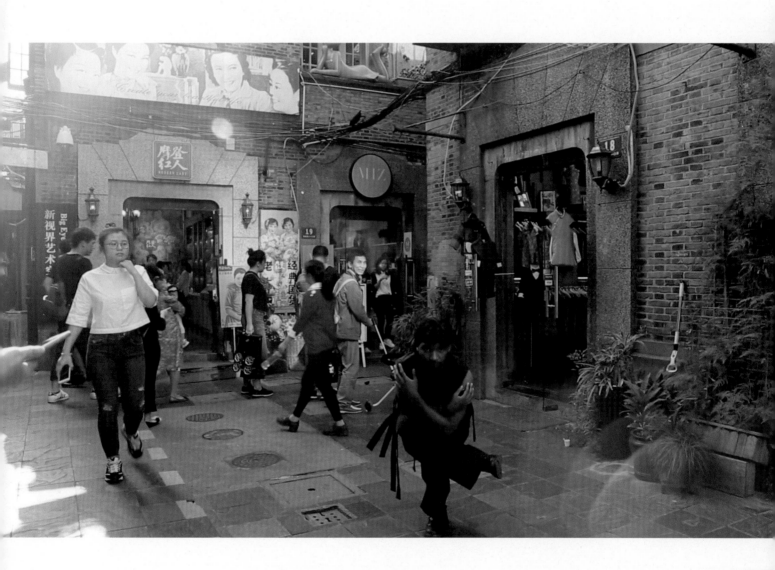

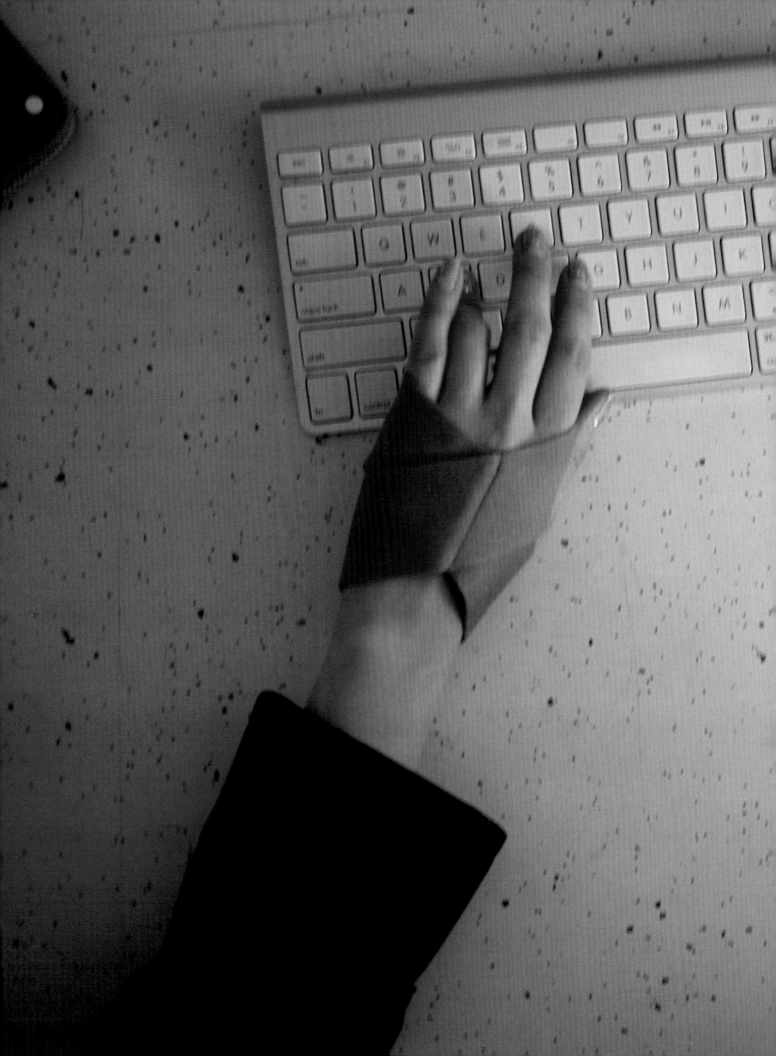

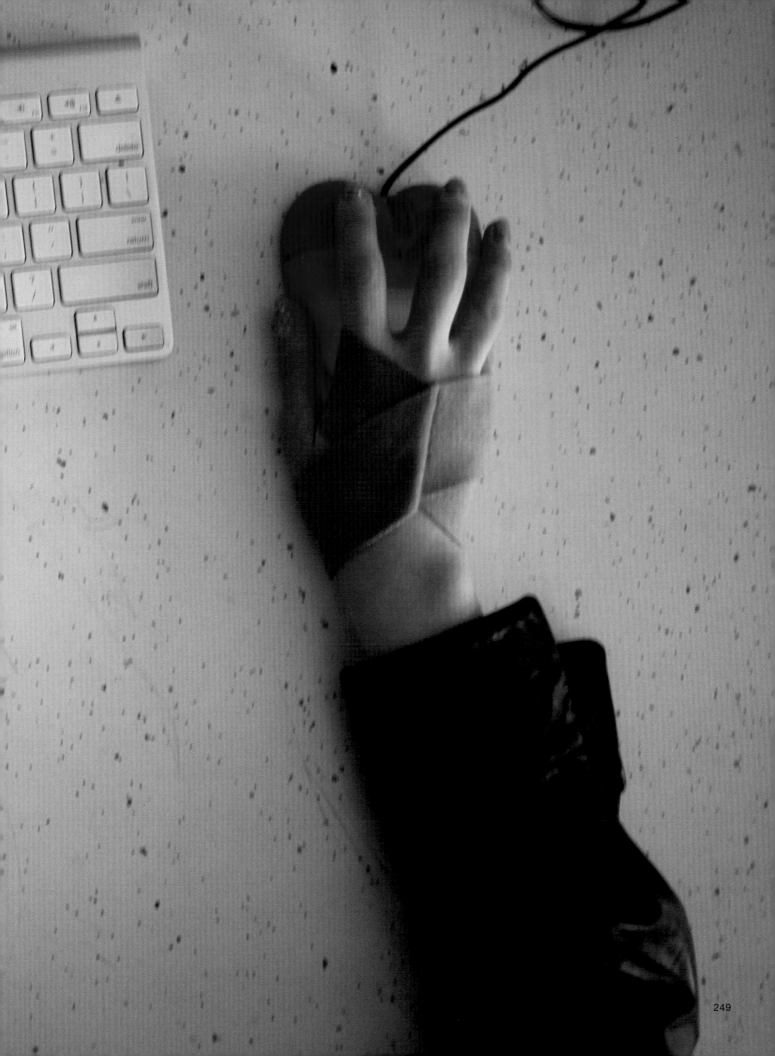

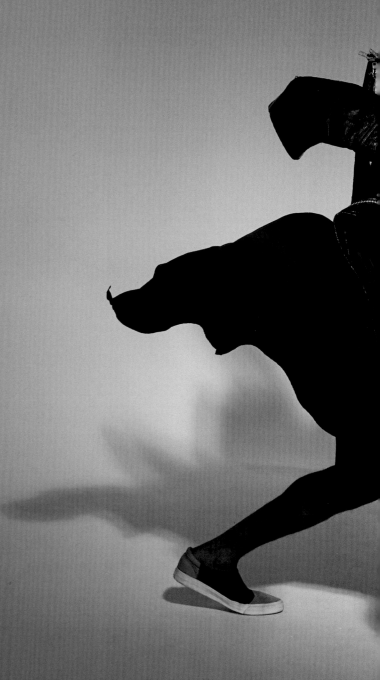

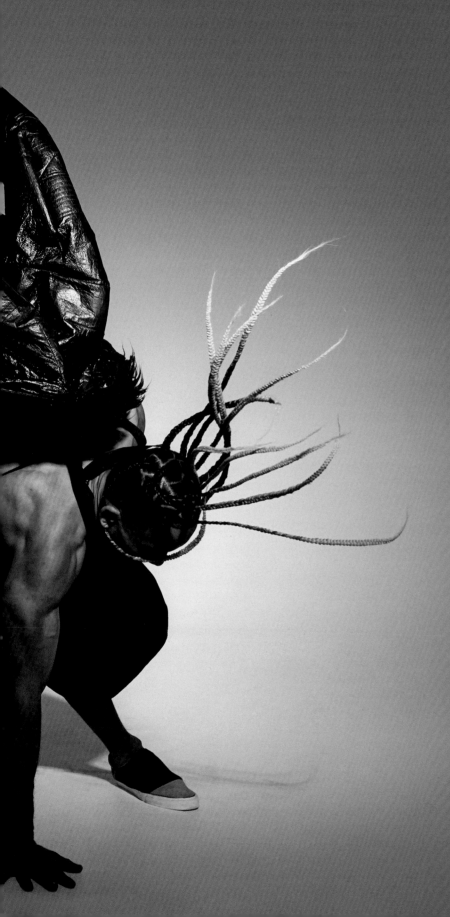

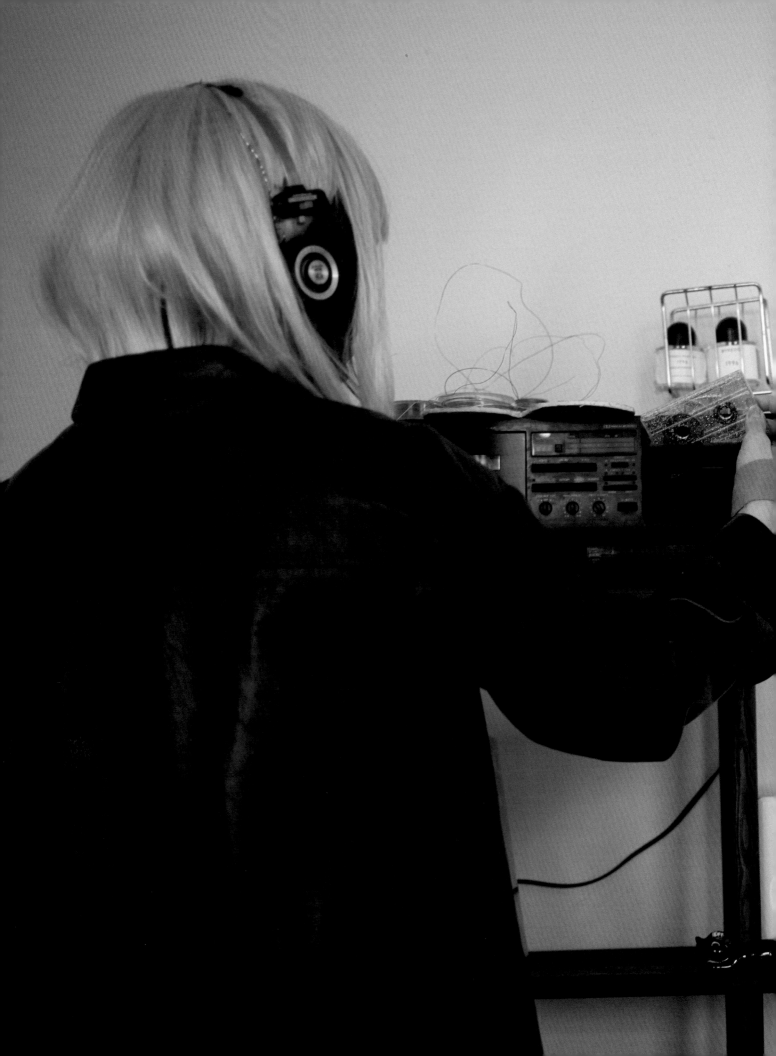

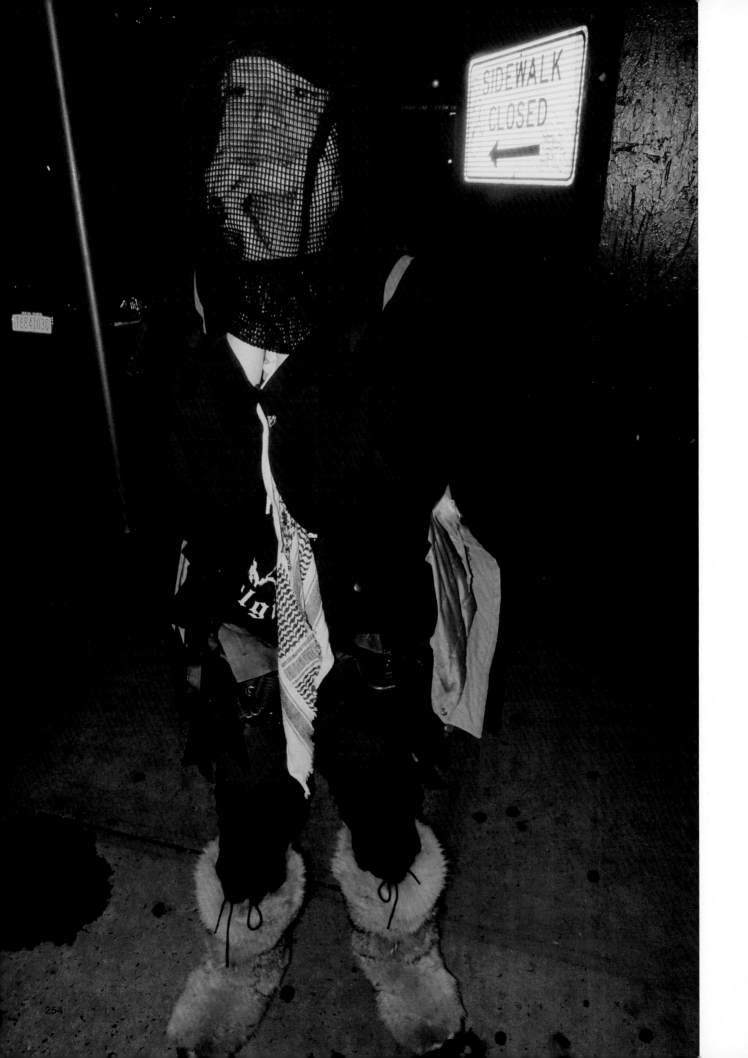

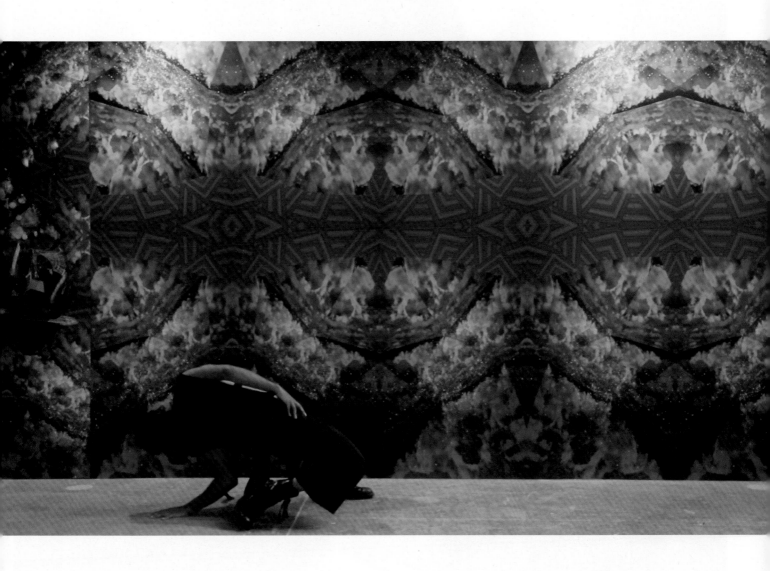

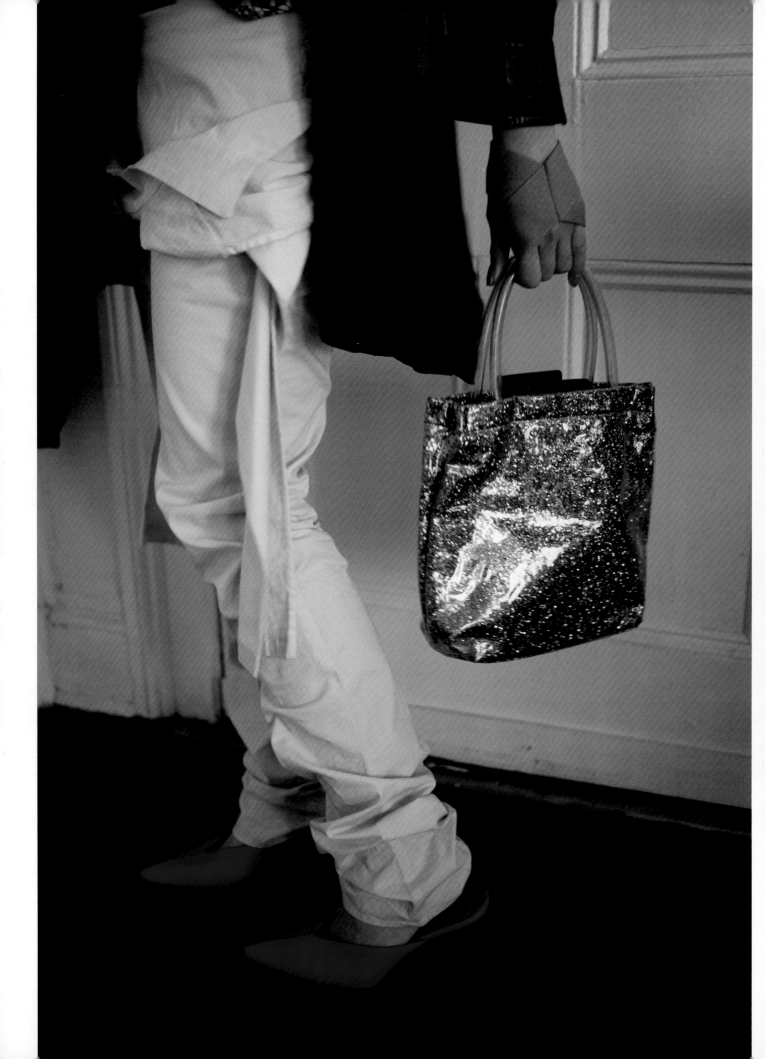

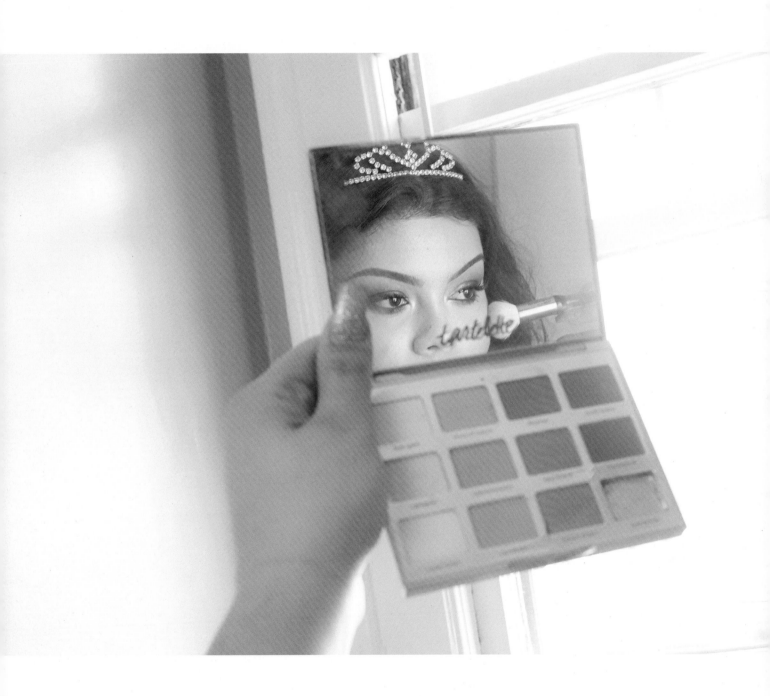

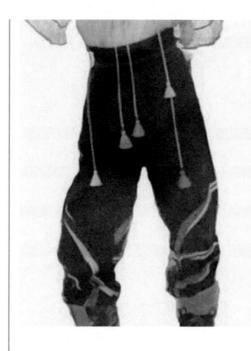

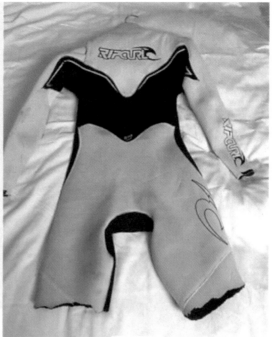

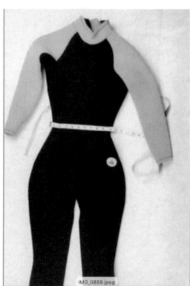

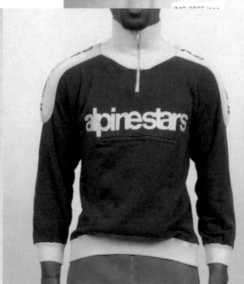

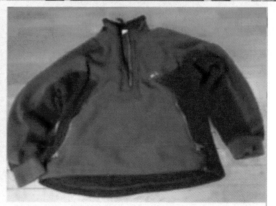

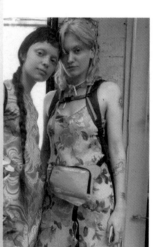

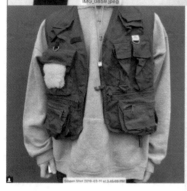

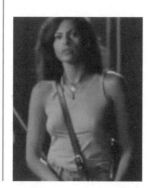

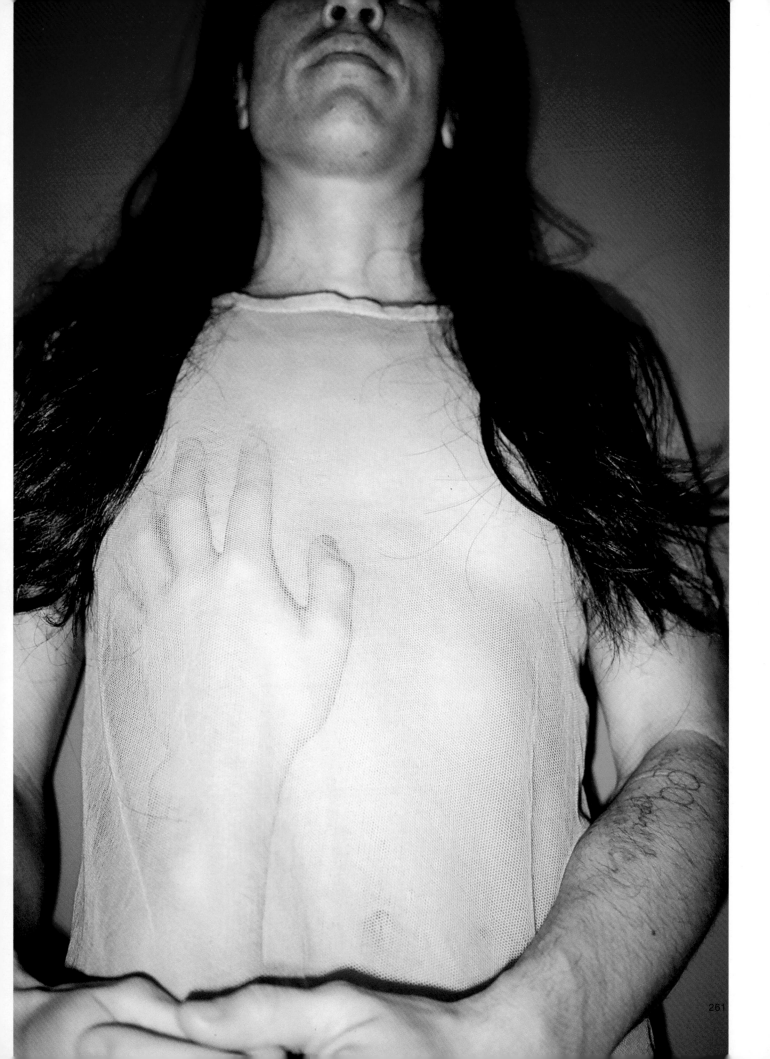

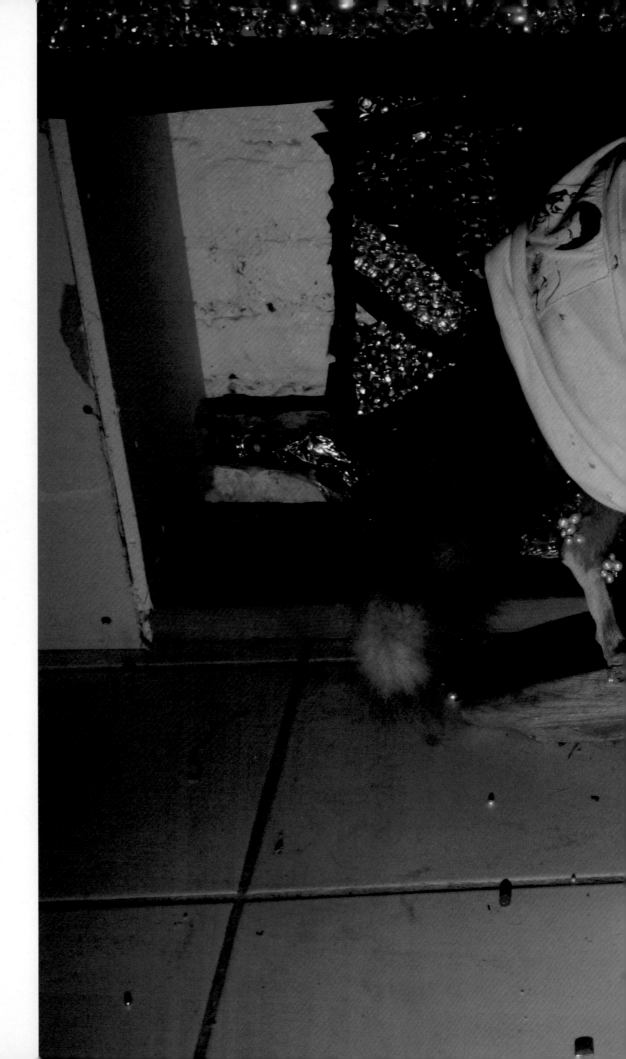

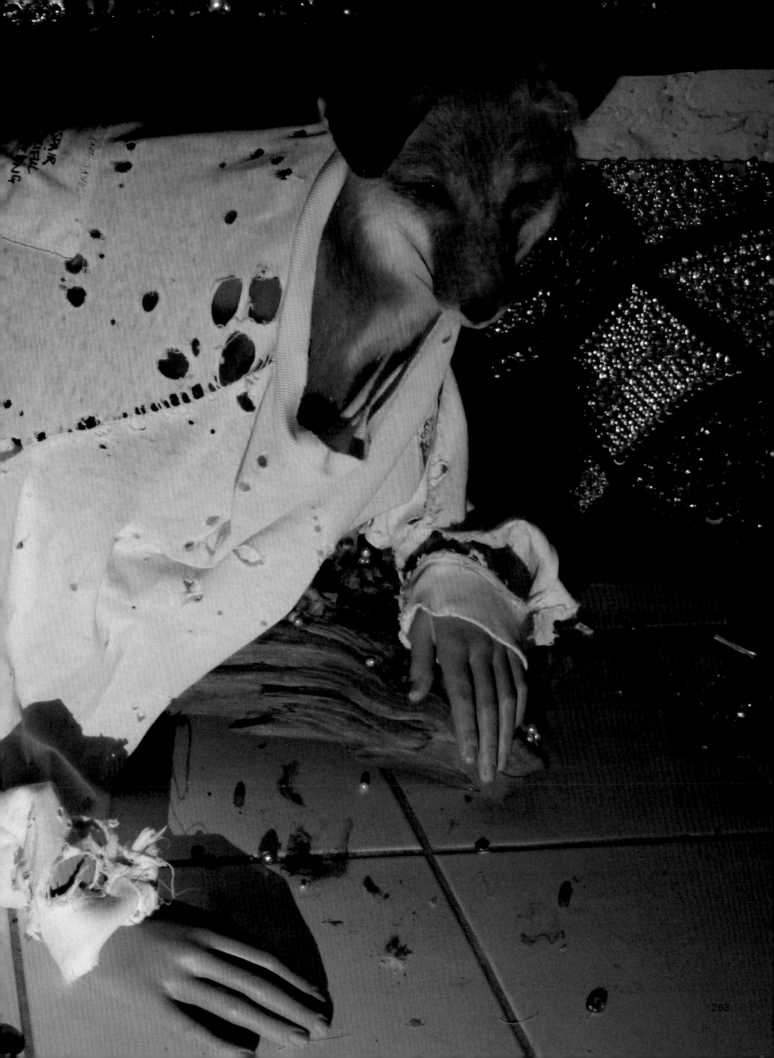

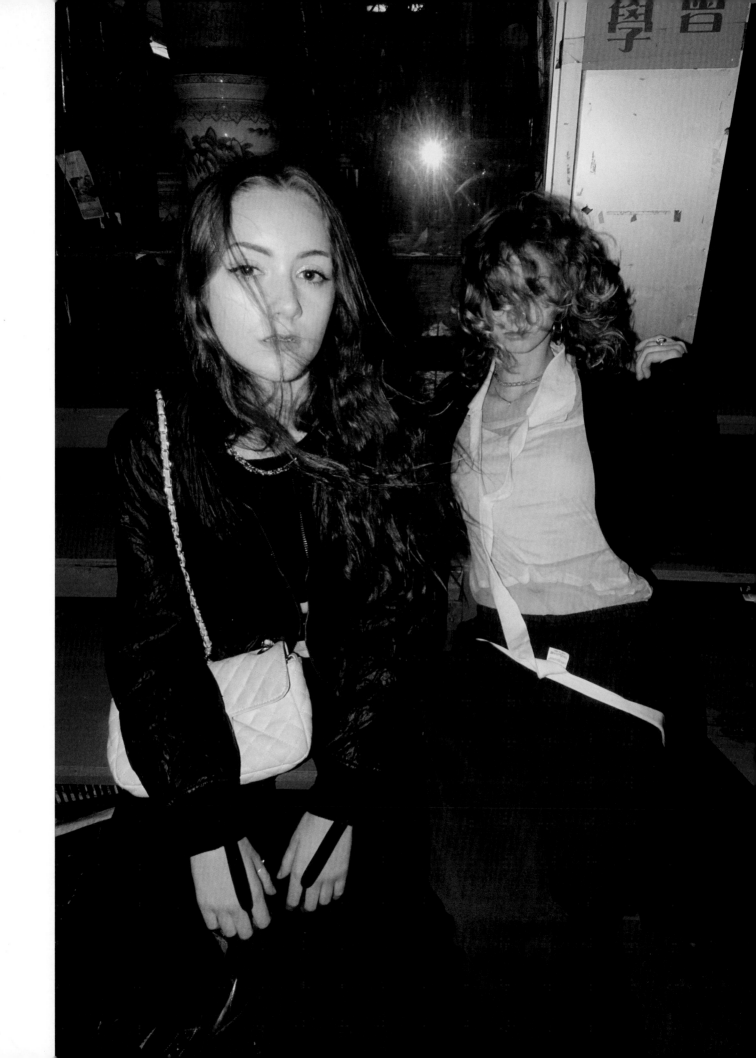

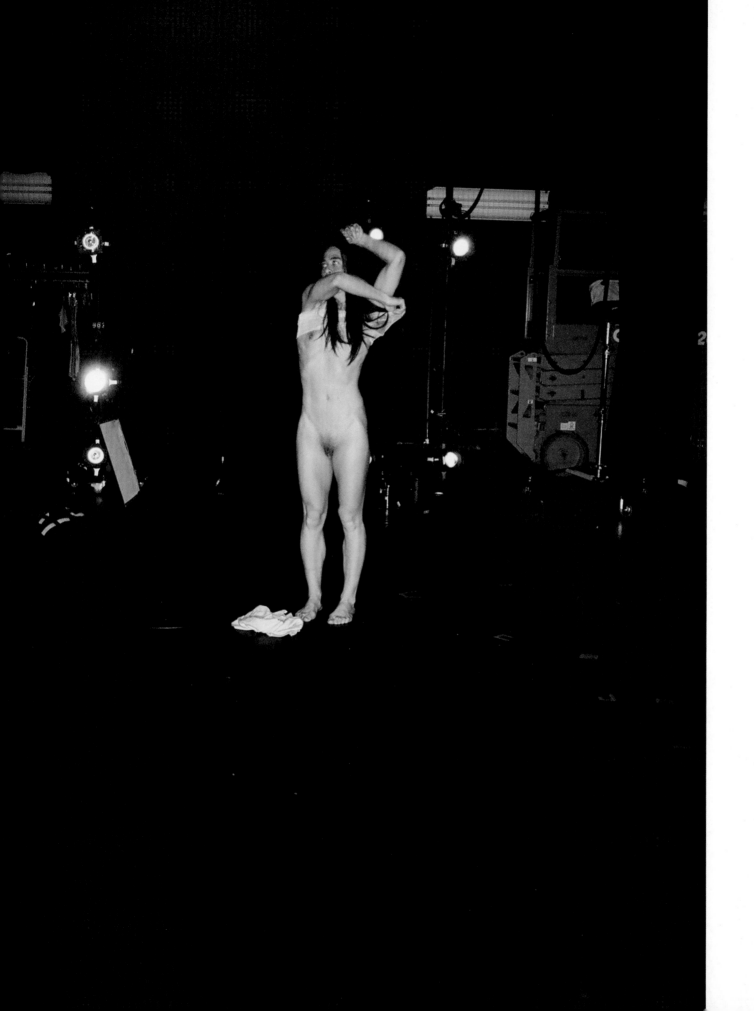

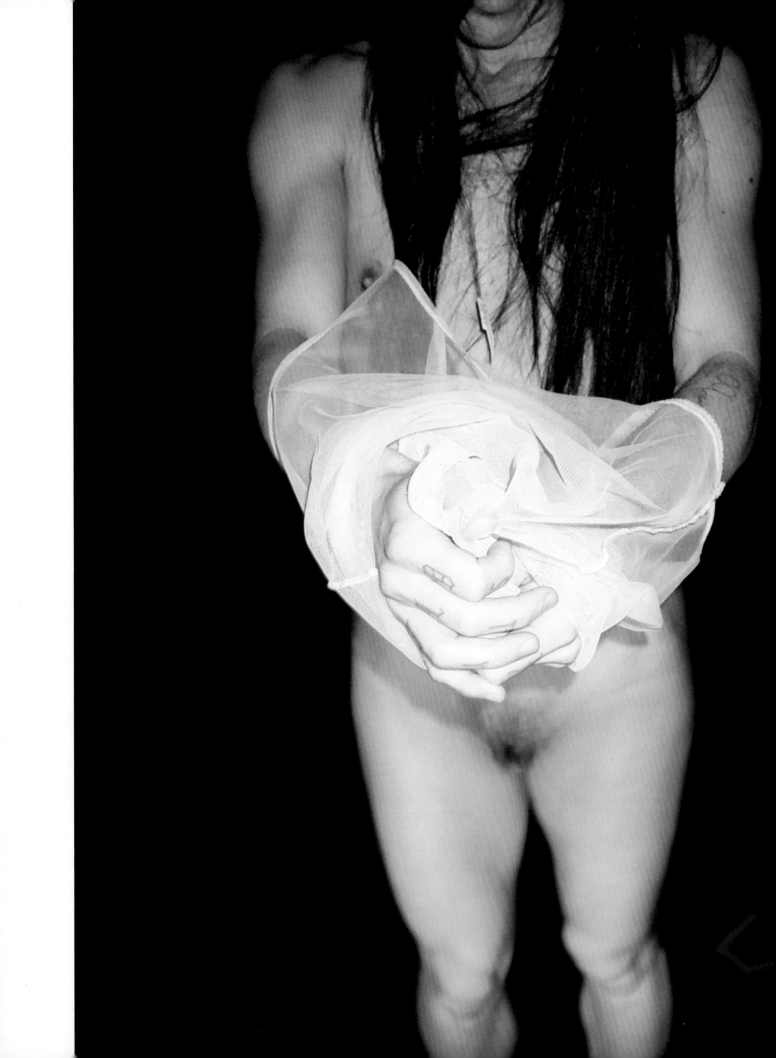

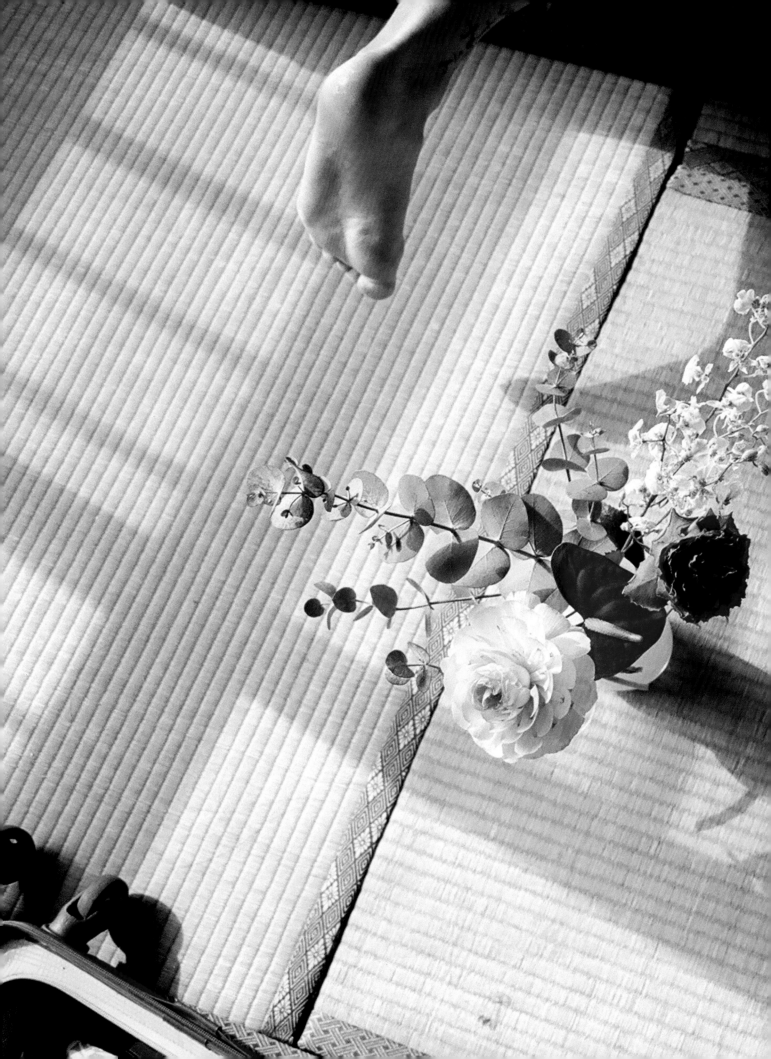

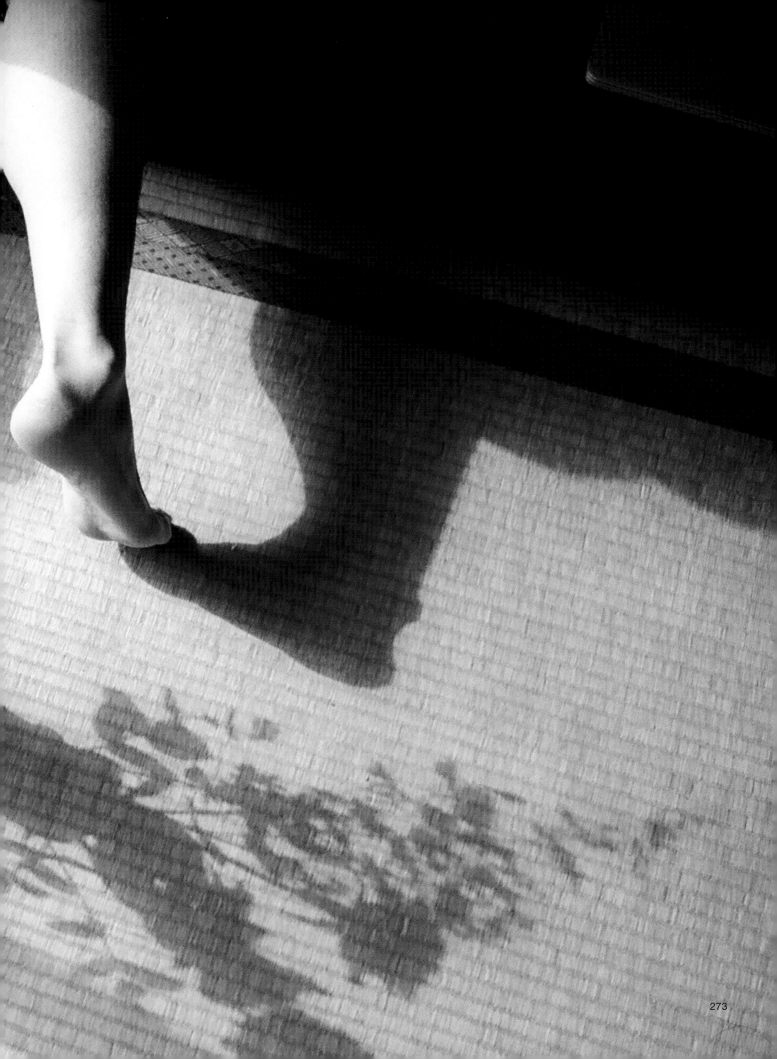

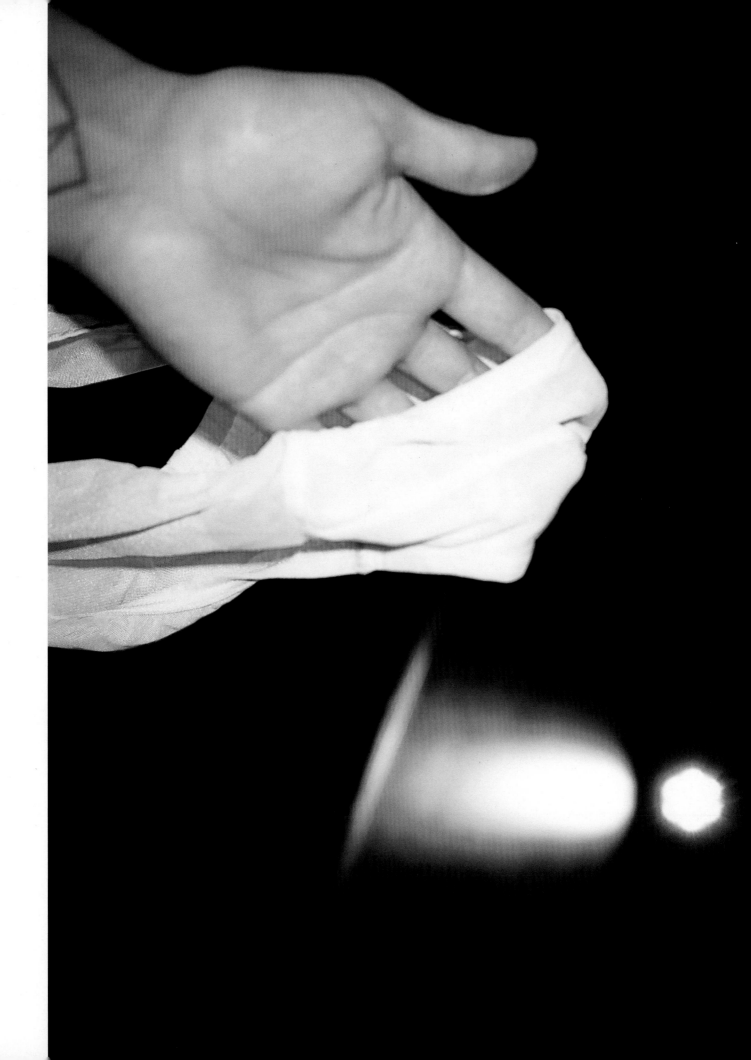

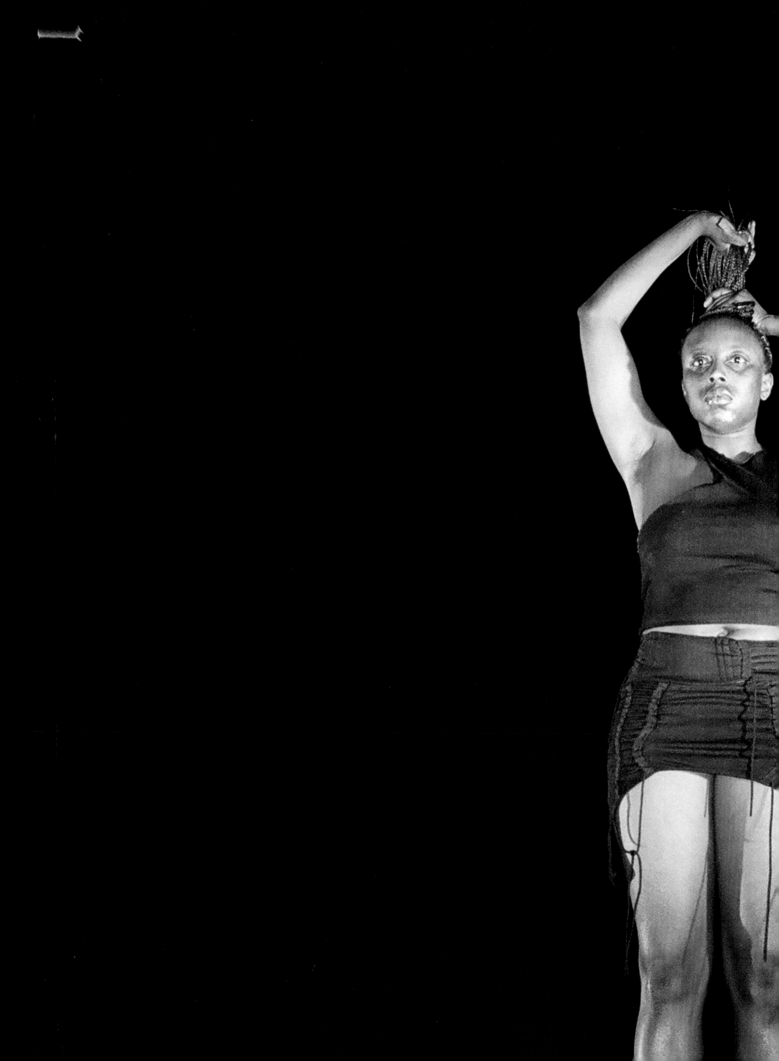

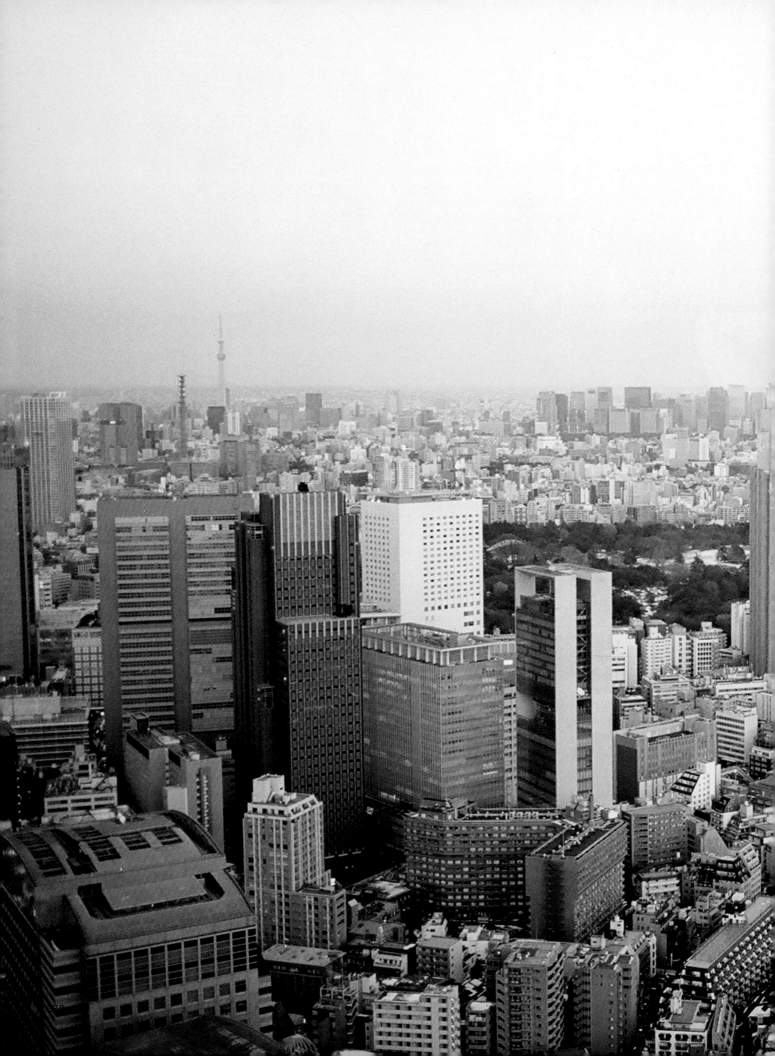

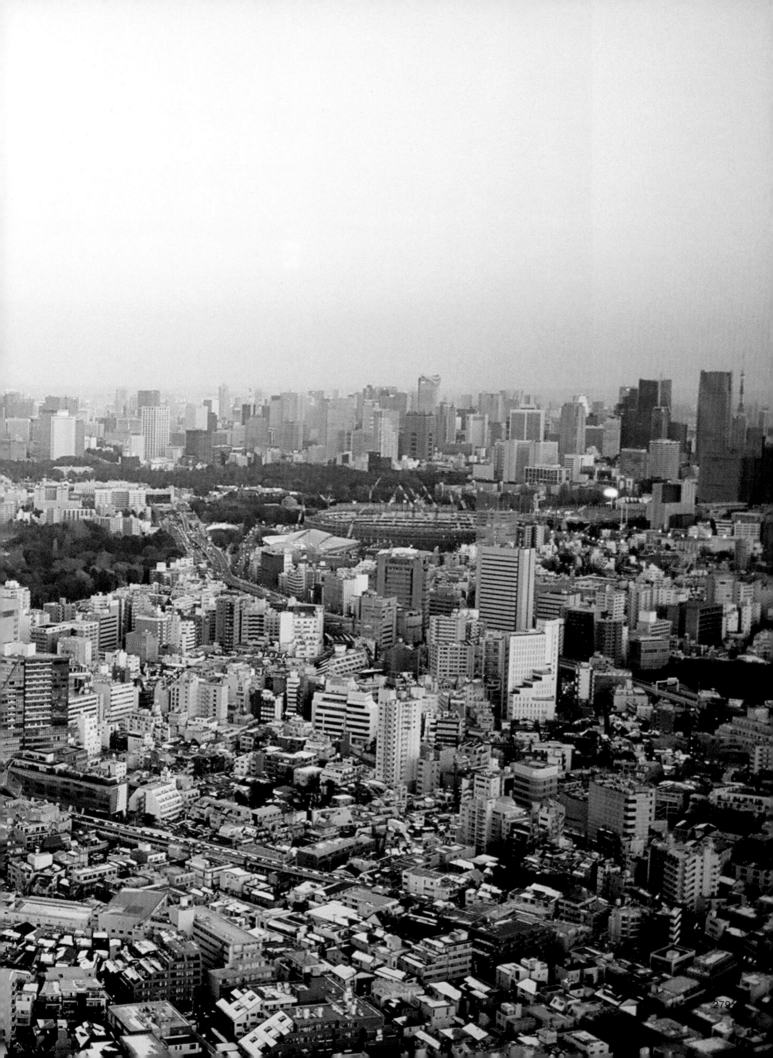

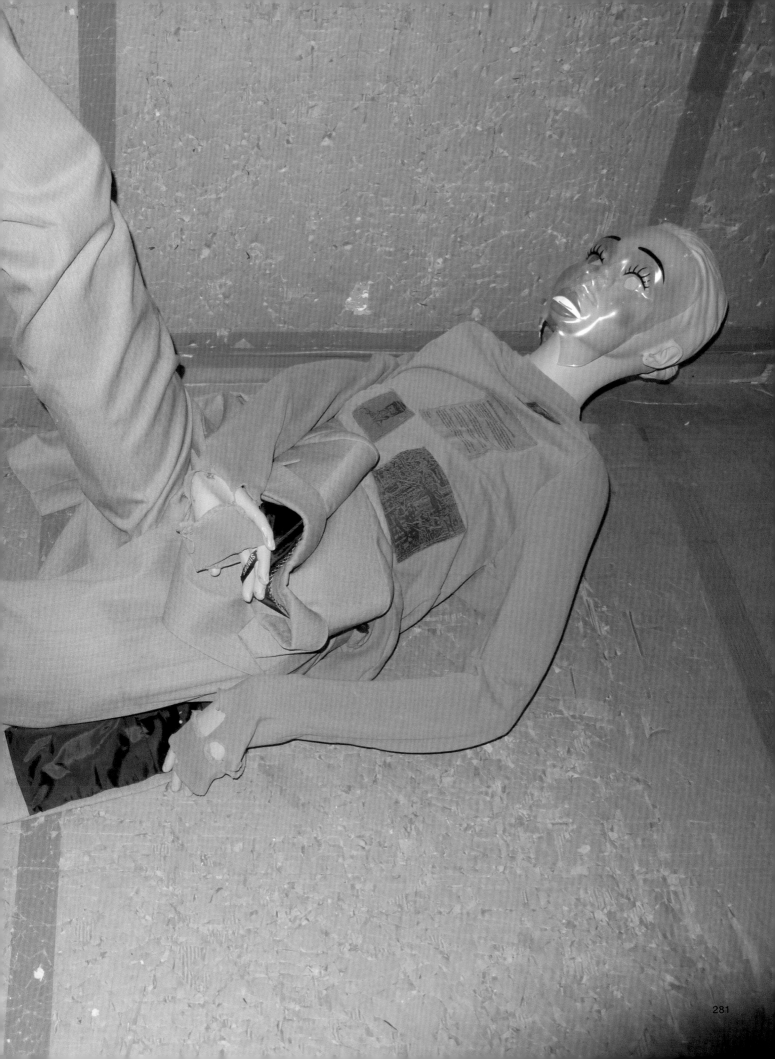

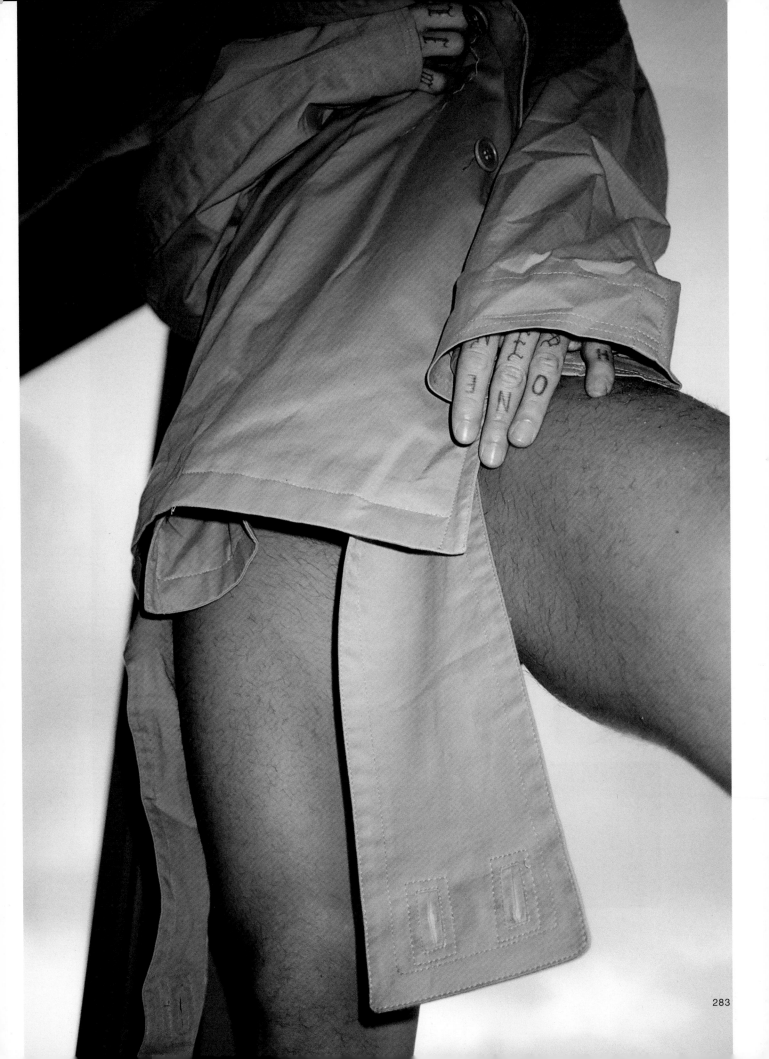

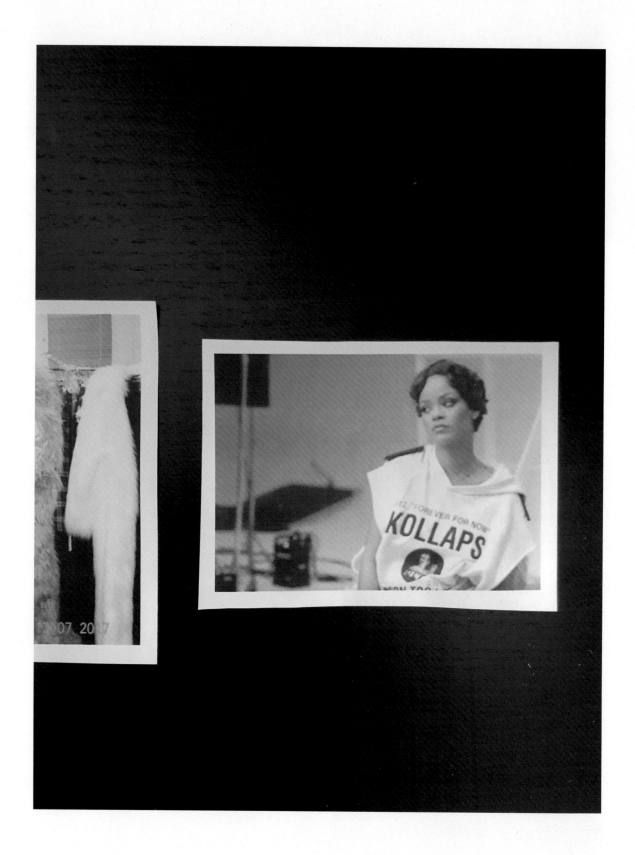

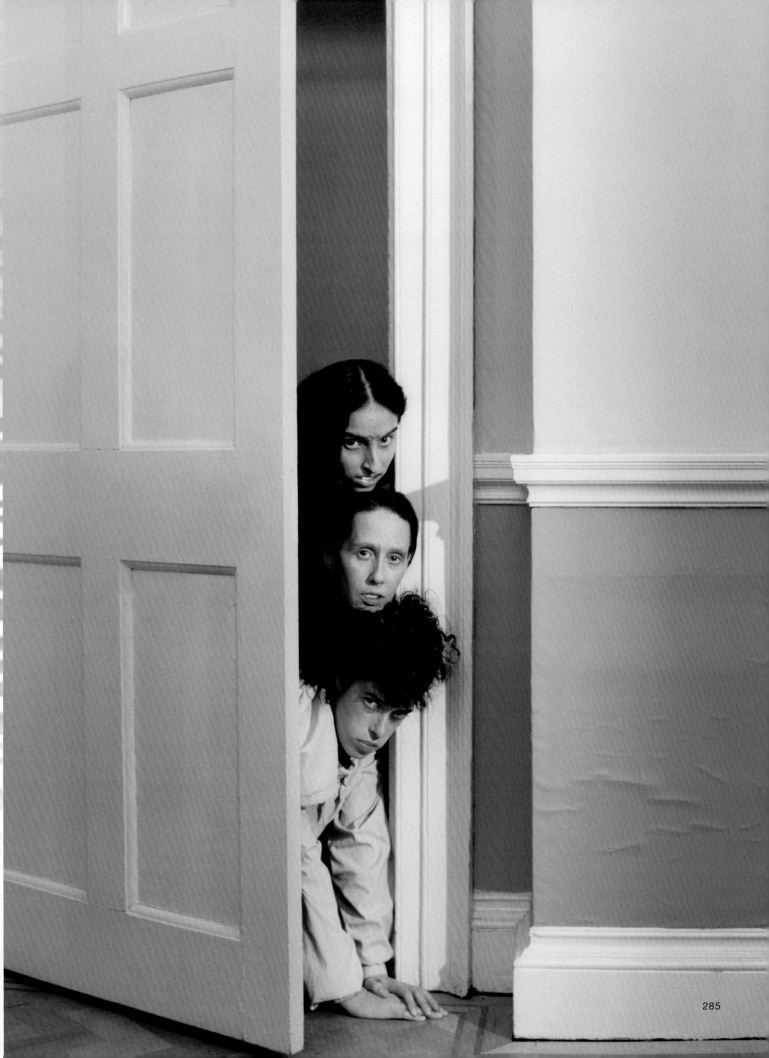

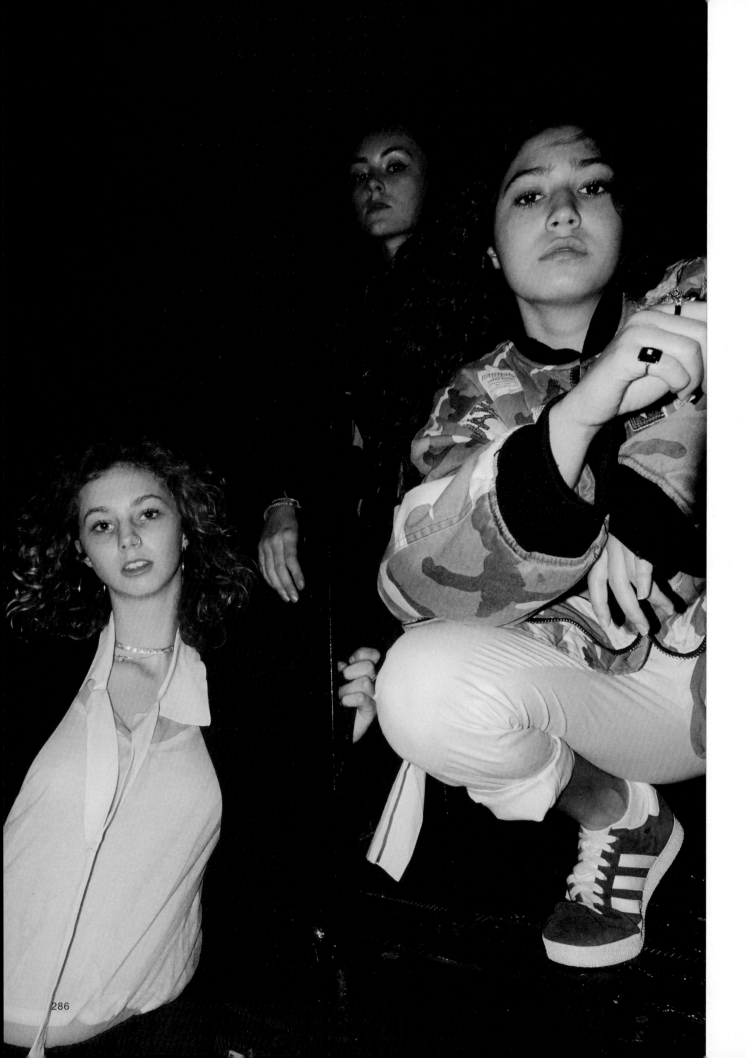

archive

DAVID CASAVANT

23, 112
RAF SIMONS AW02 SWEATSHIRT

28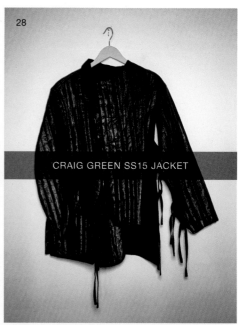
CRAIG GREEN SS15 JACKET

28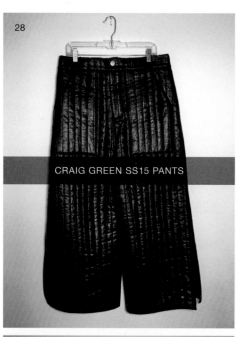
CRAIG GREEN SS15 PANTS

28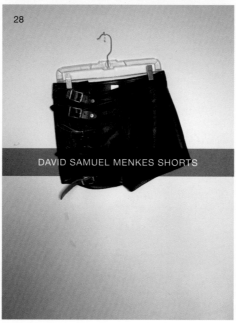
DAVID SAMUEL MENKES SHORTS

28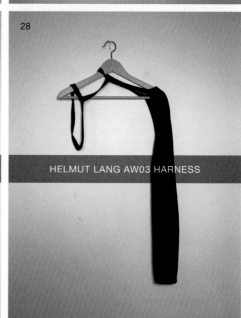
HELMUT LANG AW03 HARNESS

28
HELMUT LANG AW03 JEANS

28
JIL SANDER SS12 BOOTS

28
KRIS VAN ASSCHE AW12 HAT

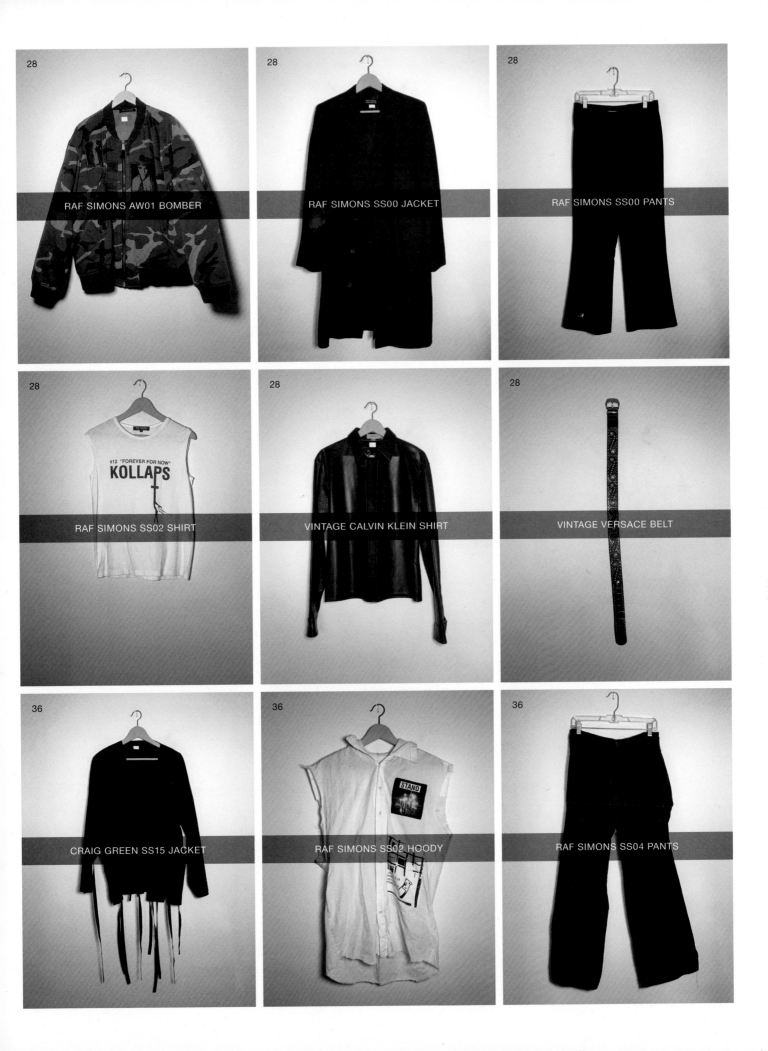

28 RAF SIMONS AW01 BOMBER

28 RAF SIMONS SS00 JACKET

28 RAF SIMONS SS00 PANTS

28 RAF SIMONS SS02 SHIRT

28 VINTAGE CALVIN KLEIN SHIRT

28 VINTAGE VERSACE BELT

36 CRAIG GREEN SS15 JACKET

36 RAF SIMONS SS02 HOODY

36 RAF SIMONS SS04 PANTS

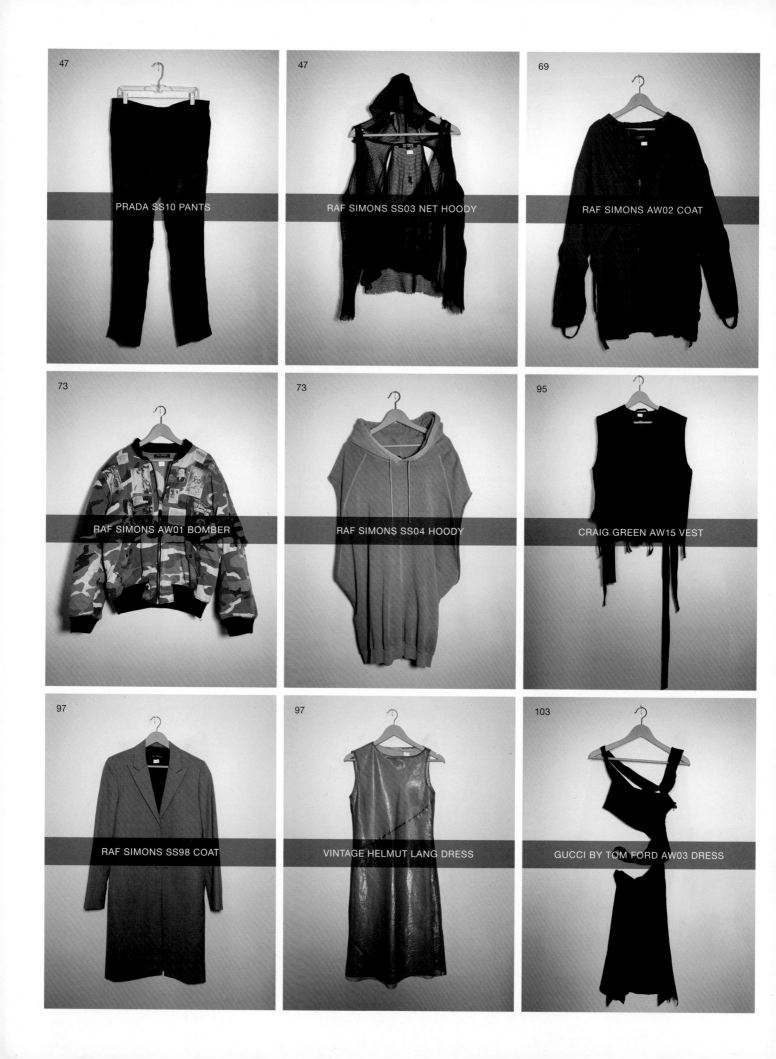

47 PRADA SS10 PANTS

47 RAF SIMONS SS03 NET HOODY

69 RAF SIMONS AW02 COAT

73 RAF SIMONS AW01 BOMBER

73 RAF SIMONS SS04 HOODY

95 CRAIG GREEN AW15 VEST

97 RAF SIMONS SS98 COAT

97 VINTAGE HELMUT LANG DRESS

103 GUCCI BY TOM FORD AW03 DRESS

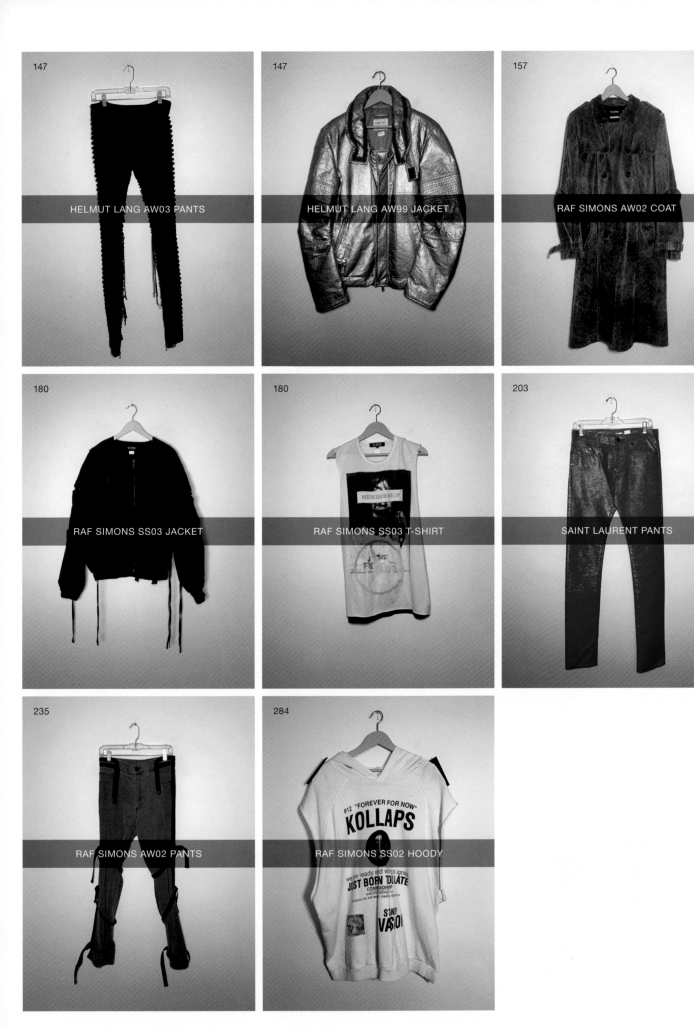

147 HELMUT LANG AW03 PANTS

147 HELMUT LANG AW99 JACKET

157 RAF SIMONS AW02 COAT

180 RAF SIMONS SS03 JACKET

180 RAF SIMONS SS03 T-SHIRT

203 SAINT LAURENT PANTS

235 RAF SIMONS AW02 PANTS

284 RAF SIMONS SS02 HOODY

XAVIER CHA

20–21, 250–251

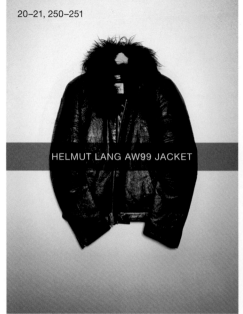

HELMUT LANG AW99 JACKET

20–21, 250–251

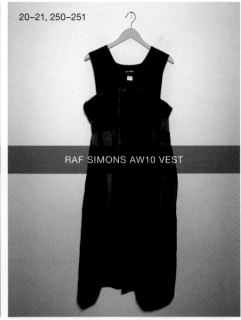

RAF SIMONS AW10 VEST

20–21, 250–251

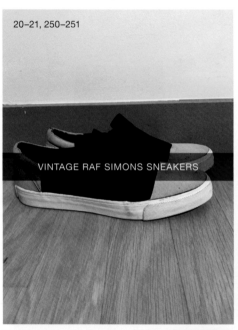

VINTAGE RAF SIMONS SNEAKERS

26–27, 148

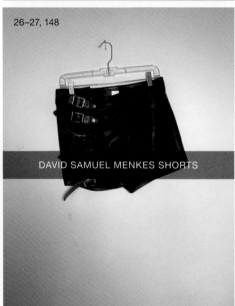

DAVID SAMUEL MENKES SHORTS

26–27, 148

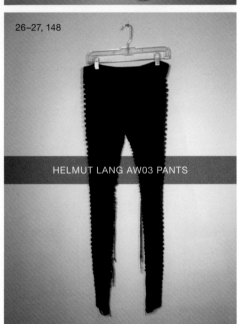

HELMUT LANG AW03 PANTS

26–27, 148

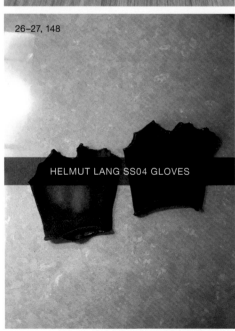

HELMUT LANG SS04 GLOVES

26–27

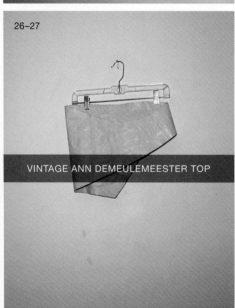

VINTAGE ANN DEMEULEMEESTER TOP

31, 186–187, 232–233

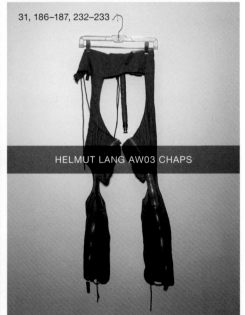

HELMUT LANG AW03 CHAPS

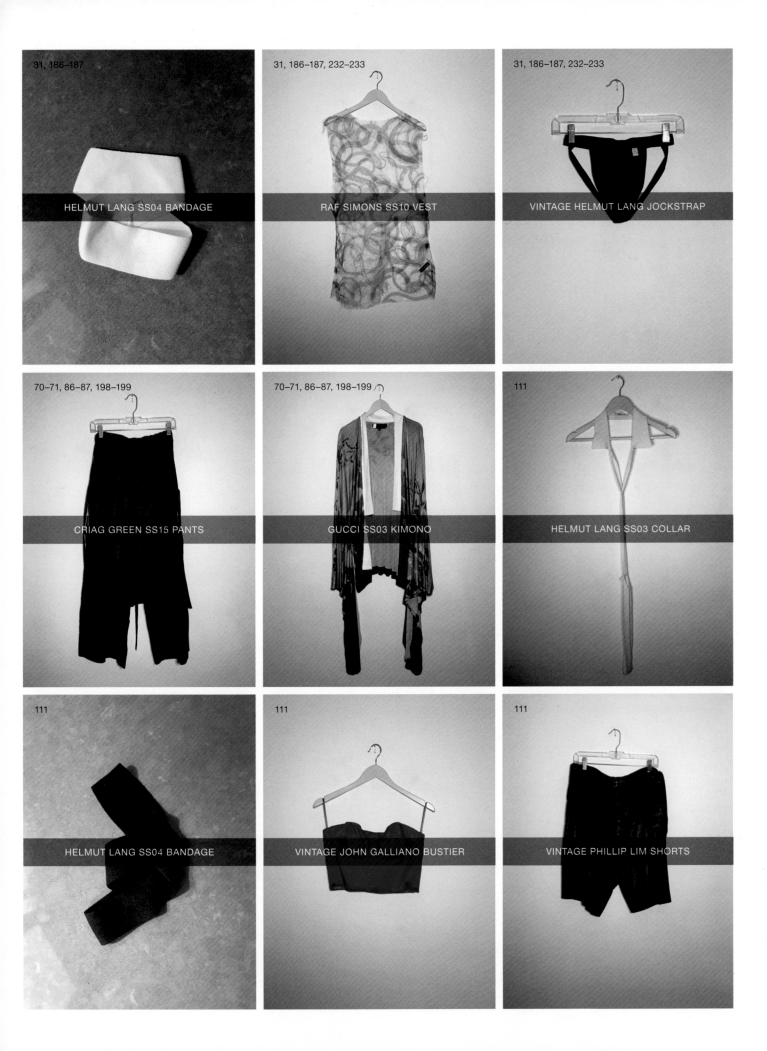

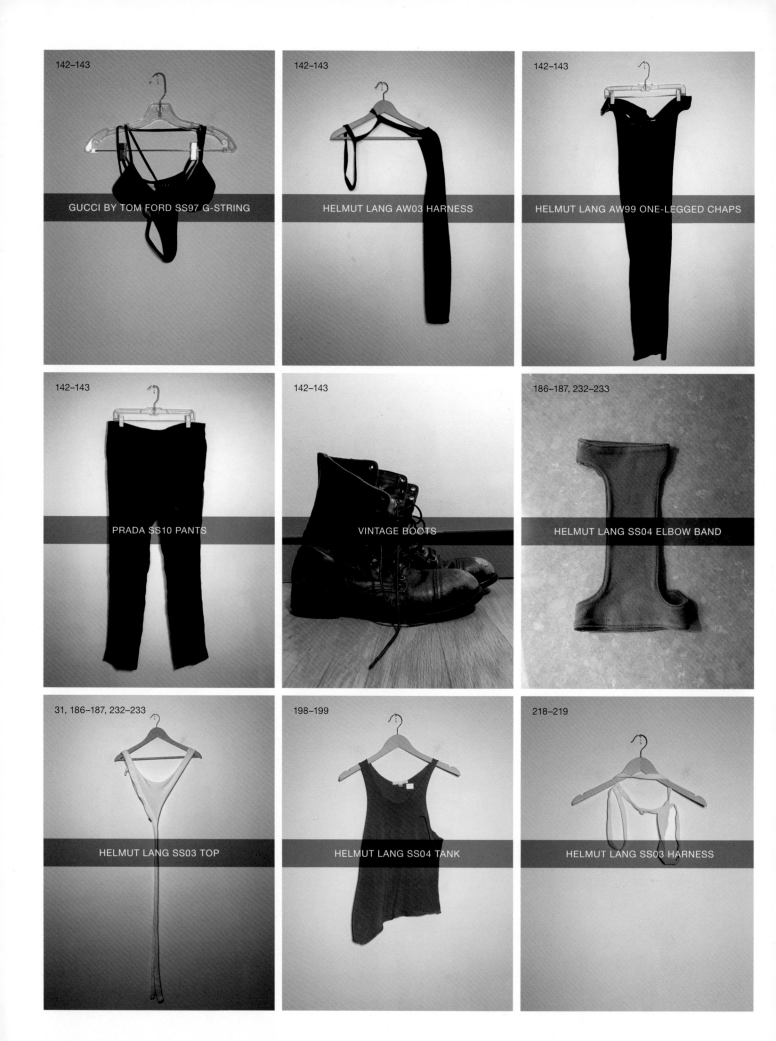

142–143 GUCCI BY TOM FORD SS97 G-STRING

142–143 HELMUT LANG AW03 HARNESS

142–143 HELMUT LANG AW99 ONE-LEGGED CHAPS

142–143 PRADA SS10 PANTS

142–143 VINTAGE BOOTS

186–187, 232–233 HELMUT LANG SS04 ELBOW BAND

31, 186–187, 232–233 HELMUT LANG SS03 TOP

198–199 HELMUT LANG SS04 TANK

218–219 HELMUT LANG SS03 HARNESS

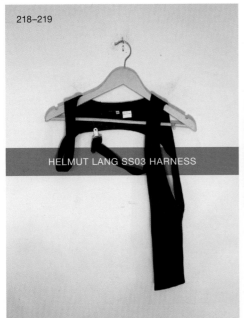

218–219

HELMUT LANG SS03 HARNESS

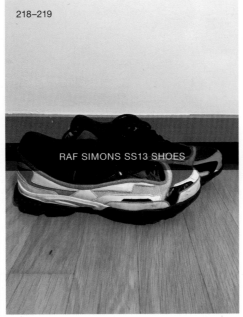

218–219

RAF SIMONS SS13 SHOES

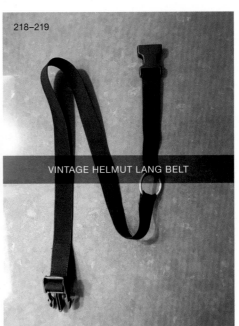

218–219

VINTAGE HELMUT LANG BELT

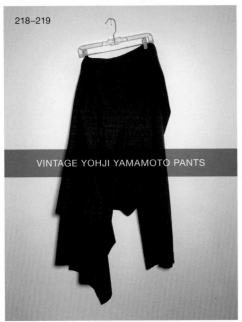

218–219

VINTAGE YOHJI YAMAMOTO PANTS

MATAO CHAMORRO

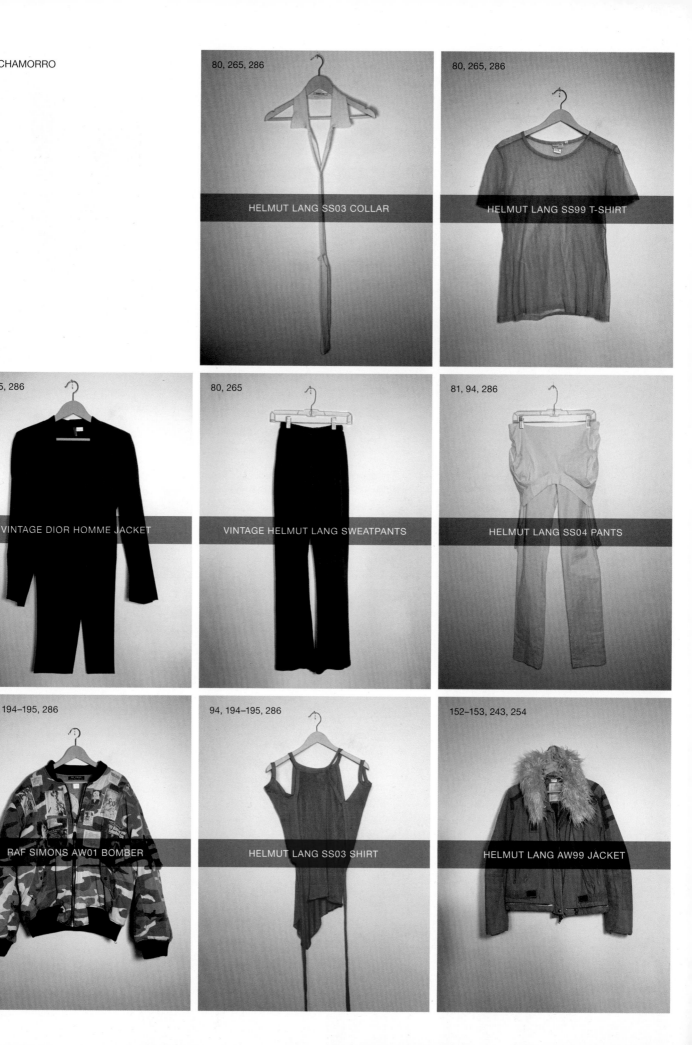

80, 265, 286

HELMUT LANG SS03 COLLAR

80, 265, 286

HELMUT LANG SS99 T-SHIRT

80, 265, 286

VINTAGE DIOR HOMME JACKET

80, 265

VINTAGE HELMUT LANG SWEATPANTS

81, 94, 286

HELMUT LANG SS04 PANTS

81, 94, 194–195, 286

RAF SIMONS AW01 BOMBER

94, 194–195, 286

HELMUT LANG SS03 SHIRT

152–153, 243, 254

HELMUT LANG AW99 JACKET

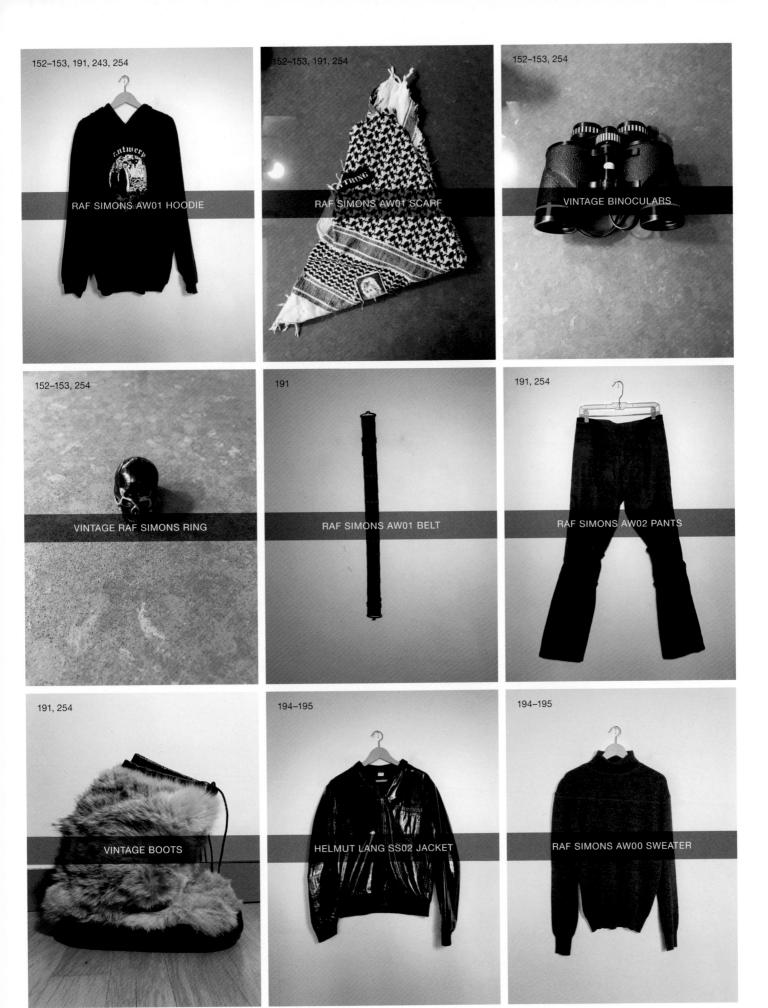

152–153, 191, 243, 254
RAF SIMONS AW01 HOODIE

152–153, 191, 254
RAF SIMONS AW01 SCARF

152–153, 254
VINTAGE BINOCULARS

152–153, 254
VINTAGE RAF SIMONS RING

191
RAF SIMONS AW01 BELT

191, 254
RAF SIMONS AW02 PANTS

191, 254
VINTAGE BOOTS

194–195
HELMUT LANG SS02 JACKET

194–195
RAF SIMONS AW00 SWEATER

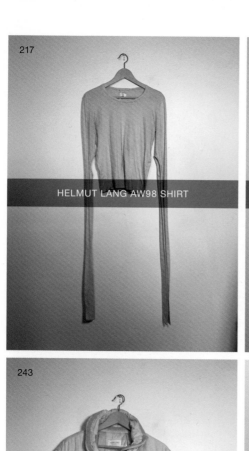

217

HELMUT LANG AW98 SHIRT

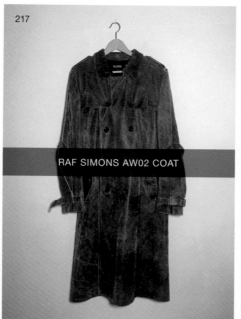

217

RAF SIMONS AW02 COAT

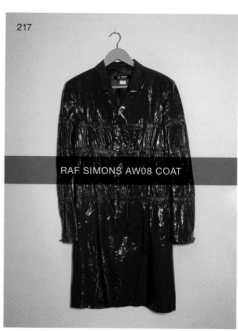

217

RAF SIMONS AW08 COAT

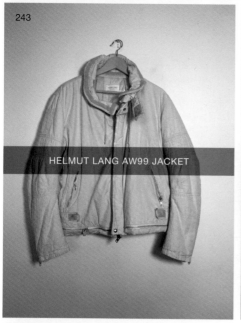

243

HELMUT LANG AW99 JACKET

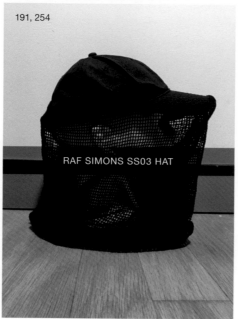

191, 254

RAF SIMONS SS03 HAT

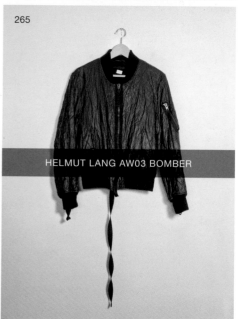

265

HELMUT LANG AW03 BOMBER

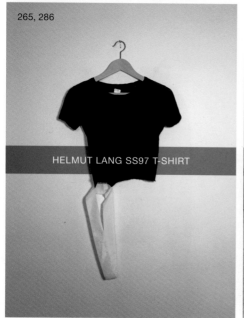

265, 286

HELMUT LANG SS97 T-SHIRT

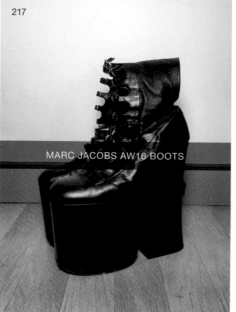

217

MARC JACOBS AW16 BOOTS

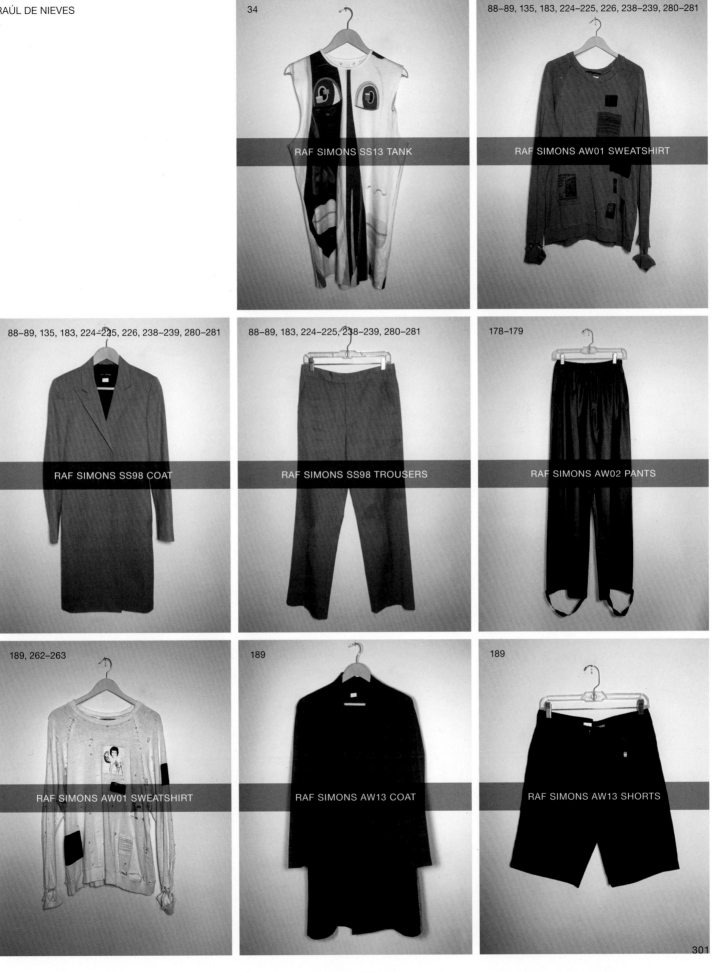

34

RAF SIMONS SS13 TANK

88–89, 135, 183, 224–225, 226, 238–239, 280–281

RAF SIMONS AW01 SWEATSHIRT

88–89, 135, 183, 224–225, 226, 238–239, 280–281

RAF SIMONS SS98 COAT

88–89, 183, 224–225, 238–239, 280–281

RAF SIMONS SS98 TROUSERS

178–179

RAF SIMONS AW02 PANTS

189, 262–263

RAF SIMONS AW01 SWEATSHIRT

189

RAF SIMONS AW13 COAT

189

RAF SIMONS AW13 SHORTS

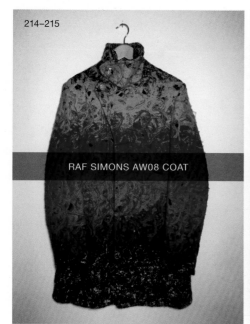

RAF SIMONS AW08 COAT

HELMUT LANG AW03 PANTS

THOMAS EGGERER

12–13, 139, 270

12, 32–33, 138, 271

SUSAN MOSS BUFORD 1875

SUSAN MOSS BUFORD 1875

17, 170

PRADA SS12 SHIRT

17, 170, 257

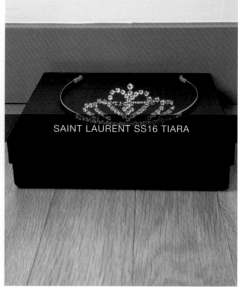

SAINT LAURENT SS16 TIARA

39, 52–53, 77, 133

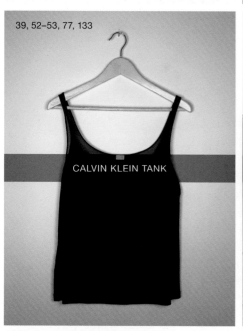

CALVIN KLEIN TANK

39, 133

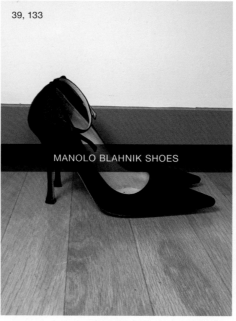

MANOLO BLAHNIK SHOES

52–53, 77

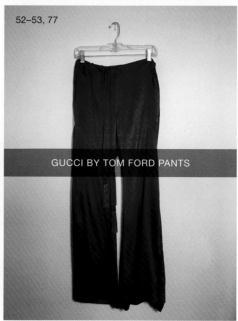

GUCCI BY TOM FORD PANTS

52–53, 77, 110

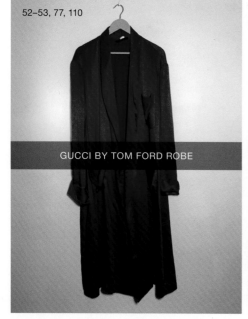

GUCCI BY TOM FORD ROBE

84

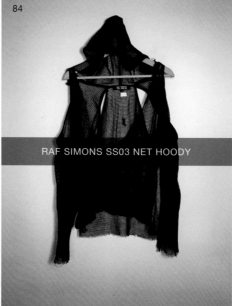

RAF SIMONS SS03 NET HOODY

113

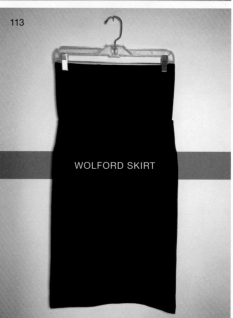

WOLFORD SKIRT

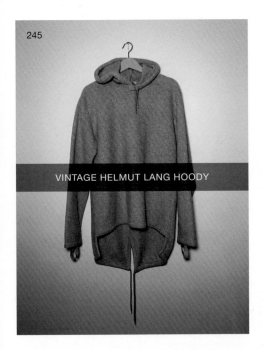

VINTAGE HELMUT LANG HOODY

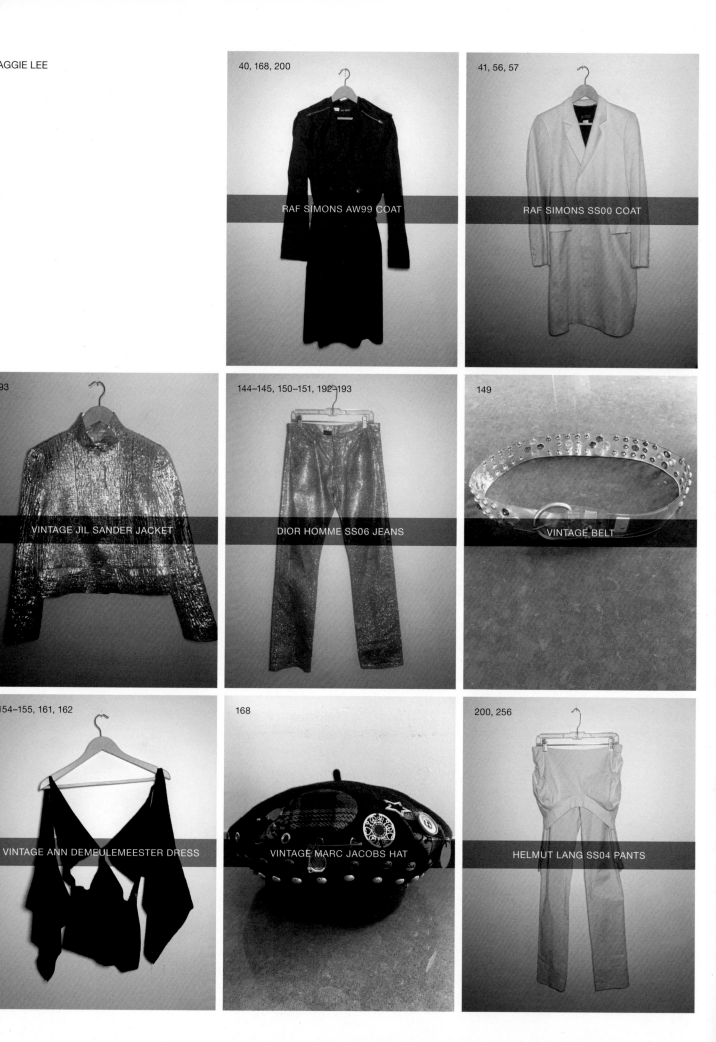

MAGGIE LEE

40, 168, 200
RAF SIMONS AW99 COAT

41, 56, 57
RAF SIMONS SS00 COAT

93
VINTAGE JIL SANDER JACKET

144–145, 150–151, 192–193
DIOR HOMME SS06 JEANS

149
VINTAGE BELT

154–155, 161, 162
VINTAGE ANN DEMEULEMEESTER DRESS

168
VINTAGE MARC JACOBS HAT

200, 256
HELMUT LANG SS04 PANTS

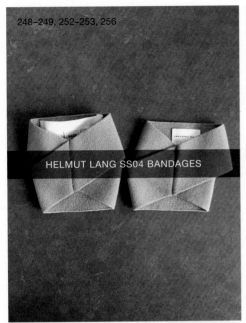

248–249, 252–253, 256

HELMUT LANG SS04 BANDAGES

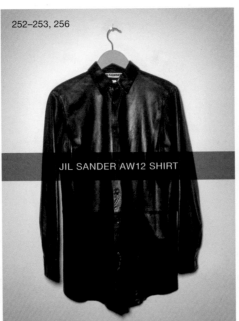

252–253, 256

JIL SANDER AW12 SHIRT

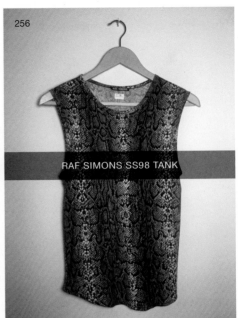

256

RAF SIMONS SS98 TANK

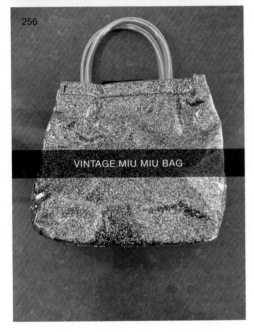

256

VINTAGE MIU MIU BAG

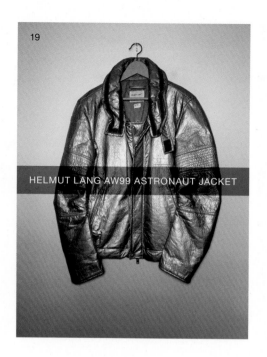

HELMUT LANG AW99 ASTRONAUT JACKET

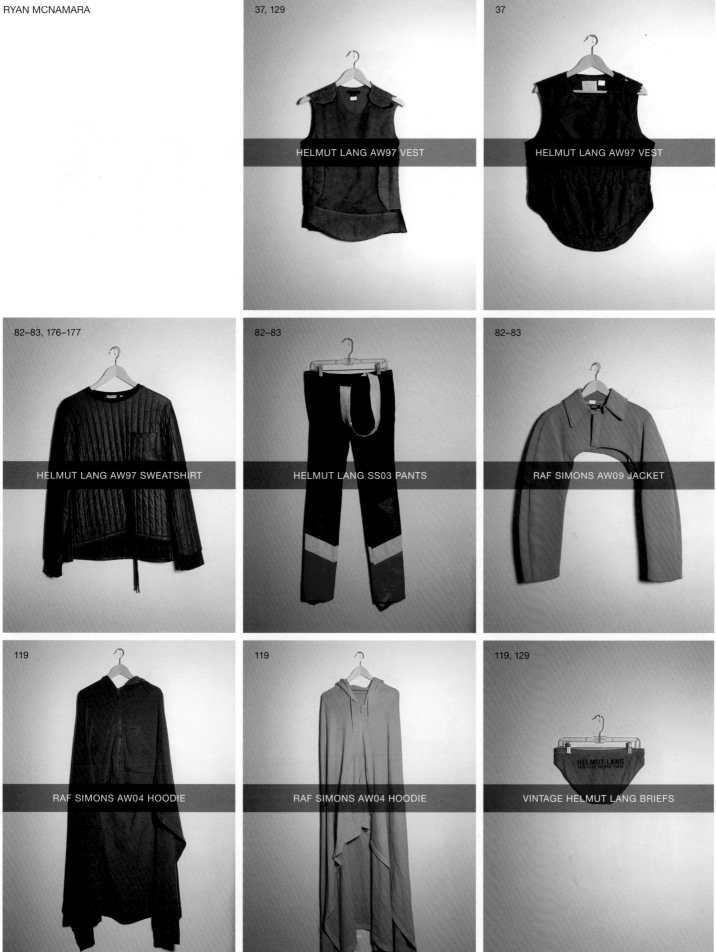

37, 129

HELMUT LANG AW97 VEST

37

HELMUT LANG AW97 VEST

82–83, 176–177

HELMUT LANG AW97 SWEATSHIRT

82–83

HELMUT LANG SS03 PANTS

82–83

RAF SIMONS AW09 JACKET

119

RAF SIMONS AW04 HOODIE

119

RAF SIMONS AW04 HOODIE

119, 129

VINTAGE HELMUT LANG BRIEFS

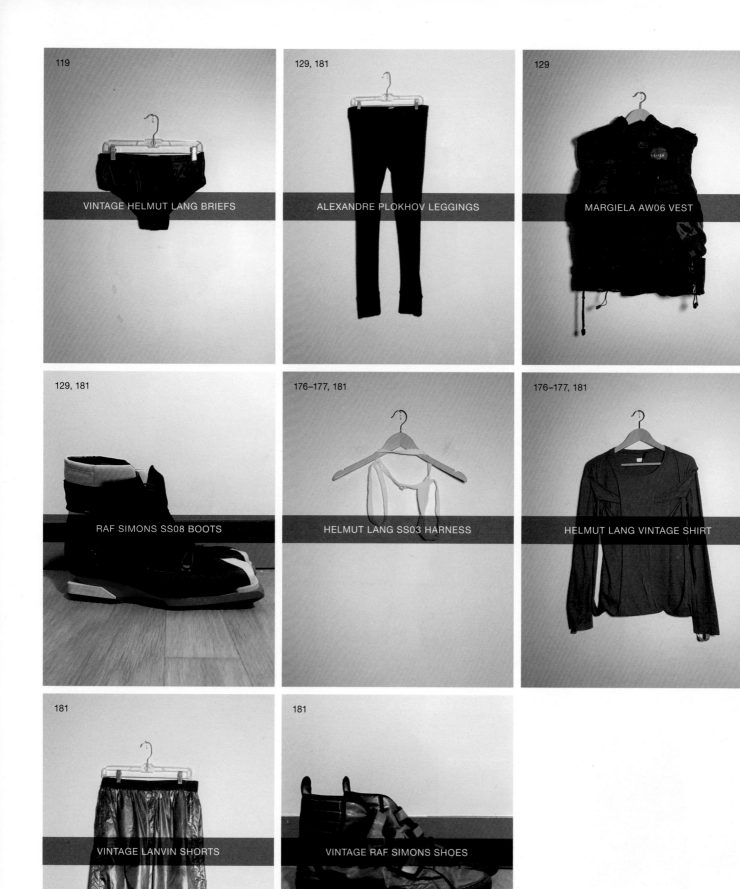

119 — VINTAGE HELMUT LANG BRIEFS

129, 181 — ALEXANDRE PLOKHOV LEGGINGS

129 — MARGIELA AW06 VEST

129, 181 — RAF SIMONS SS08 BOOTS

176–177, 181 — HELMUT LANG SS03 HARNESS

176–177, 181 — HELMUT LANG VINTAGE SHIRT

181 — VINTAGE LANVIN SHORTS

181 — VINTAGE RAF SIMONS SHOES

JOYCE NG

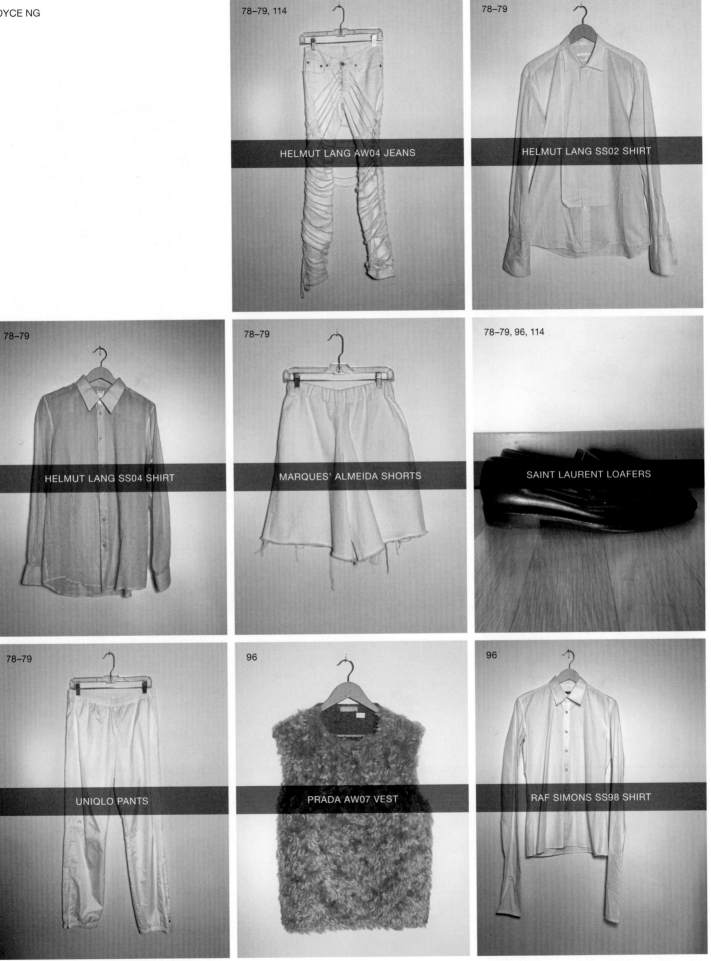

78–79, 114
HELMUT LANG AW04 JEANS

78–79
HELMUT LANG SS02 SHIRT

78–79
HELMUT LANG SS04 SHIRT

78–79
MARQUES' ALMEIDA SHORTS

78–79, 96, 114
SAINT LAURENT LOAFERS

78–79
UNIQLO PANTS

96
PRADA AW07 VEST

96
RAF SIMONS SS98 SHIRT

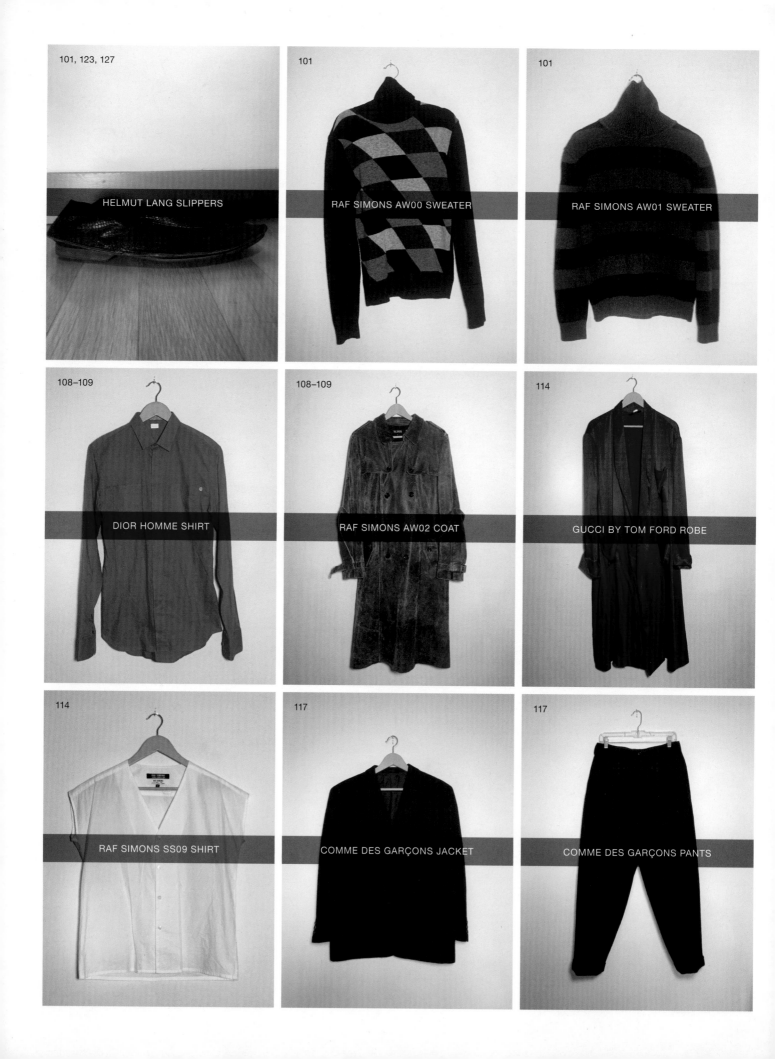

101, 123, 127 — HELMUT LANG SLIPPERS

101 — RAF SIMONS AW00 SWEATER

101 — RAF SIMONS AW01 SWEATER

108–109 — DIOR HOMME SHIRT

108–109 — RAF SIMONS AW02 COAT

114 — GUCCI BY TOM FORD ROBE

114 — RAF SIMONS SS09 SHIRT

117 — COMME DES GARÇONS JACKET

117 — COMME DES GARÇONS PANTS

117

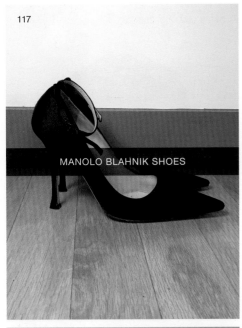

MANOLO BLAHNIK SHOES

123, 127

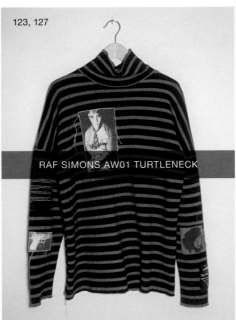

RAF SIMONS AW01 TURTLENECK

123, 127

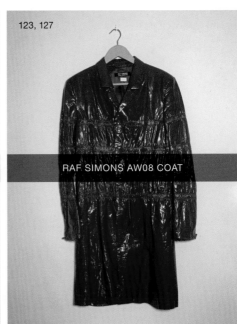

RAF SIMONS AW08 COAT

128

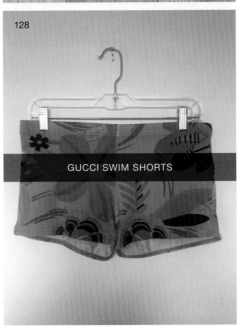

GUCCI SWIM SHORTS

128

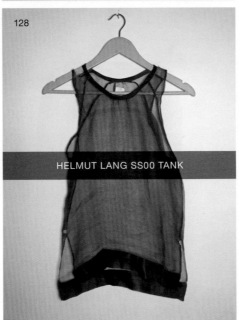

HELMUT LANG SS00 TANK

128

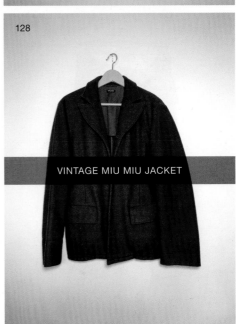

VINTAGE MIU MIU JACKET

285

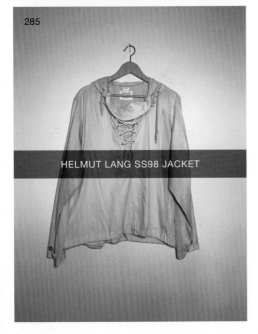

HELMUT LANG SS98 JACKET

HANNE GABY ODIELE

24–25, 234, 266–267

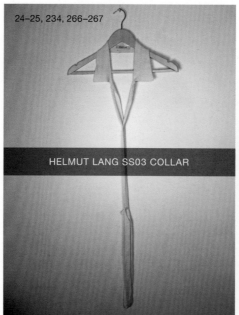

HELMUT LANG SS03 COLLAR

24–25, 212–213, 266–267

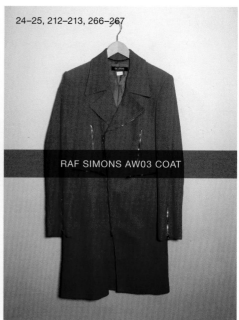

RAF SIMONS AW03 COAT

24–25

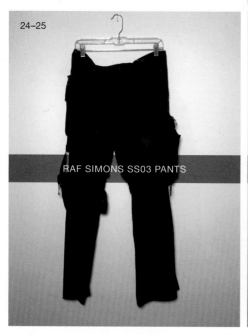

RAF SIMONS SS03 PANTS

29

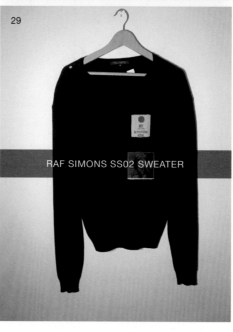

RAF SIMONS SS02 SWEATER

JACOLBY SATTERWHITE

14–15, 130, 140–141, 165, 247, 255

CRAIG GREEN AW15 PANTS

14–15, 130, 165, 247, 255

CRAIG GREEN AW15 VEST

14–15, 90–91, 104–105, 122, 130, 156, 165,
210–211, 220–221, 247, 255

JIL SANDER SS12 BOOTS

43, 104–105

DAVID SAMUEL MENKES SHORTS

43, 104–105

VINTAGE CALVIN KLEIN SHIRT

43, 104–105

VINTAGE VERSACE BELT

90–91, 104–105, 210–211, 220–221

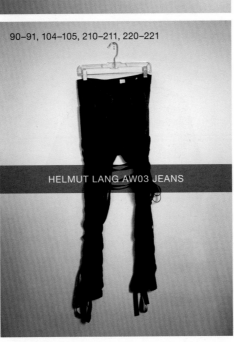

HELMUT LANG AW03 JEANS

90–91, 104–105, 210–211, 220–221

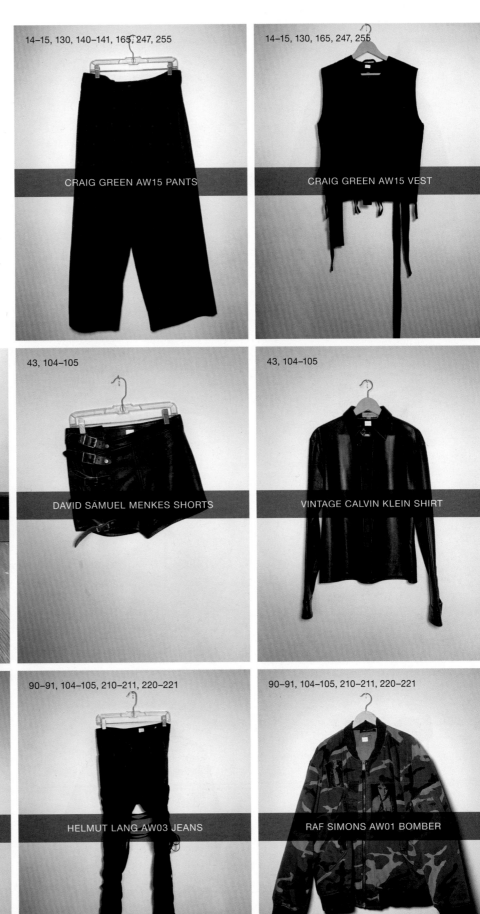

RAF SIMONS AW01 BOMBER

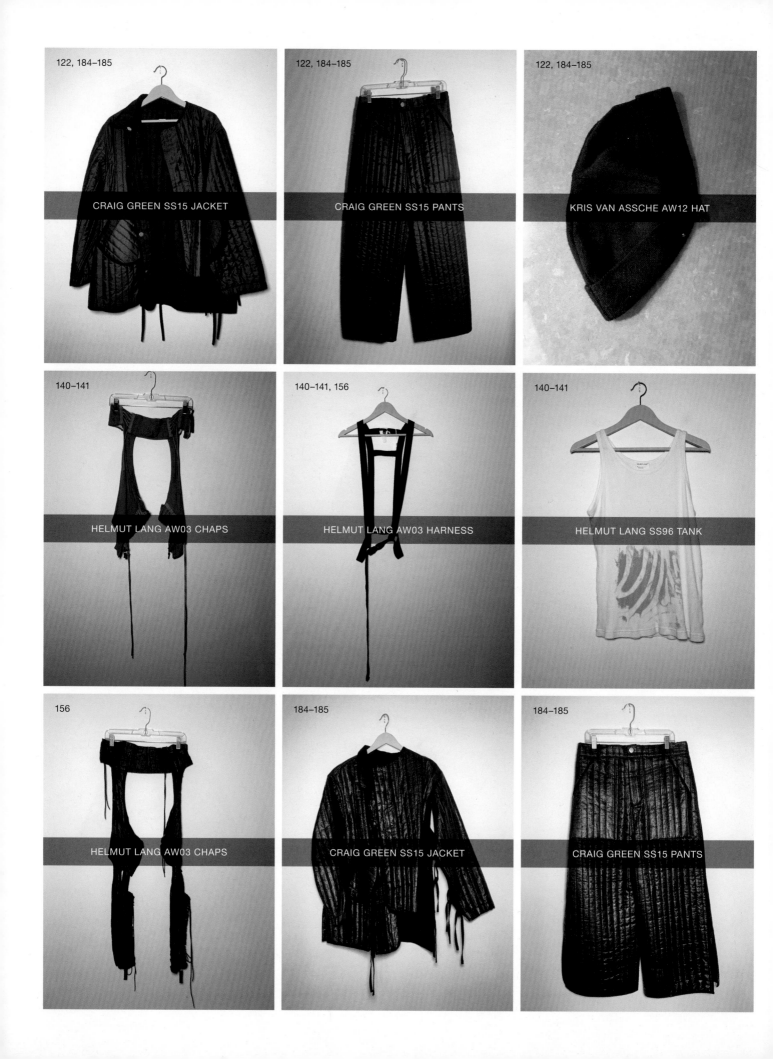

122, 184–185 — CRAIG GREEN SS15 JACKET

122, 184–185 — CRAIG GREEN SS15 PANTS

122, 184–185 — KRIS VAN ASSCHE AW12 HAT

140–141 — HELMUT LANG AW03 CHAPS

140–141, 156 — HELMUT LANG AW03 HARNESS

140–141 — HELMUT LANG SS96 TANK

156 — HELMUT LANG AW03 CHAPS

184–185 — CRAIG GREEN SS15 JACKET

184–185 — CRAIG GREEN SS15 PANTS

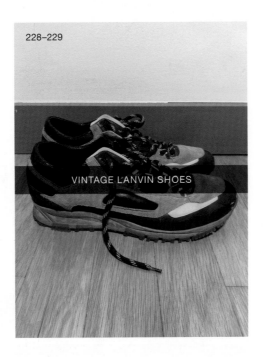

VINTAGE L'ANVIN SHOES

196–197
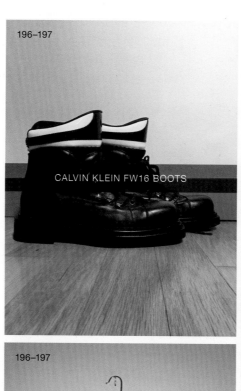
CALVIN KLEIN FW16 BOOTS

196–197
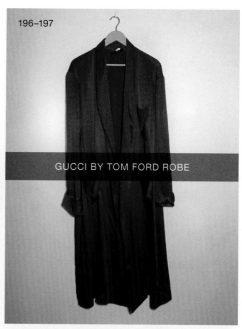
GUCCI BY TOM FORD ROBE

196–197
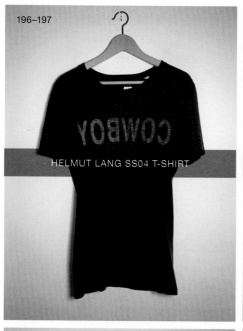
HELMUT LANG SS04 T-SHIRT

196–197
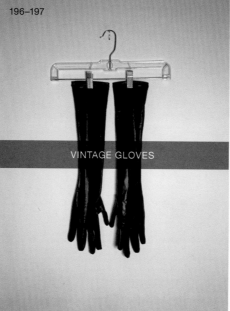
VINTAGE GLOVES

196–197
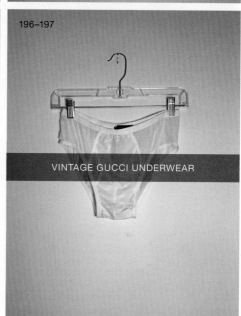
VINTAGE GUCCI UNDERWEAR

196–197
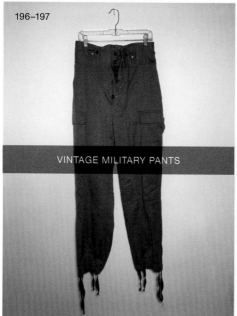
VINTAGE MILITARY PANTS

196–197
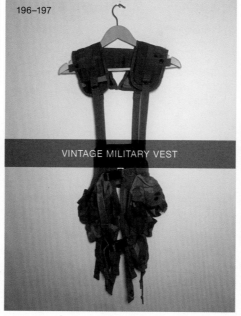
VINTAGE MILITARY VEST

196–197

VINTAGE WHISTLE

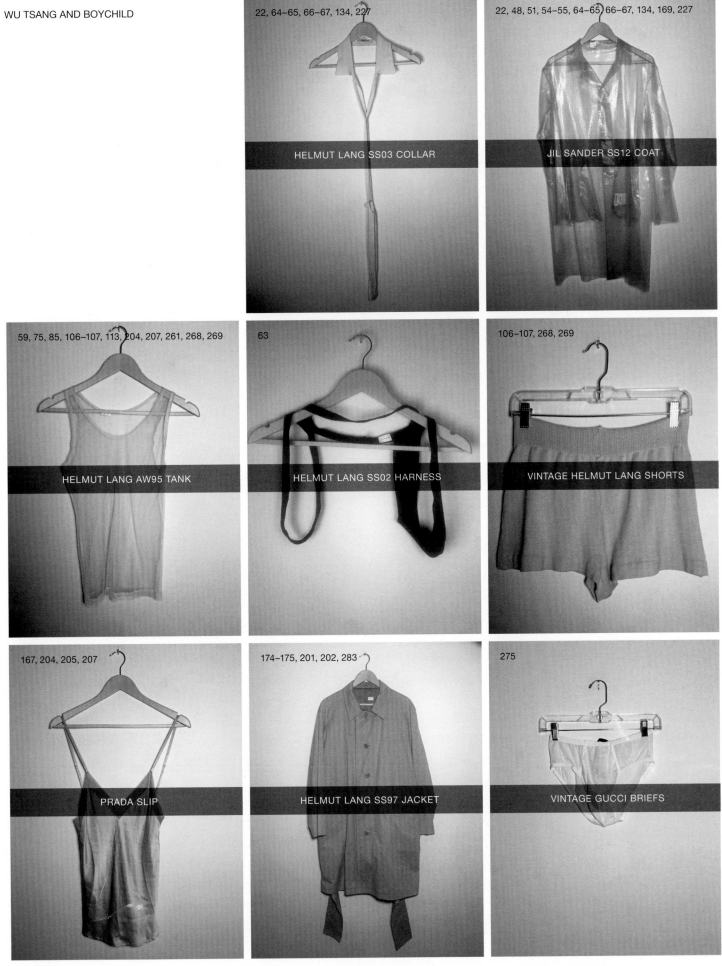

22, 64–65, 66–67, 134, 227

HELMUT LANG SS03 COLLAR

22, 48, 51, 54–55, 64–65, 66–67, 134, 169, 227

JIL SANDER SS12 COAT

59, 75, 85, 106–107, 113, 204, 207, 261, 268, 269

HELMUT LANG AW95 TANK

63

HELMUT LANG SS02 HARNESS

106–107, 268, 269

VINTAGE HELMUT LANG SHORTS

167, 204, 205, 207

PRADA SLIP

174–175, 201, 202, 283

HELMUT LANG SS97 JACKET

275

VINTAGE GUCCI BRIEFS

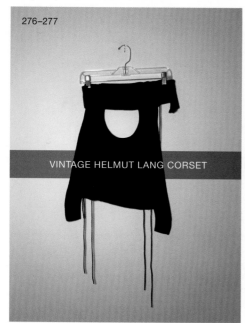

VINTAGE HELMUT LANG CORSET

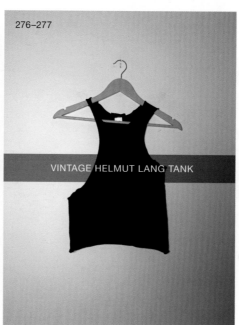

VINTAGE HELMUT LANG TANK

STEWART UOO

44–45

GUCCI BRIEFS

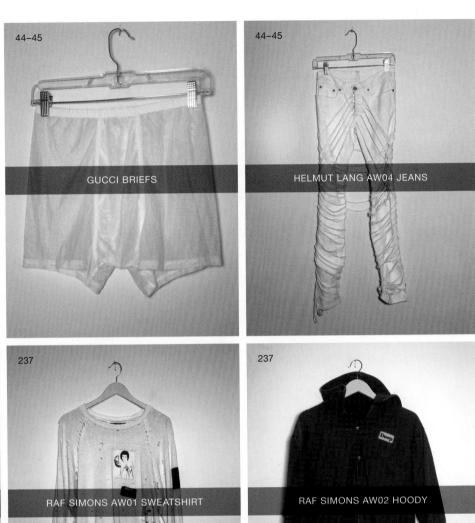

44–45

HELMUT LANG AW04 JEANS

61

GUCCI SS03 JACKET

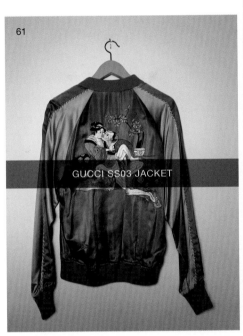

237

RAF SIMONS AW01 SWEATSHIRT

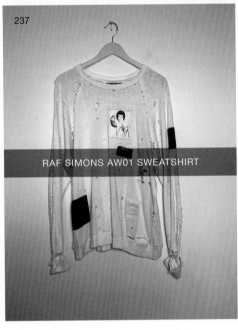

237

RAF SIMONS AW02 HOODY

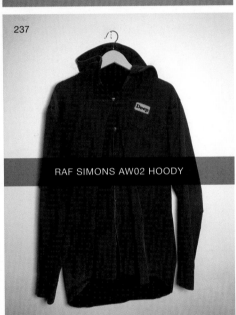

index

5	DAVID CASAVANT
6–7	DAVID CASAVANT
8–9	DAVID CASAVANT
10–11	DAVID CASAVANT
12–13	THOMAS EGGERER
14–15	JACOLBY SATTERWHITE
17	DESE ESCOBAR
19	ERIC N. MACK
20–21	XAVIER CHA
22	WU TSANG AND BOYCHILD
23	DAVID CASAVANT
24–25	HANNE GABY ODIELE
26–27	XAVIER CHA
28	DAVID CASAVANT
29	HANNE GABY ODIELE
31	XAVIER CHA
32–33	THOMAS EGGERER
34	RAÚL DE NIEVES
35	HANNE GABY ODIELE
36	DAVID CASAVANT
37	RYAN MCNAMARA
39	DESE ESCOBAR
40–41	MAGGIE LEE
43	JACOLBY SATTERWHITE
44–45	STEWART UOO
47	DAVID CASAVANT
48	WU TSANG AND BOYCHILD
49	KANYE WEST
51	WU TSANG AND BOYCHILD
52–53	DESE ESCOBAR
54–55	WU TSANG AND BOYCHILD
56–57	MAGGIE LEE
59	WU TSANG AND BOYCHILD
61	STEWART UOO
63	WU TSANG AND BOYCHILD
64–65	WU TSANG AND BOYCHILD
66–67	WU TSANG AND BOYCHILD
69	DAVID CASAVANT
70–71	XAVIER CHA
73	DAVID CASAVANT
75	WU TSANG AND BOYCHILD
76	HEJI SHIN
77	DESE ESCOBAR
78–79	JOYCE NG
80–81	MATAO CHAMORRO
82–83	RYAN MCNAMARA
84	DESE ESCOBAR
85	WU TSANG AND BOYCHILD
86–87	XAVIER CHA
88–89	RAÚL DE NIEVES
90–91	JACOLBY SATTERWHITE
92	WU TSANG AND BOYCHILD
93	MAGGIE LEE
94	MATAO CHAMORRO
95	DAVID CASAVANT
96	JOYCE NG
97	DAVID CASAVANT
99	KANYE WEST
101	JOYCE NG
102	WU TSANG AND BOYCHILD
103	DAVID CASAVANT
104–105	JACOLBY SATTERWHITE
106–107	WU TSANG AND BOYCHILD
108–109	JOYCE NG
110	DESE ESCOBAR
111	XAVIER CHA
112	DAVID CASAVANT
113	WU TSANG AND BOYCHILD
114	JOYCE NG
115	WU TSANG AND BOYCHILD
117	JOYCE NG
119	RYAN MCNAMARA
120–121	WU TSANG AND BOYCHILD
122	JACOLBY SATTERWHITE
123	JOYCE NG
125	KANYE WEST
127	JOYCE NG
128	JOYCE NG
129	RYAN MCNAMARA
130	JACOLBY SATTERWHITE

131 WU TSANG AND BOYCHILD
133 DESE ESCOBAR
134 WU TSANG AND BOYCHILD
135 RAÚL DE NIEVES
136–137 HEJI SHIN
138–139 THOMAS EGGERER
140–141 JACOLBY SATTERWHITE
142–143 XAVIER CHA
144–145 MAGGIE LEE
146 WU TSANG AND BOYCHILD
147 DAVID CASAVANT
148 XAVIER CHA
149 MAGGIE LEE
150–151 MAGGIE LEE
152–153 MATAO CHAMORRO
154–155 MAGGIE LEE
156 JACOLBY SATTERWHITE
157 DAVID CASAVANT
159 KANYE WEST
161 MAGGIE LEE
162 MAGGIE LEE
165 JACOLBY SATTERWHITE
167 WU TSANG AND BOYCHILD
168 MAGGIE LEE
169 WU TSANG AND BOYCHILD
170–171 DESE ESCOBAR
172–173 JACOLBY SATTERWHITE
174–175 WU TSANG AND BOYCHILD
176–177 RYAN MCNAMARA
178–179 RAÚL DE NIEVES
180 DAVID CASAVANT
181 RYAN MCNAMARA
183 RAÚL DE NIEVES
184–185 JACOLBY SATTERWHITE
186–187 XAVIER CHA
189 RAÚL DE NIEVES
191 MATAO CHAMORRO
192–193 MAGGIE LEE
194–195 MATAO CHAMORRO
196–197 RYAN TRECARTIN
198–199 XAVIER CHA
200 MAGGIE LEE
201 WU TSANG AND BOYCHILD
202 WU TSANG AND BOYCHILD
203 DAVID CASAVANT
204–205 WU TSANG AND BOYCHILD
207 WU TSANG AND BOYCHILD
208–209 WU TSANG AND BOYCHILD
210–211 JACOLBY SATTERWHITE
212–213 HANNE GABY ODIELE
214–215 RAÚL DE NIEVES
217 MATAO CHAMORRO
218–219 XAVIER CHA
220–221 JACOLBY SATTERWHITE
223 RAÚL DE NIEVES
224–225 RAÚL DE NIEVES
226 RAÚL DE NIEVES
227 WU TSANG AND BOYCHILD
228–229 HEJI SHIN
230–231 WU TSANG AND BOYCHILD
232–233 XAVIER CHA
234 HANNE GABY ODIELE
235 DAVID CASAVANT
237 STEWART UOO
238–239 RAÚL DE NIEVES
241 KANYE WEST
243 MATAO CHAMORRO
245 DESE ESCOBAR
246 WU TSANG AND BOYCHILD
247 JACOLBY SATTERWHITE
248–249 MAGGIE LEE
250–251 XAVIER CHA
252–253 MAGGIE LEE
254 MATAO CHAMORRO
255 JACOLBY SATTERWHITE
256 MAGGIE LEE
257 DESE ESCOBAR
259 KANYE WEST
261 WU TSANG AND BOYCHILD
262–263 RAÚL DE NIEVES

265 MATAO CHAMORRO
266–267 HANNE GABY ODIELE
268–269 WU TSANG AND BOYCHILD
270–271 THOMAS EGGERER
272–273 WU TSANG AND BOYCHILD
275 WU TSANG AND BOYCHILD
276–277 WU TSANG AND BOYCHILD
278–279 WU TSANG AND BOYCHILD
280–281 RAÚL DE NIEVES
283 WU TSANG AND BOYCHILD
284 DAVID CASAVANT
285 JOYCE NG
286 MATAO CHAMORRO

XAVIER CHA
PHOTOGRAPHY: CHRISTELLE DE CASTRO
MODEL: RAFA REYNOSO

DESE ESCOBAR
CREATIVE AND STYLING: DESE ESCOBAR
PHOTOGRAPHY: THOM CAO
MAKE UP: LILI DONATO
MODEL: LILI DONATO

RYAN MCNAMARA
PHOTOGRAPHY: RYAN MCNAMARA
MODELS: THOMAS GIBBONS, RYAN MCNAMARA

JOYCE NG
PHOTOGRAPHY: JOYCE NG
STYLING: MAKRAM BITAR
SET DESIGNER: ANDREW CLARKSON
HAIR: SHIORI TAKAHASHI
MAKE UP: DANIEL SALLSTROM
MODELS: CAMILLE SAINT-PIERRE, AARON, LEIGH BECK, SHARONDEEP
1ST PHOTO ASSISTANT: MATTHEW KELLY
PHOTO ASSISTANTS: PEDRO FERREIRA, VÍCTOR PARÉ RAKOSNIK
HAIR ASSISTANT: FRANZISKA PRESCHE
MAKE UP ASSISTANT: KAREEM JARCHE
SET ASSISTANTS: SOPHIE COATES, JEFFREY THOMSON
PRODUCTION: VÍCTOR PARÉ RAKOSNIK
PRODUCTION ASSISTANT: KIRIKO UEDA

HEJI SHIN
PHOTOGRAPHY: HEJI SHIN
STYLING: BURKE BATALLE
HAIR AND MAKE UP: JOSE QUIJANO
MODELS: CHRIS HINCHEY, MATT MCMAHON
CASTING: EMILIE ASTROM, OLIVER RESS
PRODUCTION: ADAM WILKINSON

DAVID CASAVANT ARCHIVE
BY DAVID CASAVANT

© DAMIANI 2018
© PHOTOGRAPHS, THE PHOTOGRAPHERS
© TEXT, THE AUTHORS

BOOK DESIGN
ERIC WRENN OFFICE, NEW YORK

MANAGING EDITOR
ZAINAB MAHMUD

PUBLISHED BY DAMIANI
INFO@DAMIANIEDITORE.COM
WWW.DAMIANIEDITORE.COM

PRINTED IN JULY 2018 BY GRAFICHE DAMIANI –
FAENZA GROUP SPA, ITALY

ISBN 978-88-6208-607-3